Color Matching
Handbook

Color Matching Handbook

Thunder Bay
P·R·E·S·S

San Diego, California

Thunder Bay Press
An imprint of the Advantage Publishers Group
5880 Oberlin Drive, San Diego, CA 92121-4794
www.thunderbaybooks.com

Copyright © Quantum Publishing, 2004
This book is produced by
Quantum Publishing Ltd
6 Blundell Street
London N7 9BH

Copyright under International, Pan American, and Universal Copyright Conventions. All rights reserved. No part of this book may be reproduced or transmitted in any form or by any means, electronic or mechanical, including photocopying, recording, or by any information storage-and-retrieval system, without written permission from the copyright holder. Brief passages (not to exceed 1,000 words) may be quoted for reviews.

All notations of errors or omissions should be addressed to Thunder Bay Press, Editorial Department, at the above address. All other correspondence (author inquiries, permissions) concerning the content of this book should be addressed to Quantum Publishing, 6 Blundell Street, London N7 9BH, United Kingdom.

Library of Congress Cataloging-in-Publication Data

Color matching handbook.
 p. cm.
 Includes index.
 ISBN 1-59223-178-0
 1. Color in art. 2. Color in interior decoration. 3. Color in gardening.
 I. Thunder Bay Press.

N7432.7.C65 2004
701'.85--dc22

2003064550

QUMCMD2

Manufactured in Singapore by Pica Digital Pte Ltd
Printed in China by CT Printing Ltd.

1 2 3 4 5 08 07 06 05 04

CONTENTS

COLOR .. 7

 what is color? .. 10

COLOR IN ART ... 33

 the colors ... 76

COLOR IN THE HOME ... 86

 blue .. 106

 green .. 114

 yellow and gold ... 122

 orange and peach ... 130

 red and pink ... 138

 creams and neutrals .. 146

 brown ... 154

 black, white, and gray ... 162

COLOR IN THE GARDEN .. 171

 pink .. 192

 orange .. 196

 green .. 199

 red .. 202

 white .. 206

 blue .. 209

 yellow ... 212

 purple .. 216

GLOSSARY .. 220

INDEX .. 222

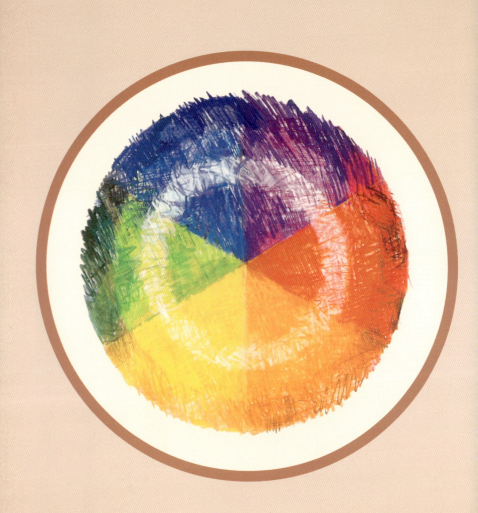

COLOR

Putting a color scheme together can be an enjoyable experience; it is not difficult to learn how to coordinate color and harmonize accents and variations. You will need to experiment, but once you have realized that colors never really clash — it is only how they are used that causes discord — you will gain confidence and find inspiration, both vital ingredients in achieving successful and well-balanced visual effects.

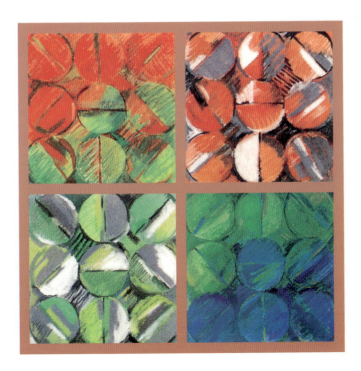

Understanding Color

Color is like the air we breathe; we don't truly appreciate it or even fully realize it is there until we begin to think about it in a specific context like art and home decorating.

Then, as we try to gain some idea of the tremendous range of different shades now available in the form of paint, papers, fabric, and carpets, it becomes bewildering, if not downright alarming. How can you ever hope to make a choice or learn to avoid the expensive mistake of buying a costly fabric or wallpaper that doesn't seem to go with anything else?

But this lack of confidence is largely a result of ignorance of the basic principles of color—for here, as in most things, there are certain rules and guidelines to follow. You may decide to break them all—some people have an instinctive sense of color and always get it right—but once you have absorbed them you will be able to deal with the apparent complexities and enjoy controlling color with confidence.

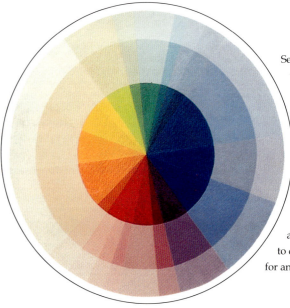

Seeing colors arranged in this way emphasizes the difference between cool, less "pushy" colors that are ideal for creating a sense of space and airiness in a small space, and warmer colors (the reds, pinks, oranges, rich browns, and sandy yellows) that create a cozy ambience because they tend to come toward you, making for an enclosing effect.

Properties of Color

Our responses to color are instinctive and wide ranging. We use it as a means of recognition and analysis – it helps us to define space and form – we use color cues as invitations or warning signals, we appreciate its purely decorative functions, and respond consciously or subconsciously to its emotional appeals.

When we watch reruns of old television programs made in black and white, we can appreciate how impoverished the world would seem without color. It takes considerable creativity to make a "colorful" statement in monochrome, though it can be done, and there is plenty of evidence in drawings, prints, film, and photography to show this. On the whole, though, color is a more stimulating medium, and we have learned to use it with great variety and invention.

The sheer wealth of color in natural and manufactured objects, along with the variations created by form, surface texture, and effects of light and shade, can make it very difficult to unravel the distinct and manageable aspects of color values when you start to make a drawing or painting.

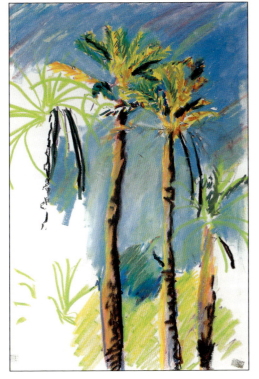

In keeping with the tropical subject, this oil pastel drawing of tall palms plays sunshine yellows and citrus greens against clear blues and mauves to produce a vibrant effect. This drawing was the basis for a silkscreen print in which a more formal design was schemed with brilliant color.

• COLOR •

What Is Color?

Color is an effect of light. The range of colors that we see in a given context depends on the quality of illumination created by the available light, but the color is a real phenomenon, not an illusory or transient effect.

Each material or substance that we perceive as having a particular color is reflecting certain wavelengths and absorbing others, and its ability to do this is inherent. A red object, for example, does not suddenly turn blue under the same light conditions, but it will not appear red if it is not receiving illumination that includes red light wavelengths.

White light contains all colors, and it is under white light that you see what might be called the "true" color of an object—what artists term local color. When a beam of light is passed through a glass prism, it separates into its component colors and can be projected on a surface as clearly defined bands of color. This effect was first studied in the seventeenth century by Sir Isaac Newton, who identified the bands of the color spectrum as red, orange, yellow, green, blue, indigo, violet—a list that has become familiar to generations of children as colors of the rainbow. The science of light and color has progressed considerably since Newton's time. The spectrum of colored light is estimated to include about 200 pure hues within the visible range, although not all of these are readily distinguishable by the human eye.

For the artist, the practical points to consider are the visual sensations of light and color, and the ways in which these are experienced. There is, however, one important principle that should be carried with you in your color work: light is the source of color. It can thus be said that the artist working with color is always trying to capture effects of light, but is doing so using materials that contribute their own physical weight and density. Coloring materials that are solid and textured behave quite differently from colored light. Because white light

is composed of colors, a certain combination of colored lights makes white, but with drawing and painting materials, the more colors that are applied, the more colorful or darkly veiled the surface effect becomes. The artist is dealing with substantial elements and must learn how they can be used to create equivalents of the insubstantial effects of light.

Below: The artist exploits the broken texture of pastel, achieving an extraordinary quality of illumination through her control of pure color values and the full tonal range.

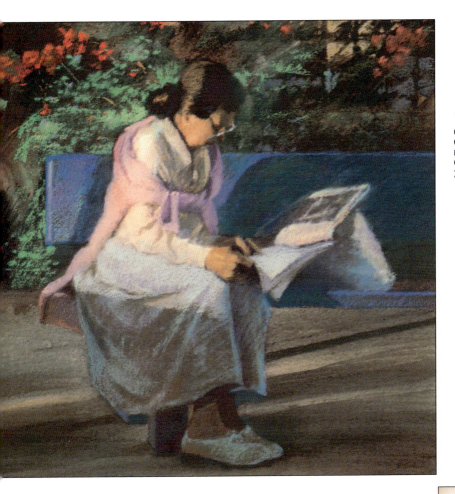

• COLOR •

Responses to Color

We perceive color in physical terms by the action of light on the rods and cones in the retina of the eye. The cones distinguish hue while the rods register qualities of lightness or darkness.

By some estimates, a person with normal color vision is capable of identifying up to ten million variations of color values. The condition known as color blindness includes several forms of incomplete color perception—an inability to distinguish red and orange hues from yellow and green is perhaps most common—and there are rare cases of people who see only in monochrome.

Whatever the scientific evaluation of our visual capacities, none of us can be sure that we see colors in exactly the same way as anyone else. It may be possible to measure the color range of light entering the eye, and to check the efficiency of the physical receptors, but this says nothing of how color is experienced by an individual. Our responses to visual stimuli are processed by the brain, which can add memories, associations, and its own inventions to the purely physical information we receive.

It is accepted that color has an emotional impact, although it is not possible to qualify the precise effects of each color. Such implications are acknowledged in everyday speech by phrases such as "seeing red" or "being green with envy." The origins are not clear—why, for example, should blue be the color of a melancholy mood, as in "feeling blue"? However, even when there is a widely accepted color association of this kind, this does not make it a reliable factor in visual terms. Matisse's *Red Studio*, for example, is not an angry painting, even though it is flooded with red, and plants, real or depicted, are not associated with jealousy because their leaves are green. Color is a relative value in image-making and its pictorial significance depends upon other aspects of the compositions as well as on the context provided by the subject. Expressing mood and emotion through color is a relatively abstract exercise more dependent on color interactions than on external influences and associations.

The creative use of color can be affected by all sorts of personal preferences, with complex and often obscure origins. Attempts to use color as a personality indicator have uncovered widely varied influences. One person may dislike a color

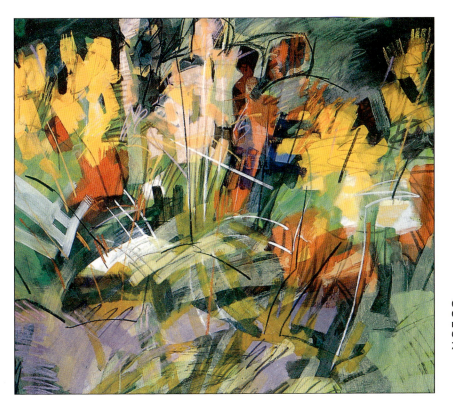

A large-scale drawing can be a good medium for releasing inhibitions about color work. This image is derived from a display of brilliantly colored garden flowers. Worked in acrylics and pastels on a paper sheet, the artist allowed the drawing to develop freely and abstractly.

because it is associated with an unpleasant occurrence, while people with entirely different personalities and tastes may all come to like a color because it is fashionable and widely promoted. Familiarity with the colors in a particular environment can make them seem independently attractive.

Most of us are fairly conservative about the colors we live with, and many people prefer to dress mainly in restrained or neutral colors accessorized with brighter accents. We usually look for harmonies, which leads us to choose restricted color combinations often containing more muted than pure hues. The same is true on a wider scale —

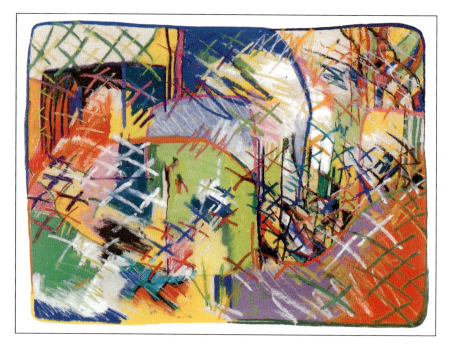

This image is the result of color doodling, an exercise by the artist purely as an abstract investigation of color relationships. It was limited to the range of colors supplied in a box of soft pastels, which covered all the six main color families. The image emerged simply from trying out all the colors and textures of the pastels and gradually organizing the different areas of the composition.

many people might like the idea of putting a red sofa in a white room, but few would choose to paint their living room walls bright scarlet.

Some colors seem more difficult to deal with than others. Orange and purple can seem hard and artificial, oddly, since garden flowers present many rich and subtle shades of these hues. Blues and greens commonly seem more sympathetic, which might have to do with their predominance in nature. Yellow is a color that many people will not wear, as it is considered unflattering and sometimes brash; yet it is also associated with sunshine and a cheerful atmosphere. Van Gogh demonstrated very effectively how well it can work as the dominant color in painting.

Color Character

If we can see millions of pure hues and tonal variations of color, the range of color values that we can identify and use is more or less infinite — an alarming prospect.

This huge number of colors, however, can be grouped into distinct "color families," and these are actually very few. We can categorize color sensations as belonging to one or another family, distinguishing colors that have a quality of redness from colors that tend toward greenness, for example, even though these are not always pure red or pure green hues.

In practical terms, artists' colors are grouped as six standard hues — red, orange, yellow, green, blue, and purple. These represent the three primary colors, which cannot be created by color mixing — red, yellow, and blue — and the three secondary colors — orange, green, and purple — that can be mixed from pairings of the three primaries. The broader variety of pure hues are theoretically capable of being mixed from different combinations of the six — degrees of red-orange, yellow-green, blue-green, blue-purple, and so on. Also related to all pure colors are the different tonal values of lightness and darkness, increasing the total range of color values.

Theories that analyze and predict various aspects of color relationships assume fixed color values. But what is confusing is that there is no actual standard for the fixed colors — no precise definition of, for example, primary red — and different theorists have come up with different ways of analyzing the relationships. To use color in drawing you must evaluate the actual color in your materials on the basis of your experience. This is not to say that theories have no place; they have produced some useful guidelines on organizing color relationships that can be put to practical use. These include ideas about the "presence" of each individual color and its interactions with others that are based on observation, but it is worth bearing in mind that they do not constitute set rules of color behavior. Part of the excitement of working with color lies in the feeling that it is still possible to make it do the unexpected.

• COLOR •

Color Terms

There are various words and phrases you are bound to come across whenever color is discussed, even in the pages of this book, so it will be useful to begin by defining them.

PRIMARY COLORS
Primary colors are the particular reds, blues, and yellows that cannot be obtained by making mixtures of other colors.

SECONDARY COLORS
Secondary colors are the colors made from mixtures of two primaries, i.e., red + blue makes purple; blue + yellow makes green; red + yellow makes orange.

TERTIARY COLORS
Tertiary colors are mixtures of one primary and one secondary; in effect, three colors. For example, red + green makes brown.

TONE
Tone refers to the lightness or darkness of a color.

HUE
Hue is the property of a color that enables it to be identified as, for example, red, yellow, or blue.

INTENSITY
Intensity (also called saturation or chroma) describes the brightness of a color. Two or more colors could be identified in terms of hue as red but still look quite different because one is more brilliant than the other.

COMPLEMENTARY COLORS
Complementary colors are those that react most with each other and are the colors that are opposite one another on the color wheel, such as red and green, or yellow and violet.

Mixing Primaries

Most people have been told that it is possible to mix every color from the three primaries, but in practice this is simply not true.

Color theory assumes that there is such a thing as one pure red, yellow, and blue, but these pure colors do not exist in artists' pigments. If you look at the next page you will quickly see the strengths and weaknesses of the three that are nearest to the ideal pure colors: cadmium red, cadmium yellow, and ultramarine.

There is one obvious weakness. Although the red and yellow make a strong, clear orange, and the blue and yellow make an acceptable green, the blue and red, which theoretically make purple, actually make a range of grays and browns. What is impressive, however, is that just three primary colors plus black and white have been used to make an additional thirty-three colors.

But they have certainly not made all possible colors, and they have not made purple, so the first extra primary you will need is a red with a slight bias toward blue—alizarin crimson. You will also be able to make a wider range of greens if you add two additional primaries: lemon yellow, which is a much paler, sharper yellow than cadmium, and cobalt blue, a cooler, slightly greener blue than ultramarine. Mixtures of these colors are shown in the chart on the following pages; this also shows that these three primaries can't do everything, either. For example, lemon yellow and alizarin crimson do not make a true orange, and you have not yet made a good purple, but lemon yellow and cobalt blue achieve a clear, sharp green. The lesson of this is that the strongest secondary colors are made by mixing those colors that have a slight bias toward each other.

• COLOR •

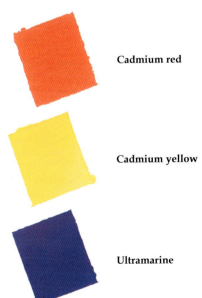

Cadmium red

Cadmium yellow

Ultramarine

MIXING PRIMARIES TO MAKE SECONDARIES

PRIMARIES

Cadmium red

ORANGE GROUP

Cadmium red ⇨ ⇦ Cadmium yellow

Cadmium yellow

GREEN GROUP

Cadmium yellow ⇨ ⇦ Ultramarine

Ultramarine

PURPLE GROUP

Ultramarine ⇨ ⇦ Cadmium red

MIXING PRIMARIES TO MAKE SECONDARIES

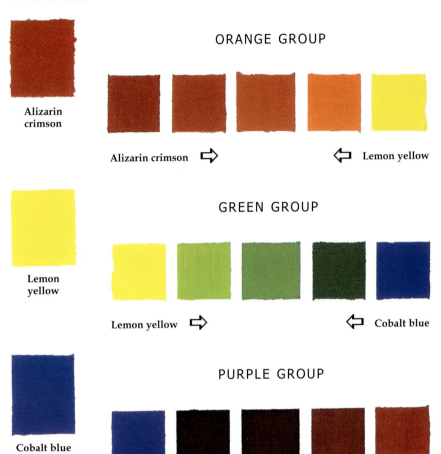

• COLOR •

The Color Wheel

Color wheels come in a variety of forms. Some show pure colors based on those of the spectrum, but these are not helpful in the context of painting.

The wheel shown here has been done with acrylic paints, using primary colors to produce both secondary and tertiary ones.

One thing you will notice immediately is the dramatic difference in tone between the colors shown here—no white or black has been used, yet the purples and blues are very dark compared to the yellows and any colors with yellow in them. You'll find that you often have to add a little white to achieve a really successful purple, while green can sometimes be lightened by adding yellow alone.

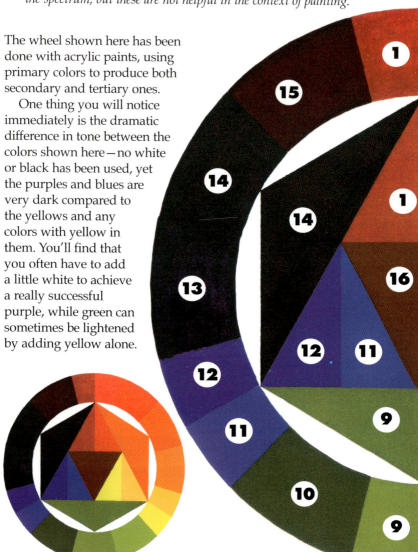

• COLOR MATCHING HANDBOOK •

20

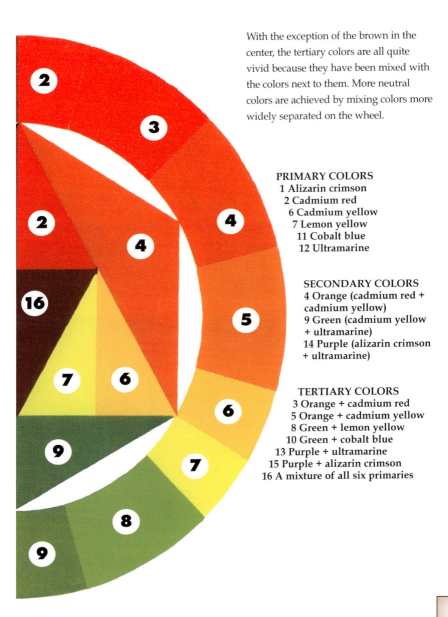

With the exception of the brown in the center, the tertiary colors are all quite vivid because they have been mixed with the colors next to them. More neutral colors are achieved by mixing colors more widely separated on the wheel.

PRIMARY COLORS
1 Alizarin crimson
2 Cadmium red
6 Cadmium yellow
7 Lemon yellow
11 Cobalt blue
12 Ultramarine

SECONDARY COLORS
4 Orange (cadmium red + cadmium yellow)
9 Green (cadmium yellow + ultramarine)
14 Purple (alizarin crimson + ultramarine)

TERTIARY COLORS
3 Orange + cadmium red
5 Orange + cadmium yellow
8 Green + lemon yellow
10 Green + cobalt blue
13 Purple + ultramarine
15 Purple + alizarin crimson
16 A mixture of all six primaries

• COLOR •

Secondary Colors

The range of hues that exist between the primary colors are known as the secondary colors and include green, violet, and orange.

First make a gradation scale of even steps from pure yellow to pure red, a red and a yellow that have absolutely no trace of any other color in them. Theoretically, at a point halfway along the scale, the

On the color sphere below, the four secondary colors are located. They are geranium lake, cobalt violet, Winsor violet, and ultramarine blue. When these are injected in the right proportions, they help create an intense violet.

secondary color, orange, should be located.

A similar exercise can be repeated making a scale from pure yellow to pure blue. During this exercise, gradually add white to the mixtures, and in doing so, control the tonal level throughout the scale. By doing this you will be articulating hue and tone at the same time and it is recommended that all the mixtures included in the yellow to blue scale should be pitched in tone approximately equal to yellow. In practice this means that the blue will be very pale indeed. Again, at a point halfway along the scale, the secondary

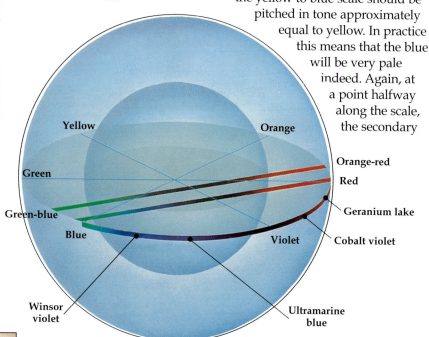

color, green, should occur. If a similar procedure were adopted with a movement from pure red to pure blue, the result would be found only to approximate the secondary color, violet, for the pure red/pure blue scale shows the greatest inconsistency or irregularity between the theory and practice of color.

If white is added to the center mixture of the pure red/pure blue scale, the result is an approximate gray/brown. To accentuate the discrepancy between theory and practice, you should try to make a gradation scale from a blue that tends toward green and a red that tends toward orange, adding white throughout in order to maintain a tonal level equal to the orange-red. If more white is added to the center mixture, the result will almost certainly be a convincing gray.

These tests show the paths described by mixing simple colors. In the color solid, they are seen to move in toward the broken and gray core. Some of the mixtures can be described as broken colors, for they are low in chroma and located far away from the region of high chroma that is on the surface of the color solid. In order to correct this loss of chroma, you should make a further gradation study from pure red to pure blue, maintaining equal tone throughout, but in this third scale you should attempt to revitalize the series with additional pigmentation. This can be achieved by introducing, for example, French ultramarine, Winsor violet, cobalt violet, and geranium lake at appropriate points on the scale. The relative differences in chroma between the center mixtures of the three blue-to-red scales can be examined by juxtaposing samples from the different series. The addition of manufactured secondary pigments into the other scales will also help increase their chroma and intensity. A continuous color band of three primaries and three secondary colors, along with an unlimited number of subdivisions, can now be assembled.

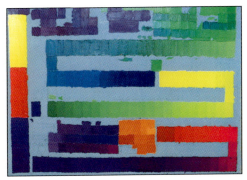

Here the artist has explored oranges, greens, and violets by plucking them out of their scales and juxtaposing them in different configurations.

Warm and Cold & Light and Dark Colors

WARM AND COLD COLORS

Something else you will notice is that the colors on the wheel fall into two groups, the so-called warm colors—the reds and yellows—and the cold ones, the blues and greens. Identifying these is very important in painting because the warm colors are inclined to come forward and the cold ones to recede. This is a way of creating space; if you paint a group of oranges against a greenish or bluish-gray background you will notice how the orange almost jumps toward you.

Using color is not always as simple as that because almost all colors have warm and cold versions. Although the warm colors are generally held to be the red, oranges, yellows, and any mixtures that contain these, such as red-brown and yellow-green, color temperature, as it is called, is relative.

Look at the different version of the primary colors on the wheel on pages 20–21, and you will see that each has a warm and cold version.

LIGHT AND DARK COLORS

It is surprisingly difficult to judge the tones of colors, as the eye is much more receptive to hue than to how light or dark it is. However, it is important to learn to identify tones, as contrasts of light and dark have a vital role in painting, and you may find it helpful to make charts like the ones shown below.

On the left side is what is known as a gray scale, with white at the top, black at the bottom, and five equal steps of gray between them. Opposite each one of these has been placed the primary, secondary, or tertiary color that best matches the particular shade of gray. You could extend this chart by using some of the secondaries mixed with black or white.

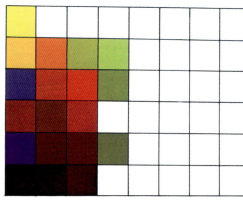

Harmonious and Complementary Colors

You will also see in the color wheel that the colors next to one another are harmonious — that is, if you used them together in a painting they would not set up any kind of discord or clash. Those directly opposite one another are quite different, however.

These—red and green, yellow and violet, and blue and orange—are known as complementary colors. They also play a central role in painting, because when they are juxtaposed they set up a kind of vibration that makes both appear brighter. A large area of green can be given an extra sparkle by the addition of small touches of red, and a little green on the shaded side of a red object brings out the color in the same way. The Impressionists used such effects widely, claiming that every shadow contained touches of the complementary color of the object.

The next thing you will need to learn about color is how its intensity (or chroma) relates to tone, which, as you already know, simply means lightness or darkness of a color.

• COLOR •

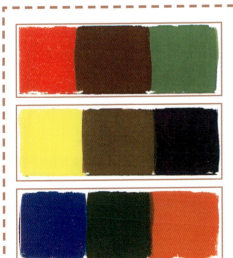

COMPLEMENTARY MIXTURES

As we have seen, the most vivid secondary colors are those made by mixing two primaries that have a bias toward each other and thus are close together on the color wheel.

Mixing complementary primaries produces the opposite effect. These neutral colors can be a useful foil on an otherwise bright color scheme.

25

How Colors Work Together

Color contrasts can be obtained by using complementary colors or by juxtaposing different hues or colors with different tonal values. This seems fairly obvious, but there are three other important factors that affect color contrast, and these are less obvious.

First, contrast is affected by the relative size of the color areas. You can try this out very easily. Paint a small square of blue and surround it with a large area of red. Then reverse the colors, with the red occupying the smaller area. You will see that the colors do not look the same.

The second factor is the texture of the paint. A flat area of color looks different from one in which the brushstrokes are visible, and if the paint is applied thickly with a knife it will look different again. You can try this out, too—you may be surprised by the result.

The third contrast, between warm and cool colors, has already been explained on the previous pages, but it is worth reiterating that the warmness or coolness of a color does not exist in isolation. Although blue does tend to recede, it will only do so if the other colors used are sufficiently warm to provide the necessary contrast. Inexperienced landscape painters sometimes make the mistake of painting background hills a vivid blue, secure in the knowledge that blue recedes, only to find that because none of the other colors match the blue in intensity, it does exactly the opposite. The strongest color in a painting will always tend to advance, particularly if it occupies a large area.

One of the difficulties—and delights—of using color is that all is relative. No color has an independent existence; it is "made" by the way it is juxtaposed with other colors. This fact is central to painting, as it is this that allows artists to simulate the colors of nature with what is, by comparison, a fairly small range of

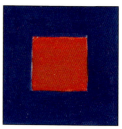

Primary contrasts can be effective, but you can often bring out the vividness of a color by juxtaposition with a neutral tertiary color.

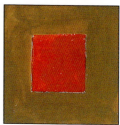

pigments. Not even a whole manufacturer's range of colors can reproduce all the colors you see; you will always have to make red look more red or orange more orange by the way you orchestrate the colors around it.

One of the biggest problems in home decorating springs from the failure to realize that color is a perversely changeable thing. No one color exists by itself; it is given its character by the other colors that surround it, and an area of color can be made to look smaller or larger in the same way.

It is easy to opt for a "safe" beige or gray, only to find, when you put it in place, that it looks quite wrong because it is a warmer or cooler shade than the walls or carpet.

Theoretically, all greens are cool, but if you place an olive green next to one of the bluer greens, like jade, you will have difficulty perceiving them both as green—the olive will look distinctly brown. Much the same applies to the reds. In principle they are all warm, but some of the lighter tints of crimson will look bluish if placed next to a bright fire-engine red. This is why it is vital to choose all the component parts of a color scheme together, taking a sample of your chosen paint or wallpaper with you when you look at fabrics and floor coverings.

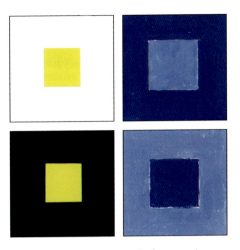

The central squares are exactly the same size, but a pale color surrounded by a dark one always appears larger than the reverse.

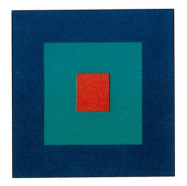

In the square above, cool colors tend to recede while warm ones advance.

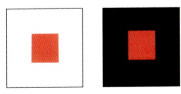

Here, a red square looks smaller on a white background than on a black one.

• COLOR •

27

Discordant and Vibrating Colors

The natural environment consists largely of broken hues and dull colors. Earlier studies of harmonics have helped demonstrate the incidence of color harmony and gradation that exists in nature. Some color relationships, however, are not harmonic – they are discordant.

Before searching for examples of discordant colors in the natural world, you should first examine color discord in the abstract.

Colors arranged in a discordant relationship will compete or clash. In order to achieve the exciting effect of color vibration, the natural indigenous tonal order of colors must be reversed. This order was mentioned earlier. This introduces an element of opposition into a color relationship that would normally be harmonious, albeit sometimes contrasting. For example, a visual screaming effect can be achieved by juxtaposing two complementary colors in which the normal tonal order has been marginally reversed or inverted. For example, in a blue-orange discord, blue should be made fractionally lighter than orange. Blues are normally darker than orange. Red is generally considered to be brighter than blue, and yellow is brighter than red. The most saturated red is lighter than the most saturated blue, and the most saturated yellow is lighter than all the principal hues.

Any two colors, whether they are adjacent or diametric, can be made to clash, either by making tonal values equal or by creating an inversion of the natural tonal order of hues. You will find that some pairs of colors will be more difficult than others. Among the complementary pairs, violet and yellow will probably cause the greatest difficulty. Remember that violet must be made as light as or even lighter than the yellow. It will therefore appear almost white and will seem to have lost its hue or saturation of pigment. However, this is not so, because, as was said before, the addition of white does not alter the hue in a color.

Opposite: The artist has chosen a yellow as the lightest color. There is a strict natural value order for colors. The darkest is violet, so that in order to raise to the value of yellow, it has to be made very light. This accounts for the paleness of the violets and blues in this particular exercise. The interaction of discordant color is important in painting and drawing, so study the effects achieved in this exercise closely.

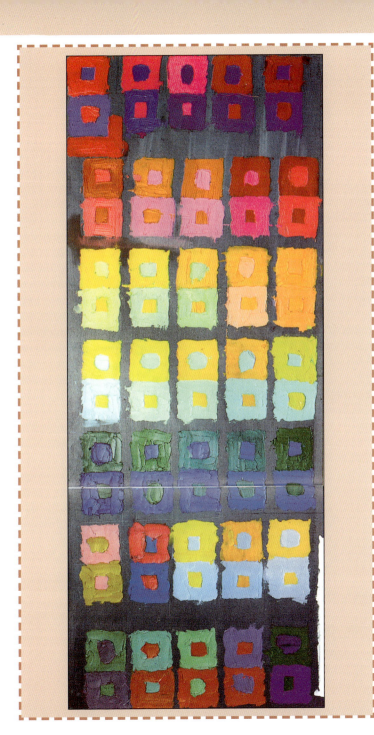

• COLOR •

Optical Mixing

Many artists have become obsessed with the fascinating intricacies of color theory, but the French artist Georges Seurat (1859–91) was a particularly notable pioneer in this field.

Having studied both scientific treatises on color and the diaries of Eugène Delacroix (1798–1863), who had also been an ardent color theorist, he developed a completely new method of painting. This method, known as "Pointillism" (though Seurat himself preferred the term "divisionism"), was based on the idea that it was possible to produce brighter, more vibrant secondary colors if the appropriate primaries were applied to the picture as tiny blobs, close together but not actually mixed. The mixing takes place in the viewer's eye — or, to be precise, in that part of the brain that governs color perception.

Thus the most brilliant green, Seurat considered, would be obtained by applying pure dots of primary blue and yellow, which, when seen from a reasonable distance, would fuse together to read as green. The Impressionists had used a less systematic version of the technique earlier when they increased the brilliance of their colors by breaking them up into a mass of varicolored brushstrokes.

You can carry out your own experiments in optical mixing by painting on graph paper. The closer the colors are in tone, the better they will mix.

Deceiving the Eye

In a sense, the whole business of painting – creating the illusion of three dimensions on a flat surface – is a series of optical tricks, so it is important to realize that many visual illusions take place in painting.

One such illusion is seeing a color that isn't there. If you look hard at a color for half a minute and then look away or shut your eyes, you will automatically see its complementary. Try this by painting a red cross on the top of a piece of light gray paper, about 2 in. in height and width and with lines about ½ in. wide. Stare at it hard for a minimum of thirty seconds. Now look down at the empty bottom half of the paper and you will see a distinct green cross. This curious phenomenon is one of the reasons why the complementary of a color appears in its shadow. When you look from a light-struck area to a shadowed one, the afterimage becomes apparent in just the same way.

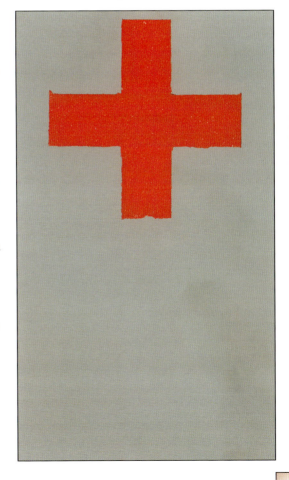

• COLOR •

Staring hard at a color and then shutting your eyes or transferring your gaze to a blank, neutral area of color will produce an afterimage of the color's complementary.

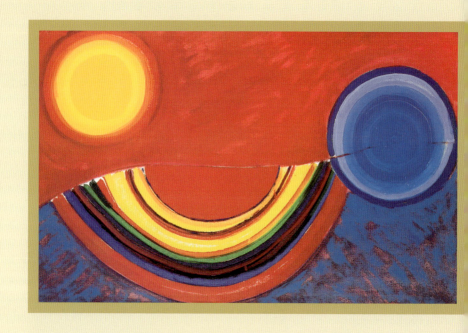

COLOR IN ART

The colors of our surroundings are not what they seem, at least not to an artist. Think of a gray concrete wall. We look at it in bright sunshine, on a dull day, or in the rosy light of sunset, and it's still gray. Under these three different types of illumination the light reaching our eyes is of very different composition, and yet we still see the concrete as the same color. How can this be? The answer lies partly in the fact that we expect concrete to be gray and we cannot believe it to be anything else.

Our eye and brain respond to color relationships rather than absolute color. Both the concrete and its surroundings are being lit by the same light source, and as this changes, the relationship of one color to another remains fairly constant.

Let's take another example: an orange. Hold it in your hand, and on close examination you can see that it is not a uniform orange color all over. This is known as its local color. Our orange is receiving light from different parts of the room as well as from light reflected off other objects, so it cannot appear the same orange color all over. It is the painter's job to observe the color relationships in front of him, to find their equivalents in paint, and create an equivalent of the original subject on canvas.

Seeing Colors You Want to Paint

The way to do this is by clearing your mind of preconceptions – forgetting what you think is there and really looking hard and seeing.

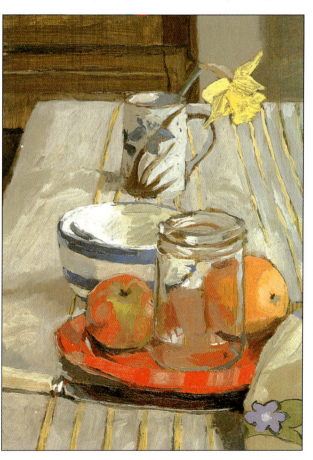

Here is a little oil study of textures called *Still Life with Daffodil* to illustrate the type of variety of color and tone to look for when painting. Let us first look at the orange to the right of the picture. How much of it is painted in orange paint? Only the top right-hand quarter, and even this is in three tints of orange. Below this area are shadowy browns, and behind the glass jar the orange is painted in an assortment of

STILL LIFE WITH DAFFODIL by Jeremy Galton. Color isn't what it seems. Much of the "yellow" in this daffodil is painted in greenish paint, while the "white" of the sugar bowl actually appears as an assortment of blue-gray, green-gray, and even a little pure orange. The off-white tablecloth is painted in a wide range of color mixtures.

reddish shades, rising as reflections from the red plate on which it is standing. The red plate itself is painted in many different reds and mauves, their exact relationships giving the illusion of a flat, shiny plate with a raised rim.

MIXING THE RIGHT COLOR

We now know that there is no "right" color to paint, only right color relationships, so in a way it doesn't matter if you haven't mixed up the exact color of what you're painting so long as the surrounding areas relate correctly to it. But it may matter to you because the colors are what you find most interesting about a subject, and for the same reason many painters do strive to get as close as they can to the colors in front of them.

The act of mixing the color you want requires the same sort of mental process as trying to sing in unison with a musical note or seasoning a soup until it tastes just right. Mixing paint until it's just right is much more difficult, though, as both tone and color have to be adjusted and there are far more wrong directions to take. It is a question of matching—adding a little bit more blue, now a little black, and so on until you are satisfied you have the right color. Knowing when you have the right color can be tricky because you have to memorize the color for a moment while taking your eyes away from your subject and down to your palette. In addition, the palette is likely to be under a different light than the subject, making exact color matching impossible. One way of doing it, however, is to simply hold the paint on your brush up to the subject so that the colors can be seen side by side. If, for example, the paint is not quite yellow enough, mix in a little, bit by bit, until the colors coincide.

• COLOR IN ART •

Judging Color Relationships

Color relationships can be established by continually comparing your picture to your subject and marking alterations and modifications until you judge the relationships to be satisfactory.

This does require very careful observation, which develops with experience. Try to look at the world around you with a painter's eye all the time, thinking of the colors you could mix for that yellow-edged cloud or those interesting greenish shadows on the unlit side of someone's face. You'll learn a lot, and you may find being stuck in a traffic jam less frustrating.

A good way of analyzing color changes is to use a piece of cardboard with a ½ in. hole cut in it. Hold this up about 12 in. from you and look at an area of color that appears at first sight to be the same all over—an orange, for example, or the cover of a sketchbook. The little square of color you see, isolated from its neighbors, will look pretty meaningless, but now try moving the card slightly and you will begin to see variations in the color. You will notice darker shadow areas and slight changes in color intensity caused by reflected light or the proximity of a different-colored object. By taking one area of color out of context, you are able to see what is really happening in terms of color instead of simply what you

expect. You don't have to use a piece of cardboard—making a small circle with your fingers will do just as well.

MAKING COLOR NOTES

On the next few pages there are examples of some artists' own systems for making color notes so that they can re-create a scene in the studio. You may remember the general impression of a color, but no one can recall the subtle variations, so if you're out looking for a likely landscape subject, try to jot down some impressions in a rough pencil sketch. This can be done in words, for instance, "sky very dark blue-gray, mixture of Payne's gray and ultramarine," or "green very blue, perhaps viridian and cobalt blue." If you have paints, pastels, or even crayons with you, make some quick visual notes right then and there, trying out various combinations until you are satisfied.

COLOR MATCHING HANDBOOK

36

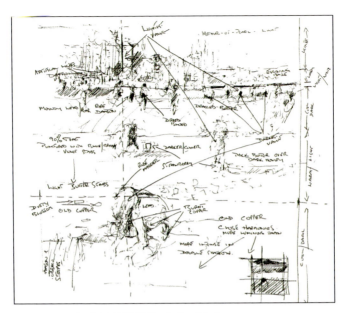

THE SUNSHINE STAKES, WEYMOUTH by Arthur Maderson

Every artist develops his own method of recording the essentials of a scene that can be used as a trigger for painting done later in the studio. Here Arthur Maderson uses nothing more sophisticated than a ballpoint pen to jot down written color notes: "I am fascinated by the quality of light at the end of the day—anywhere between late afternoon and dusk. Since the light changes so rapidly then, I rarely paint on the spot. Instead, I take photographs and make rapid sketches on which I scribble color notes in my own personal shorthand. I tend to favor using associations of colors, which somehow trigger a quite specific value and textural quality. 'Ripe damson' tells me more than simply saying 'dark red,' for instance. 'Moldy lead' gives me variations on a luminous world of pale viridian and blue. I also try at this stage to establish a strong and simple pattern of light and dark values that will hold the picture together."

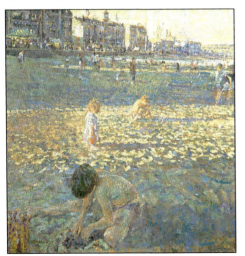

• COLOR IN ART •

37

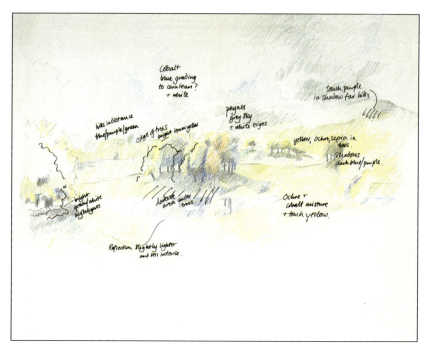

RYDAL WATER by Moira Clinch

This artist works in watercolor, but often uses crayons to record her on-the-spot impressions. "My watercolors are fairly large and I'm a slow worker, so I usually do the actual painting in the studio from sketches, notes, and sometimes a photograph. Colored pencils are a handy sketching medium, and I tend to carry them around with me, sometimes making this kind of color notation in the car if the weather is cold. Here I've put down a general impression of the colors, but as pencils are a cruder medium than watercolor, I like to make written notes as well. The most important things to note in this case were the direction and quality of the light, both of which radically affect the choice of colors for the finished painting."

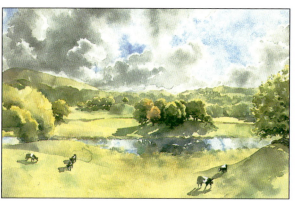

FISHING FOR MACKEREL, CLEY BEACH,
by Jeremy Galton

Shown here is a finished painting, along with a rapid oil sketch done on the spot to record the colors. The artist observed, "Unfortunately there was such a powerful wind blowing that I could hardly breathe, let alone paint a picture, but the colors of the sea and sky were so incredibly rich that I felt I had to record them, so for twenty minutes I mixed the colors that I judged to be the most important and painted them onto a small board. After two months or so, when the paint was completely dry, I returned to these 'notes' and used them as a basis for a finished painting. I had also made a drawing on a separate occasion, and although the colors then were completely different, this did not matter, as I had recorded the color in the sketch. When doing the finished painting, I matched the colors to the sketch by dabbing bits of mixed paint onto areas of the color notes."

• COLOR IN ART •

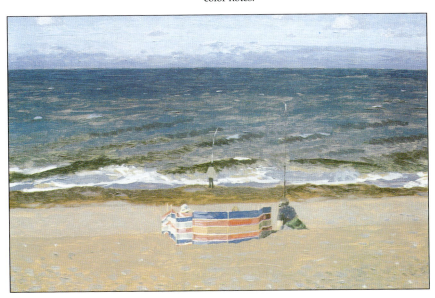

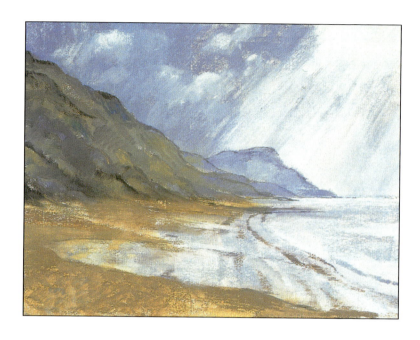

LOW TIDE, CHARMOUTH by Hazel Harrison

Oil pastels have been used here to record the colors and light effects in a rapid on-the-spot sketch. The artist said, "I like oil pastels as a sketching medium, particularly if the finished painting is to be done in oils, as the two media are similar enough to give the same sort of effect. Personally, I never find making watercolor sketches for an oil painting quite satisfactory, and this subject particularly seemed to demand an opaque medium with a good deal of white. For the light areas in the sky I simply laid down an area of very pale gray and then worked other colors into it with a brush dipped in white spirit. The beauty of oil pastel is that a sketch like this can be done very quickly — this one took no longer than half an hour."

• COLOR IN ART •

Deciding on the Final Colors

*Traditionally, both in oil and watercolor, the artist would first establish
the tonal relationships of a painting in broad areas of thin wash
or by using a pencil or charcoal drawing.*

In oils, an earth color such as terre verte, raw umber, or sometimes ultramarine diluted with turpentine would be used to lay out the darker areas, thus producing a rough monochrome image. Bit by bit, more color would be added and the painter would gradually build up a network of tone and color gradations and contrasts, continually approaching closer to an equivalent of the subject in paint. Toward the end of this process the final adjustments would be made.

Some artists still work in this manner, but it is by no means essential—you can aim for the final colors immediately. In pastel, every mark on the paper must be final because it cannot be erased satisfactorily or drawn over—a pastellist must plan the picture carefully in advance. Watercolor painters also now tend to start with the final colors or paler versions of them, finding that this approach gives a fresher and more immediate look to a picture. This applies equally to oil; a free, spontaneous painting can be the result of treating every brushstroke as the final one, as the Impressionists did. It is not always necessary to do underpainting if the pitch of the painting has been established from the start.

Watercolor differs from oil in that although both bright and subtle colors can be achieved, accurate color equivalents are not always possible. Too much mixing destroys watercolor, as does a succession of too many washes laid on top of each other. Watercolor relies more on tonal relationships, which are gradually developed throughout the execution of the painting.

The advantage of acrylics, when used thin, is that layer upon layer can be added until you arrive at the color you want. Of course, they can also be used opaque and treated in much the same way as oils.

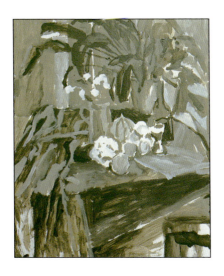

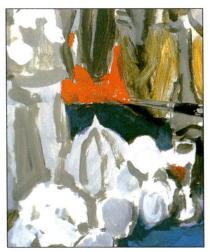

1 This painting has been started in monochrome, a method that was standard up to the mid-nineteenth century and that many artists still find the best way of working. The idea is to establish the broad areas of light and dark and all the basic forms before any color is put in, creating a complete map of the lightness and darkness of each color.

2 The next step is to paint the brilliant red and blue of the background and foreground, because all the smaller areas of color, such as those of the fruit, bottle, and jug, must relate to these. The big areas of vivid color can be modified later in relation to the rest of the painting.

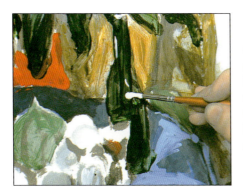

3 Having painted the mid-green of the jug and the melon beside it, the darkest colors can now be painted in. Touches of white are added to the dark green bottle, to be toned down if they are found to be too bright.

• COLOR IN ART •

43

4 The blue of the drapery needs to be given some modeling, and it seems too uniform in color, so some touches of lighter blue and violet are added. Notice how close the finished painting is to the initial monochrome painting in terms of tone. The artist has not had to waste time balancing dark, light, and medium colors against one another because he was able to follow the guidelines he set in the first stage.

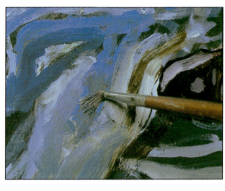

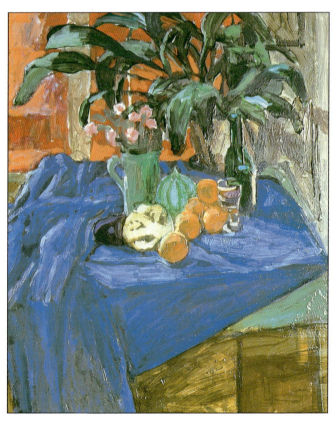

STILL LIFE WITH ASPIDISTRA by James Nairn

A Method for Direct Color Matching by Jeremy Galton

I have evolved my own system for a direct matching of colors and tones that may help a beginner make accurate observations.

It avoids the necessity of repeatedly looking up at the subject and down at the palette. To explain what I mean, I describe on these pages how I mixed some of the colors for a painting I did in southern France. I began with the sky, because once one area of a painting is correct in tone and color, the others can be balanced against it. In this case the sky was the key. I first took some white paint on my brush, then added a little cobalt blue to it. By holding the brush up to the area of sky in question, I could see by direct comparison that the paint was both far too blue and too light in tone. I continued to make adjustments, adding touches of raw umber and other colors until the color matched so perfectly that the paint was virtually indistinguishable from the relevant bit of sky.

The beauty of the method is that it establishes the correct tonal key. When I began on the buildings I found that the paint needed here was close to pure white, but even the whitewash was not as white as titanium white straight out of the tube, and I had to add minute

proportions of raw sienna and Payne's gray. Beginners are generally very hesitant about sharply contrasting tones, and I admit that I frequently have difficulty establishing a tonal key when conditions prevent me from using this method.

Shadows always present a problem. Their colors are elusive because they are often far removed from what we expect. Shadows falling on a sunlit path may be blue or violet, not the dark brown or gray that we may suppose. The reason for this is that while the sun is shining on parts of a scene, the areas in shade are receiving only the blue light from the sky. Don't be afraid of the color you arrive at using the matching method — once all the surrounding colors have been painted in, they will work together and you'll see that the mixtures obtained in this way were right.

OTHER COLOR MATCHING METHODS

The main drawback with the direct method is that it can only work if

• COLOR IN ART •

the lighting conditions are just right. Both the subject and your brush and paint must be illuminated by the same light source. For example, if bright sunshine is lighting a landscape, then your brush must also be lit by the sun. If your paint-laden brush is in shade and held up to a sunlit landscape, the paint will look black against the landscape. Similarly, if you are painting into the sun, the brush and paint will be merely a silhouette. There are also certain precautions to take. While holding the brush up in front of you, its angle of tilt is important. If this is varied, the apparent color of the paint on the brush changes, so this angle must be kept the same throughout.

Unfortunately, the method only really works well for oil paints. Acrylics will tend to dry before you have mixed the color you want, especially if it's a difficult color and is taking a long time to match, and both gouache and watercolor are virtually invisible on a brown sable brush. However, a similar method can be used for the other media, which is that of mixing up a little paint on the edge of a small piece of paper and holding it up to the subject in the same way. This may not give you a perfect match, as it is less precise than the method just described, but it certainly helps you to judge tones, as you can see immediately if the color you have mixed is much too light or much too dark. It will also give you a very good idea of whether a green is too yellow or a pink not warm enough, especially if you can hold your mixed paint close to the subject, as when painting flowers or a still life.

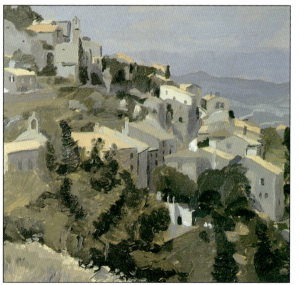

PROVENÇAL VILLAGE, LACOSTE
by Jeremy Galton
This picture was done on the spot in two hours, using the artist's special method of direct color matching.

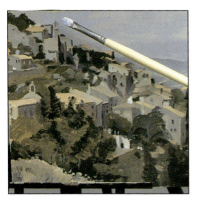

1. Just as I did when painting the real landscape, I begin by mixing white with a little cobalt blue on the assumption that the sky is quite pale. I hold the brush up to the color I am matching and find that it is much too light and blue. From experience I know that I can successfully modify it with Payne's gray and raw umber, so I mix in a little of both.

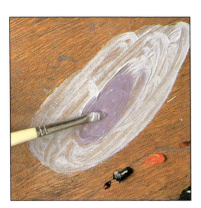

2. Holding up the brush again, it is obvious that the sky is more violet than the paint. Something is needed to achieve the correct adjustment. The options include alizarin crimson, burnt sienna, or Winsor violet. I choose the latter, which, with one or two more fine adjustments, gives a color that perfectly matches the sky at the top of the picture.

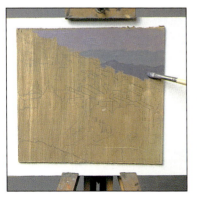

3. The sky is often much darker than one thinks. Painting on a toned ground helps here—a white background would show up these sky colors as being unbelievably dark. Now I am painting in the distant hills with the same paint I used for the bank of clouds but with a small addition of Payne's gray, ultramarine, and raw umber.

• COLOR IN ART •

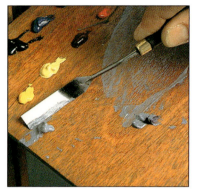

4 To make more space for mixing on my small traveling palette, I push aside the mixtures made for the sky and distant hills for possible use later on. I then block in large areas of foliage with green made from mixtures of ultramarine, Payne's gray, and cadmium yellow, and in places using terre verte straight from the tube.

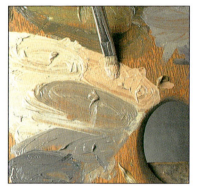

5 Now that the darkest areas have been established, I have a key for the colors and tones of the houses and I find that the "whitest" house is surprisingly dark. The pinkish roofs are based on raw sienna and white modified with varying amounts of cobalt blue, raw umber, and alizarin crimson. The bluer shades on the walls are obtained partly from my reserved sky mixtures.

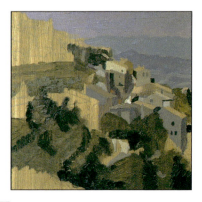

6 When using the direct matching method, it is important to have complete trust in it—never try to alter your colors because you don't believe that what you see is true. Once a number of adjacent colors have been painted, you will find that their interrelationships are perfectly correct.

Thinking in Color

Drawing directly with color requires a different kind of approach, because you must regard color from the start as one of the major compositional elements, influencing both your choice of subject and your arrangement of it into a pictorial image.

When you draw in monochrome with a graphite pencil or charcoal, the medium naturally prescribes which elements of the subject you can successfully convey. Because you are not using color, it is easier to focus on qualities of contour, mass, and texture, qualities that can be described effectively with a medium of line and tone. The process of learning to view a subject selectively, to analyze and interpret its essential forms, is an important experience that can be gained through drawing, and is at least one of the reasons why drawing is often thought of as a preliminary to painting rather than as a self-contained method of developing finished images. The traditional relationship between drawing and painting encourages artists first to separate form and color, then to put them back together.

This does not mean you should ignore the other main ingredients of two-dimensional composition — outline and contour, mass and volume, light and shade, pattern and texture — but it is necessary to think in color from the beginning because the color relationships will significantly affect the character of the composition. The aim of the drawing exercises and finished examples on the following pages is to demonstrate the principle of "keeping color in the picture" throughout the process of planning and executing a drawing.

Whether your subject is a still-life grouping, a figure, or a landscape, and whether a single or composite image, each real object or view that you are looking at presents a mass of visual information — basic forms, spatial relationships, color details, effects of light and shade. The fluid medium of paint allows you to manipulate these elements to some extent as you work, but with the slower processes of drawing this is less easy. You need to develop a reasonably systematic approach.

• COLOR IN ART •

Tonal Values

There are two distinct aspects of tonal values in color drawing – the balance of inherent tonal values in the local colors and the effects of light and shade that modify the color values.

"Tone" is a general term referring to qualities of lightness or darkness. It is easiest to think of this in terms of a monochrome scale from white (lightest value) through a range of grays to black (darkest value). A three-dimensional object reflects a degree of light across its external form according to the strength and direction of the light source falling upon it. The tonal scale of reflected light is independent of the local color, but it can be difficult to perceive these tonal values accurately because of the relative values of different colors. Imagine a yellow cube standing next to a purple cube, both lit from above by the same light source. The upper plane of each cube has the lightest tonal value because it receives direct light, but yellow is naturally seen as a lighter color than purple. So, in a drawing of the cubes, two tonal factors would need to be combined to render the colors accurately.

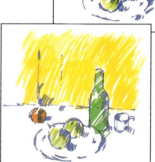

This sequence shows stages in an exercise in composition, establishing line and tone before introducing local color, then extending the color range and finally redeveloping the pattern of light and shade. This approach is demonstrated here with felt-tip pens.

• COLOR MATCHING HANDBOOK •

Form and Space

Tonal values are used to model form in terms of light and shade, and the shadow areas caused by the fall of light are particularly important in defining contour and volume.

The parts of an object that receive little direct light—surfaces that are angled or curved away from the light sources—show a gradual change from light to dark tones, while the side of an object facing in the opposite direction from the light source may receive no direct light at all, constituting the darkest value in the tonal range. The same applies to a hollow interior receding at an angle to the direction of the light that falls on the exterior of the object.

Schematic representations, as used in certain types of illustrations and graphic imagery, are based on an assumed light source, and here the tonal gradations can be artificially plotted to create an effective simulation of three-dimensional form. But objective drawing presents a different problem, as the tonal variations in the subject may be quite complex. This is because it is quite unusual to have a clearly directed, single light source; often the light is spread or diffused, reflected back from different directions. Surface qualities also affect the way tonal variations are presented. A shiny surface bounces back more light than a matte one, and overall tonal gradations are often easier to see on a smooth surface than on a heavily textured one. Pronounced textures create a highly intricate tonal network of their own that coexists with the patterns of light and shade across the underlying form.

The other main function of tonal values in a drawing is to locate the subject in relation to its surroundings by means of cast shadows—the shadows that occur when an object stands between the light source and another object or surface, thus blocking the passage of light. Cast shadows, such as that thrown by an object standing on a tabletop, help to provide a more authentic sense of spatial location in an image. Sometimes, however, they can cut across and confuse the tonal gradations that model a form, and this is something you should consider carefully when you are arranging a portrait or still-life grouping.

• COLOR IN ART •

51

Tone and Color

To judge tonal values correctly, it helps to think of the effects of light and shade in terms of a monochrome scale, but this does not exactly explain how these can be translated in a color drawing.

If you depended on a system of adding white to lighten the tones and adding black to darken them, you would achieve a rather dead quality in the picture surface. Since we know that white light is composed of colors, we can assume that highlights and shadows have some colorful qualities. You will also find that black pigments reduce the interaction of color values between pure hues, giving a corresponding reduction of subtlety in the surface effects.

If you look carefully you will probably notice that there are distinct color shifts in highlights and shadows, and you can use these to enliven the tonal values. A highlighted area may have a slight yellow or pink tinge under warm light; shadows on a yellow object may have a green or red tinge, depending on the quality of light; a blue surface may shade into cold purplish tones where it falls into shadow. Some of these effects are innate properties of color values produced by a combination of local color and surface texture under a directed light.

The tonal patterns of a subject can be broken down by using colors—perhaps gradations of a single color or a limited range corresponding to the darkest, lightest, and one or two middle tones. When you have studied a subject in terms of tonal rather than color values, try putting together the tonal gradations with the blocks of local color as previously described, and you will then begin to build a composite picture of the forms and colors.

A useful exercise in "thinking in color" in relation to tonal variations is to try creating colorful blacks and grays by using combinations of various hues. Blue, purple, and brown will mix to produce a rich, dark tone that might stand for the darkest shadow areas in a drawing, eliminating the use of pure black. Experiment with combinations that vary the warm or cool qualities of the mixed darks and the depth of dark tonal values according to the number of colors you have interwoven. You can develop light tones using bright or pale hues; open techniques of hatching and stippling can give subtle color to an area that will still appear white in the drawing when it is set against the heavy, dark tones.

Complementary Colors

If you stare at a bright red area of color for a minute or two and then transfer your gaze to a white sheet of paper, you will see a green afterimage. The particular green that you see is referred to as the complementary of the particular red you looked at.

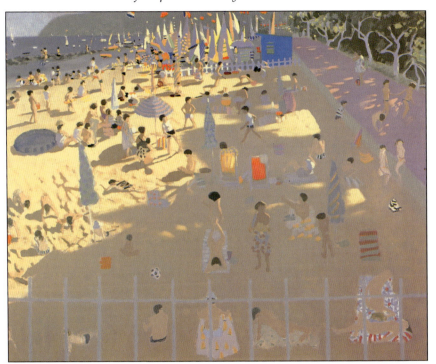

• COLOR IN ART •

BEACH AT SAN BARTOLOMEO by Andrew Macara
Our eyes often perceive the shadows in a scene as being the complementary color to that of the illuminated part, and here the artist has played with this perception, giving a violet tinge to the shadowed area of the yellow beach. For the path on the right, he has used a purer violet that perfectly balances its complementary, yellow, at the left of the picture.

If you reverse the process and start with an area of green, you will have a red afterimage. Every color has its complementary, which can be found in the same way. These have nothing to do

with the nature of light itself, but arise for physiological reasons related to the way our eyes perceive light. You will notice that on the color triangle each primary color has its complementary on the opposite side: blue is opposite orange, red opposite green, and yellow opposite purple. When you mix two complementaries you get a neutral tertiary color because you are in effect mixing the three primaries. In terms of painting, unmixed complementary colors are useful because they intensify one another. A small patch of red in a large area of green can make the green look that much brighter. Nearly all painters have used this kind of juxtaposition to some extent. Seascape painters sometimes paint a sail orange to enhance a blue sea, and Van Gogh sometimes used complementaries to create a deliberately jarring effect. In one of his paintings, he said that he had "tried to describe the terrible passions of humanity by means of green and red."

USING COMPLEMENTARY COLORS

Instead of using tone to describe form, modeling can be achieved by the use of complementary colors. The warmer members of each pair of complementaries are used to paint the highlights, while their cooler partners are used for the shadows; for example, an arm may be painted in yellow, with the shaded portion in violet.

Complementaries placed side by side form a particularly bright and eye-catching boundary that can be used to draw the viewer's attention to that part of the picture. This effect occurs even when the colors are quite muted. Look, for instance, at the pale yellows and violets in Andrew Macara's painting of a beach. Robin Mackertitch has used reds and greens in a similar way in her *Three Geraniums*. The cooler member of a pair of complementaries tends to recede while the warmer one advances.

THREE GERANIUMS
by Robin Mackertitch

Green and red are complementary colors, and the boundaries where the two meet can sometimes be striking, even quite dazzling if they are used in pure form. Here the greens and reds are relatively quiet, but you can see how the leaves at the lower left that are surrounded by red provide a more forceful image than those surrounded by blue further up the picture. The area on the lower right could have been dead and meaningless had it not been for the triangle of green in the corner. This, contrasting with the red cloth, acts as a stabilizer by balancing all the activity in the plants themselves.

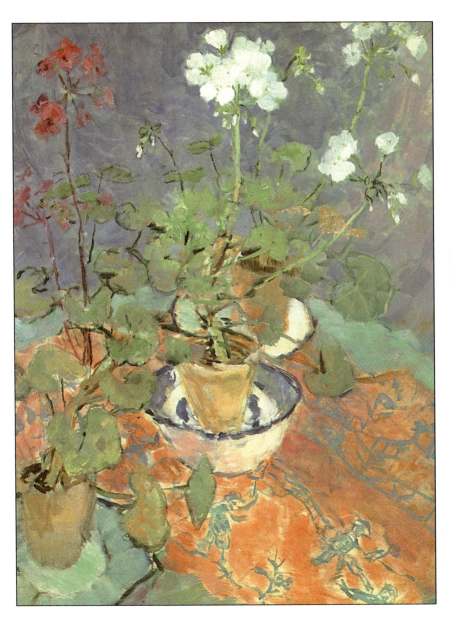

• COLOR IN ART •

Warm and Cool & Dark and Light Colors

A picture can be said to be painted in a particular color key rather in the way that a piece of music is written in a key that the composer thinks is most fitting for the mood and character of the piece.

One can often describe a painting as having an overall main color. For example, it may be predominantly a pale or dark green or a dominant overall red color—or indeed any color you can think of. Sometimes a painting may be in a simple color combination of more than one main color.

This overall color effect is called the "color key" of a painting. You could assign a color key to most of the paintings illustrated in this book. If a painting does not have a definite color key it may well be unsuccessful. Imagine a piece of music written in a random motley of keys. The result would be a disaster unless in very skilled hands. Just one or two dominant colors give distinction to a painting. If there are too many, they compete, drowning each other out instead of adding together. Likewise, a key or theme is needed in other art forms, including such everyday ones as cooking or choosing what to wear.

COLOR TEMPERATURES

Some colors are described as "warm" and others as "cool," the former being the reds, oranges, and yellows and the latter being the blues, blue-grays, and blue-greens. A painting with an overall blue color may give you a feeling of tranquility, while one in reds, oranges, and yellows may give an impression of warmth. The origin of these temperatures may be partly a matter of everyday associations— an overheated person gets red in the face; the hot sun is orange-red; blocks of ice have hints of blue, as do the shadows in a snow-covered landscape. But whatever its origins, color temperature is a useful tool in painting, particularly to create a

PORTSMOUTH by Albert Goodwin (opposite)

This picture is painted in a color key of pale blue, with all the blues, blue-grays, and violets closely related to one another. Greens and reds have no place here, and the only other clearly defined color is orange, which, being the complementary of blue, heightens the apparent intensity of sky and water.

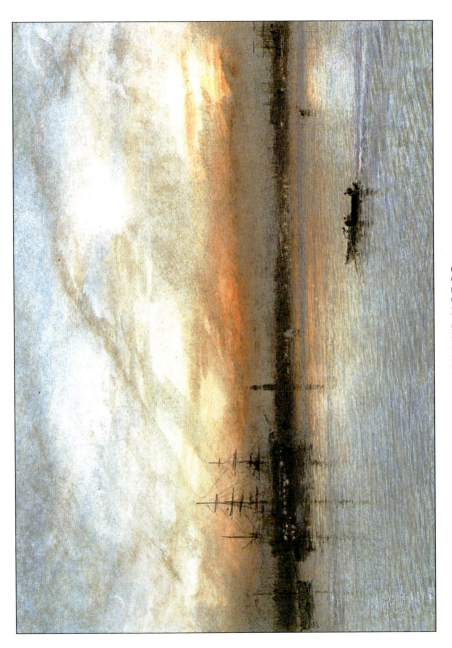

• COLOR IN ART •

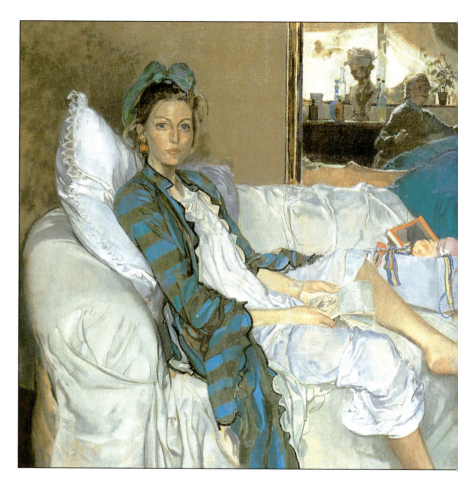

THE TURKISH ROBE by John Ward
This picture uses predominantly cool colors in a very carefully controlled range and gives an impression of peace and relaxation. But even here some colors are relatively warm. For instance, the striped robe is made up of alternating bands of cool blue and warm ocher, continued into the hair, while the pinks, yellows, and oranges of the open gift box are considerably warmer than the blue of the pillow behind. The sheet and robe, as well as the face, hands, and feet, are a mixture of cool and warm colors, reflecting the dominating blues.

feeling of space and recession. Just as a line of distant hills appears as a cool blue-gray, the cool colors tend to recede while the warm ones push themselves into the foreground. However, like everything to do with color, this is relative. Although the blues are theoretically all cool, some are warmer than others and some reds cooler. For instance, Prussian blue is cooler than ultramarine, which has a hint of red in it, while alizarin crimson is cooler than cadmium red.

A successful painting usually has contrasting or interlocking areas of either warm and cool colors or of dark and light tones, or often both. A painting that lacks these contrasts, for example, one that is all pale and painted entirely in cool blues and grays, besides failing to catch the eye, will be off balance and unpleasant to look at. It is a good idea to try to counteract warm areas with cool and vice versa even if it's just by using a warm ground showing through paint that is otherwise mainly cool. I personally paint all my water scenes on warm grounds.

As we have seen, cool colors tend to recede, but in spite of this, the shape of areas is usually more powerful than the color temperature.

COLOR BALANCE

The distribution of light and dark areas, warm and cool areas, and the pattern made up by its colors gives rise to the balance of a painting. A badly balanced painting is one that does not make a whole; that is, one that looks as if it needs a portion chopped off, or one that gives the impression that it is really part of a larger picture.

A range of pure hues passing from warm to cool colors shows the variation of effects: yellows, for example, may appear warm and sunny or relatively cold and harsh.

• COLOR IN ART •

59

Pattern and Color Echoes

A painting needs to have a uniform pattern, whether simple or complex. The simplest type is the even distribution of forms over the entire picture surface.

The danger here is that the picture can turn out dull and lacking life, but if the shapes direct your eye around the picture's surface, this need not be the case. A landscape consisting of a patchwork of fields gives a uniform scattering of shapes, as can be seen in *Mistral Plain*. What keeps the eye moving is that certain shapes and their colors are echoed through the picture, drawing the viewer's attention from the foreground to the distance and back again. The main shapes in the middle ground of this painting are the rectangular pale yellow cornfields that repeat themselves into the distance and are echoed in the shapes of the white buildings.

Sometimes when you have

MISTRAL PLAIN by Robert Buhler
This painting has a very strong pattern element. The first thing we notice is the checkerboard effect of the rectangular fields, which become increasingly linear toward the mountains, creating an obvious perspective. The shapes of the fields are echoed in the white buildings, while the trees that surround them have their echoes in the ears of wheat. Colors are repeated, too. Notice how the red of the poppies appears again in the roofs, though in a more muted form, so that they keep their place in the middle distance.

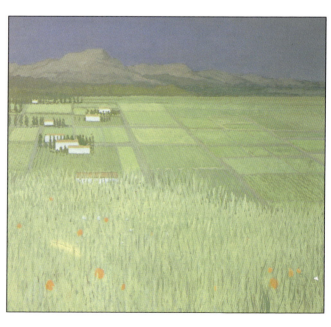

SUPPER WITH BERNARD OFF THE PIAZZA BRA by Diana Armfield This picture comprises three main layers, the top one being the blue background, the middle one the white shirts, tablecloths, and chairs, and the lower one the foreground with its still-life group of fruit, bottle, and glasses. But the viewer is encouraged to look from one part of the picture to another by the repetition of small colored shapes—the man's face, the peach, and the remains of the wine in the glass, the dark fruits and two dark heads above it, the green bottle and the similar-colored pillars above—so that the layered structure only becomes apparent if you look at the picture upside down.

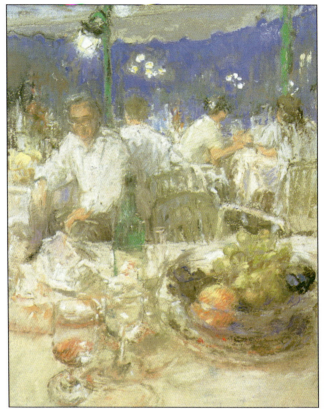

• COLOR IN ART •

nearly finished painting you may find that a large area is bare and seems to have little relation to the rest of the picture. Ideally, you should have foreseen this situation and taken steps to prevent it, but you can often save the picture at the last minute by echoing one or two features of the interesting part of the picture in the empty part. Imagine Diana Armfield's pastel (above) with the tabletop totally bare in the lower half of the picture. It would be top-heavy and rather absurd. The man's face to the left is a striking, roughly circular patch of pinkish ocher. The peach in the fruit bowl echoes his face, since its shape and approximate color are similar. The tabletop now bears a relation to

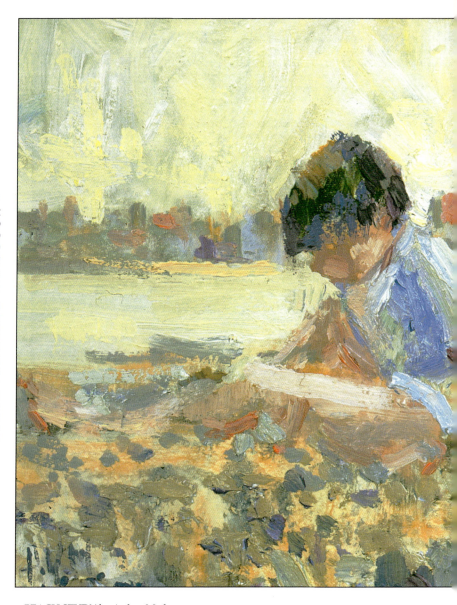

BEACH STUDY by Arthur Maderson
This little painting is held together by the way similar patches of color have been repeated throughout, even though they are describing very different subjects. For example, there are

the top half of the picture. Not only this, the patches of dark blue of the bunches of grapes in the bowl echo the dark heads of two more people at the top of the picture. Continuing to explore the tabletop, we see that the red wine in the glass at the extreme bottom left again echoes both the peach and the man's face, thus linking the lower left quarter of the picture surface with the rest. The man's face, the peach, and the wineglass are the corners of a triangle. The dark bunches of grapes and the two dark heads are corners of a rectangle. These interlocking shapes help to hold the picture together.

• COLOR IN ART •

near-identical blue patches representing the boy's hair, parts of his shirt, pebbles on the beach, and buildings in the background; the pinks of the skin appear again in the buildings; and the mauve in the sky has also been used for shadows on the figures and foreground pebbles.

Atmosphere

The colorful effects of different kinds of natural illumination are combined with and modified by the atmospheric qualities of varying weather conditions.

This is another area in which you are reliant on your perceptual skills and visual memory in devising a method of making marks that can represent, for example, falling rain or snow, a dense mist, or the shimmer of sea spray in the air. There is continual change and motion, and with this, an apparent lack of substantial visual cues.

These are ambitious subjects to tackle in drawing. The vaporous and liquid qualities of such phenomena are perhaps more readily described with a fluid paint medium that allows a rapid technique. But to bring the problem into more familiar territory, consider that rain, mist, and spray are, like light, all elements that are acting upon tangible forms and surfaces, things you can identify and convey. The problem is thus not so much how to "draw rain" as how to represent its effect on the colors and forms of a landscape or townscape.

Concentrate your analysis first on the kind of rain. Are you seeing heavy rain that seems to pass directionally across the fixed elements of the view, or a fine drizzle or mist that masks the definition of forms and dulls the colors? Now think about drawn marks that might correspond to that visual sensation. Stippling, layered washes, or finely drawn colored scribbles might create the diffused, amorphous quality of form seen through mist or

A pastel drawing by Judy Martin is based on the impression of a line of flowering trees seen in the distance, the colors more distinct than the forms.

spray, whereas a more definitive, calligraphic style might capture the slanting fall of a heavy downpour. It may be effective to work in terms of an overall texture on the drawing surface, with a view of active marks and no clear areas of flat color.

It has to be said that this area of image-making is not easy, and many artists solve the problems by avoiding them altogether. But if you are interested in the challenge of atmospherics, do not be put off by the difficulties. Give yourself time to study the effects in relation to a familiar subject—such as the view from a window in your home—and try different ways of transmitting what you see through a variety of media and techniques. Then you will have a good chance of arriving, either by accident or design, at a technical solution that corresponds to your perception.

Above: William Tillyer works with watercolor on a large scale to produce atmospheric landscape effects. The calligraphic image shows the fluid passage of the brush, laying in soft washes and hard lines of color.

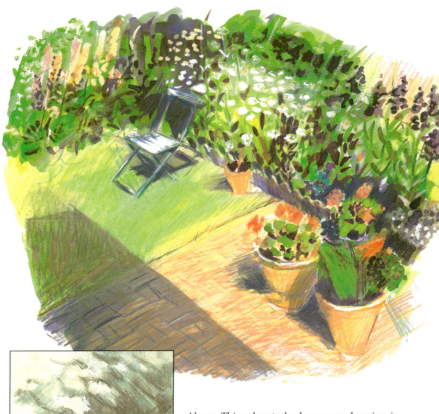

Above: This color study shows a garden view in afternoon light, with rich, strong colors under full sun and hard-edged dark shadows cast from the standing objects.

Left: A study of water by Elisabeth Harden showing a turbulent current re-created by dense hatching with pencil point and brush tip.

Harmony

Here again there are analogies with music, clothing, and food. Some combinations of musical instruments sound better than others; the colors and patterns of items of clothing may go well together or they may not; food receives its overall taste through a combination of flavors, some nicer than others.

The order in which you eat your food is important. In the same way, the colors of a painting may or may not work together, or harmonize. To some extent the success of a combination of clothes depends on the current fashion trends, but there will always be certain mixtures that are disastrous and certain colors that clash. These colors are those saturated ones that are similar enough to compete with each other in a given situation, such as red and orange or two different reds. Shapes can compete with one another in a similar way. Suppose you are sitting in a train opposite a thin-faced person and a very round-faced one. If you gaze at the long thin face for a bit, the round face begins to look quite ridiculous, and the same happens when you have become accustomed to the round face.

If you use a limited palette, you will be using the same colors over and over again and a certain harmony will naturally arise. This is especially true if you don't mix the colors too much so that they are continually repeated throughout the picture. This is one of the reasons why it is recommended to have a very limited palette for watercolors, but it can be a good discipline to work in this way for oils, too.

A natural landscape has its own self-imposed harmony; indeed, we probably receive our ideas about color harmony from our surroundings in the first place. If you are painting a landscape, adhering faithfully to the colors before you, the painting is likely to inherit a natural harmony automatically.

You will find that you will be repeatedly using certain paints to mix up the colors. On a certain day, for instance, you will find that every color needs quite a lot of violet or ultramarine mixed in with it, which will set the underlying color key and establish harmony. A cool picture like this is perhaps best painted on a warm ground so that the coolness has something to relate to. The opposite is true where an overall warmth pervades the picture, such as a desert scene or Mediterranean landscape. This may be most effective if painted on a cooler ground such as raw umber.

• COLOR IN ART •

67

Man-made structures, however, frequently do not harmonize with natural landscapes, and may not do so in a painting. For instance, a boat, particularly an old one, usually looks good in the sea, but many people would agree that a shiny car does not blend in happily with a forest, lake, or mountain scene. A car painted in emerald green would be perceived as being false and artificial against a background of natural green vegetation. Similarly, the same color combination in a painting may produce the same reaction from the viewer. But this is by no means always the case. Sometimes an unexpected touch of color that would normally clash with its neighbors is vital in a picture.

STILL CITY, EARLY DAWN by Robert Buhler
A subject like this must have no jarring note, or the impression of peace and silence would be destroyed. The sky, water, and buildings are all closely related in color, since they all contain differing proportions of the same blue. The range of tones is quite small, too: the whites of the moon and church are not pure but contain blues and yellows, while the shadowed sides of the buildings are a relatively pale blue-gray mixture.

• COLOR IN ART •

ROLLED HAY by Doug Dawson
Landscape subjects such as this create their own harmony to some extent, which the artist can accentuate by controlling the colors. The best way to do this is to use closely related colors and to repeat them throughout the painting. Here the color key is based on pink and green, and although these are near-complementaries, they harmonize perfectly because they are precisely equal in intensity. The artist has taken the pale yellow greens of the distant fields into the sky instead of attempting a faithful description of the true sky color.

DIANE'S PINK GOWN by Doug Dawson

The most obvious way to create harmony in a painting is to use cool or pale colors, but here all the colors are bright and hot—almost clashing. But the picture works beautifully because all the reds, pinks, and browns are closely related, and also because the tones have been very carefully controlled. Notice the bright pink highlights on the shadowed left arm and shoulder that separate the deep pink from the red-brown of the door. The blue of the curtain and the paler blue of the sky seen through the window have been tied to the rest of the picture by areas of pink repeated from the dress.

Expressive Color

If you look at the life's work of almost any major artist, you see similar themes and subjects recurring through the years. Pictorial themes are continually reworked, with different developments of shapes, forms, and colors — sometimes with only minimal changes, but sometimes with a dramatic leap of artistic invention.

Above: A delightful and deceptively simple image that required a steady and confident hand to achieve the fluid line quality and composed interaction of the lizard shapes. Such apparent simplification of a recognizable form must capture an essential quality of the subject.

This is the clearest demonstration of the threads that link personal responses to real sensations and the means of expressing them. This kind of reworking is a gradual investigation of all the visual possibilities, which finally become familiar properties, allowing the artist to select the ingredients of a personal style.

Many children can draw with an easy disregard for reality that creates a vividly personalized "other world." With growing experience of the real world, that spontaneity and confidence are commonly replaced by an anxiety about "getting it right." It takes time and discipline to gain the experience of drawing to allay that anxiety, but once there is a basic confidence about drawing reasonably well and fluently, there may also come a sense that there is somewhere else to go, something else to say through drawing.

The emphasis is on going beyond the basic disciplines of objective drawing to develop a more individualistic form of expression. It is not a matter of forgetting what you have learned, but of building on your existing knowledge to add an extra dimension. Color is an especially vital element of self-expression,

having the potential for varying moods and emotions, for suggesting movement and activity, and for tempting the viewer to respond directly to an image rather than stand back and observe. This potential is always present; the artist's task is to draw it out by intervening between subject and image to make a more significant translation of visual impressions.

This watercolor portrait study combines the expressive pose of the subject with vivid color treatment emphasizing the mood. The technique appears loose, but it requires careful control to build the color strengths and descriptive textured effects of merged and diffusing hues.

Interpreting Color

"How do you see this tree? Is it really green? Use green then, the most beautiful green on your palette. And that shadow, rather blue? Don't be afraid to make it as blue as possible." This remark, attributed to Paul Gauguin, was astonishingly bold for its time.

Even now we can appreciate it as an encouragement to release the sensations of color from strict boundaries of realism. It is also important to understand that Gauguin was not endorsing a purely abstract use of color, but suggesting that a different kind of realism was to be found through artists allowing their perceptions of color to be felt and expressed uninhibitedly. The tree is green, the shadow is blue, so the depiction Gauguin advocated was to an extent based on an objective response.

As a method for developing a personally expressive approach to color work, this is a useful model. It is a way of putting yourself and your responses to color into your drawing without going so far as inventing a personalized language of color. It provides the opportunity to allow yourself a bold statement that has a referential framework. You can find what interests you most about a subject and focus on that element, then exaggerate it. This principle can be applied to all the different aspects of color already

discussed so far — the relationships of pure hues and tonal values, color accents, surface detail, and the color key of your drawing.

All drawing is a contrivance — if your only purpose was to reproduce a picture of a subject, you could simply take a color photograph. It is the choices and interventions that have to be made in translating real objects into a drawn image that motivate the activity. There are, however, degrees of objectivity; also within your range of decisions about picture-making are methods of deliberate manipulation that, in giving mood, drama, or emphasis to a pictorial image, represent the particular kind of reality that you have seen in the subject.

ADJUSTING THE BALANCE
The colors and tones in a drawing give body to the structure of the image. In representational work you are most concerned with how the real color values contribute to the illusion of form and space, with identifying and recording them in what appears to be a "correct"

• COLOR IN ART •

73

relation. At a certain point, however, your attention is also taken by the internal dynamics of the drawing and how it works within specific parameters. A drawing is a record of something you have seen and of the process by which you have described it. You may find that you want to focus more on working up the balance of the image in its own terms, if necessary allowing it to become somewhat detached from its model in the real world so that it can be developed more strongly in terms of the drawing processes.

This may involve adjusting the emphasis of both the color values and the gestural quality of the marks you have used to convey those values. Take as an example a subject that has a basic solidity and static form and a naturally controlled color key, such as a townscape view containing blocks of neutral color and relatively muted hues. You may render this quite faithfully in terms of what you see, but then find that the drawing is lacking in some way—perhaps it fails to catch some quality of light or color accent that would give it more life. You then need to study it more closely to see whether there are hints of color that could be played up, whether the apparent flatness of walls, streets, and sidewalks could be given some internal activity, perhaps simply in terms of a more vigorous approach to

This simple symmetrical image isolates the form of a flowering tree and reinterprets its colorful effect in terms of abstract dabs and dashes of bright gouache color. This idea was later developed into a series of fully abstract paintings.

making marks within the drawing. Adjusting the balance of line and mass may activate the image, especially if the color stresses are rhythmically linked between the two elements. It is possible to give quite strong emphasis to such surface qualities in a drawing without losing the coherent sense of structure that is also a crucial part of such a subject.

DOMINANT COLOR

A powerful effect of color intensity comes from allowing a single color to dominate the drawing. There is a natural overbalance of color type in some subjects—greens in landscape being perhaps the most obvious example. In an interior, warm reds, yellows, or oranges or,

alternatively, cooler blue and purple hues may occur due to the lower light levels and the particular quality of a natural or artificial light source. These naturally created color biases help to set the mood or key of an image.

The idea of allowing one color to dominate has been exploited by artists from Van Gogh onward to produce both expressionistic and abstracted imagery. There are ways of using close tonal values and strong color intensity that redefine the sense of form. In a drawing with a contained sense of space, such as a small interior or a figure study, the sense of closeness created by the broad spread of a single, dense color value can contribute particularly effectively to the interpretation of the subject.

There are two main ways of employing a dominant color. One is to block in solid areas of close-toned color values to form the basic ground of the image, and the other is to interweave lots of hues and tones of the same color family to create a very busy surface texture that reads as solid form. A good way of trying out the effect of a composition expressed in terms of a single dominant color is to choose a piece of strongly colored paper and work mainly with line and calligraphic linear marks, in color, to sketch in basic detail of contours, highlights, and deep shadows.

Apply this technique to picking out essentials of form and definition, allowing the color of the paper to hold the main balance of the image. This will give an overall impression of the color balance without requiring a lot of time-consuming work in building a colored ground with drawing materials.

Here the artist takes a calculated risk in slanting the vivid red of the glider wings right across the width of the image, but this is a successful contrast to the muted, dense colors of the landscape below.

• COLOR IN ART •

75

The Colors

We have seen that the three primary colors — red, yellow, and blue — can be mixed to produce all the other colors, so obviously these must be included in our basic palette.

But if we ask in our local art shop for red, yellow, and blue paint, we will be asked "Which one?" because there are so many different reds, yellows, and blues to choose from. The first ones to buy must be of the brightest, most intense hues because mixing always results in loss of color intensity. For oil, gouache, and acrylic, white is another essential paint because many colors straight out of their tubes, particularly blues and reds, are too dark for most purposes and only produce their most brilliant and characteristic colors when diluted.

When you start painting landscapes, it is recommended to use a very limited palette consisting only of cadmium red, lemon yellow, French ultramarine, and permanent white. You may not want to use black, relying instead on obtaining the darkest tones by mixing red with ultramarine and a touch of yellow. However, you may find that you need colors not obtainable by mixing the three primaries, so begin to extend your palette with violet, magenta, and different versions of the primary colors — alizarin crimson, cadmium yellow,

and cobalt blue. Also add browns (raw umber, burnt umber), yellow ocher, and black.

We will now take a look at possible starter palettes for each of the different media. Beginning with oils, but because the pigments used are more or less the same in all media, the descriptions of colors — some well known and others less so — are relevant to the others as well.

The description of colors relates to artists' quality paints only, since some colors in the students' or "sketching" ranges contain mixtures of pigments.

THE BLUE PAINTS

If you want to buy only one blue, French ultramarine, a strong, rich paint, is the one to purchase. Other artists might recommend the greener and slightly paler cobalt blue, but ultramarine is a bit brighter and more versatile even though it is a little less permanent. It seems to mix better than cobalt blue because it can form a greater range of colors when combined with other paints.

Whichever one you choose at

first, make yourself thoroughly familiar with it and then try the others. Later on you could buy a tube of cerulean blue. This is particularly suitable for some skies, but although a lovely rich hue, it has low coloring power. Prussian blue, a very strong greenish blue, is favored by some painters, as is phthalocyanine blue (or simply phthalo), similar to Prussian blue but even more intense and with a higher permanency rating. Proprietary names for it include monestial blue (Rowney) and Winsor blue (Winsor & Newton). Both these blues have high coloring strength and can be mixed with yellows to form very rich but rather synthetic-looking greens.

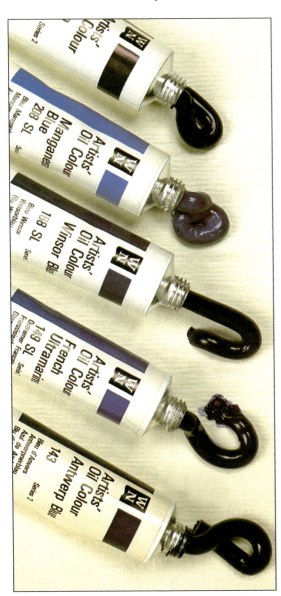

THE YELLOW AND BROWN PAINTS

There are two bright yellows that should be included in any palette—cadmium yellow and lemon yellow. Cadmium yellow is the warmer color, with a hint of orange in it. It mixes with the blues to form warm yellowish greens. Lemon

• COLOR IN ART •

yellow is cooler and paler and forms bluish greens when mixed with the blues.

Yellow ocher also has a place on most artists' palettes. It is a dark yellow verging on the browns. It has great strength and mixes well when added in small amounts. A similar color is raw sienna, which is slightly redder than yellow ocher and less powerful, making it easier for fine adjustments when mixing.

Also available are cadmium yellow pale and cadmium yellow deep, but neither are really necessary, as both can be made, in the first case by mixing cadmium yellow with a little white and in the second by adding a little ocher. Naples yellow, on the other hand, is a useful color for obtaining skin tones, although it can be imitated by mixing yellow ocher with white and a tiny proportion of cadmium yellow. Other yellows include aureolin,

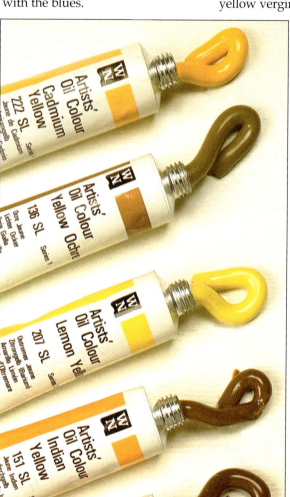

chrome yellow, and chrome lemon. These are less permanent and generally can achieve nothing that cadmium yellow or lemon yellow cannot.

There are only two browns that are recommended to start with. The first is raw umber, a versatile, slightly greenish brown ideal for dulling the blues, yellows, and greens; it has a fairly low strength, so is easy to mix. The second is burnt sienna, a rich reddish brown that has such coloring power that even tiny quantities added to a mixture can alter it drastically. Burnt sienna mixed with white forms a warm pink. You can use it to modify blue and white mixtures to obtain sky tones. Another useful (though not essential) brown is burnt umber.

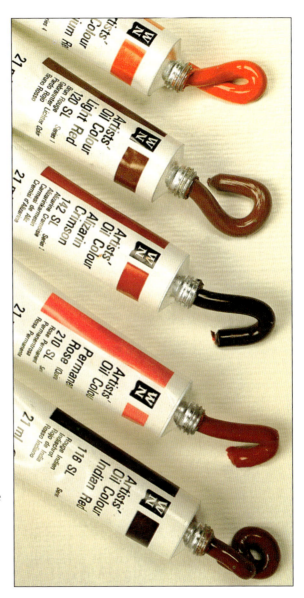

THE RED PAINTS

The essential reds are cadmium red, a dense, opaque color, and alizarin crimson, a deep, powerful, transparent one. Cadmium red is very brilliant, identical in color to poppies, but it loses its identity

• COLOR IN ART •

79

quickly on mixing with other colors. Mixed with white, it forms a warm pink, and mixed with blue, a very muddy purple. It is at its best when used straight from the tube or either darkened with alizarin crimson or lightened with yellow ocher. Mixing it with cadmium yellow gives a brilliant orange, identical to cadmium orange, so it is unnecessary to buy an orange paint. Alizarin crimson is most useful in mixtures. It can be used with white to make a cool pink, with blues to counteract their brilliance when painting sky and sea, and combined with yellows and browns to achieve skin tones. (Alizarin is one of the slowest paints to dry on your palette, and areas of painting where it has been used will remain tacky for a long time.)

Occasionally you may find you require even more brilliance than can be given by these two reds— when painting flowers, for instance. This subject may call for the use of paints like magenta (a purplish version of alizarin), carmine, the various rose colors (Rowney rose, rose doré, rose madder), geranium, and perhaps vermilion. This last, an intense, warm, brilliant red, is one of the most expensive paints available and is definitely not essential. The carmine and rose colors must be used with caution, as they are less permanent than the other reds.

THE GREEN PAINTS

A range of greens, including most of those occurring in a natural landscape, can be mixed from yellows with either blues or blacks, so you may not need to buy any greens initially. However, you will soon find you want some of the brighter greens to cope with the man-made colors of clothing or paintwork and also vegetation in unusual lighting conditions such as sunlit foliage sparkling in a dark forest. Viridian is perhaps the most useful. It is dark and transparent, cool and bluish. When mixed with white, it retains its hue, giving pale, cool greens that cannot be matched by mixing yellow and blue. The opaque counterpart of viridian is called opaque oxide of chromium. Many painters use it a great deal for landscapes.

Brighter than these two are colors like chrome green and cadmium green, both pale, yellowish greens that can be good on occasion for foliage. Another useful green is terre verte, a dull green of low coloring power. Straight from the tube, it is often identical to the dark foliage in a landscape and can be used in mixtures to modify the colors of sky, sea, foliage, flowers, skin—in fact, almost anything! However, it is not essential, since an identical green can be mixed from cadmium yellow, lamp black, and a little ultramarine. Emerald green in

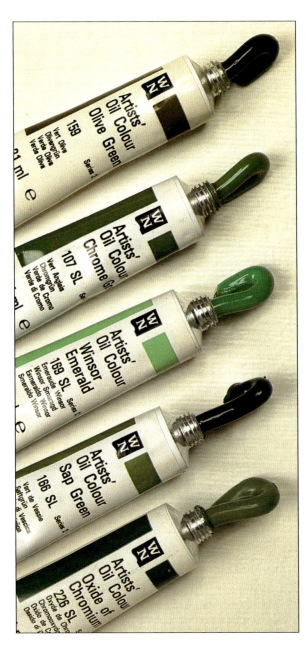

the Winsor & Newton range is an artificial-looking, pale color that does not mix well, but in some ranges it is an excellent and reliable alternative for viridian.

THE PURPLE AND VIOLET PAINTS

Purple, like the greens, can be mixed, but only in a low intensity. The brightest violets or purples will have to be taken straight from the tube or mixed together to yield exactly the color you want. Cobalt violet is excellent, but probably the most useful is Winsor violet, which when mixed with rose madder, alizarin crimson, or magenta, along with white, will give almost any violet or purple. It is also extremely useful for modifying the blues of the sky or sea and for making grays with yellows, browns, and greens.

• COLOR IN ART •

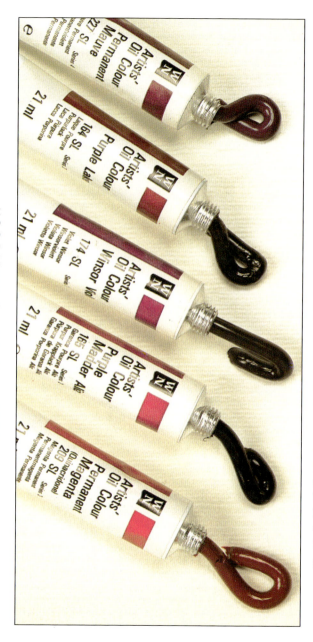

THE BLACK AND GRAY PAINTS

Black is used mainly for mixing with yellow to make greens; for this, use lamp black, which is slightly bluer than ivory black. Black will also darken any green, but only small amounts should be used, as it destroys the vitality of other colors, so should be treated with caution. Sometimes, of course, these dark tones can be just what is needed, as when painting the very darkest shadows. In such cases, ivory black is the best one to use, as it is more neutral and a little more transparent. Payne's gray, which is a kind of diluted black with relatively less strength, is very useful for modifying blues, browns, and greens.

THE WHITES

There are three whites widely available in oil colors, but at first only one is needed—titanium white. This contains a dense pigment called titanium dioxide (which, incidentally, is used by food manufacturers to whiten products such as cottage cheese, icing, and horseradish sauce). It is very opaque and small quantities will whiten any other paint. It is slow drying and will remain workable for days.

Flake white, made of basic lead carbonate, is the fastest drying and most flexible of the whites, and is widely used in underpainting. It should not be used with any red paint containing beta naphthol (many of the reds in the student ranges), as it causes their color to fade. Zinc white, which has a blue tinge, is the least opaque of the whites and the slowest drying. Because of its relative transparency, it is mostly used for mixing colors for glazes. It tends to dry to a hard, brittle film.

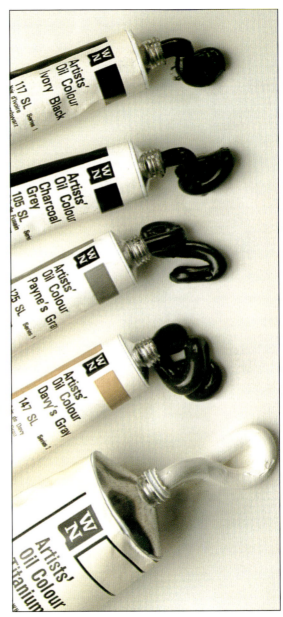

• COLOR IN ART •

STARTER PALETTE: OILS

Lamp black Titanium white Raw umber Lemon yellow Alizarin crimson

Ultramarine Cadmium red Viridian Cadmium yellow Winsor violet

STARTER PALETTE: ACRYLIC

Burnt sienna Raw umber Yellow ocher Ultramarine

Phthalo green Cadmium red Dioxazine purple Lemon yellow

Payne's gray Napthol crimson Mars black Titanium white

STARTER PALETTE: WATERCOLORS

| Raw umber | Burnt sienna | Light red | Ivory black |

| Alizarin crimson | Cadmium red | Cadmium yellow | Yellow ocher |

| Viridian | Ultramarine | Phthalo blue | Winsor violet |

• COLOR IN ART •

STARTER PALETTE: GOUACHE

| Lemon yellow | Permanent white |

| Cadmium red | Alizarin crimson | Viridian | Emerald green |

| Ultramarine | Spectrum violet | Brilliant yellow | Burnt sienna |

COLOR IN THE HOME

All rooms, like all people, look different. Even in a building with identically structured rooms, no two are the same; this is because each room is on a different floor or has a different orientation, so the light in each is different. Light affects the way that colors strike the eye, so suiting your choice of colors to the prevailing light is vital. It is color that gives a room its identity.

There is almost no such thing as an ugly room; virtually any room, well painted, can look good. A beautifully painted room will look beautiful even if there's nothing else in it. (Indeed, excess furnishing detracts from a room by confusing the color and the fall of light, and in extreme cases can wreck the proportions and form of the space.) It is color that gives a room brightness, warmth, or coolness, drama, elegance, or playfulness; it is color as much as shape that gives a room atmosphere, for it is the fall of light and the luxury of our color vision that give the world visible form and ambience. The sheer range and panache of color can intimidate people — when they do not take it for granted — and yet the basic principles of color are very simple.

87

Choosing a Color Scheme

Colors are usually arranged on a chromatic scale and displayed on color charts, but the famous color wheel remains the most effective way of demonstrating the structure of color.

These colors that appear opposite each other on the wheel, or nearly so, are called complementary. This is because when they are mixed in equal quantities they cancel each other out and, rather surprisingly, you get gray as a result. Mix red and turquoise in slightly different proportions and you will get variations of gray. The same thing will happen with blue and orange. (This is assuming that the pigments are pure — in fact, most commercial complementary paints are not pure and will produce a muddy khaki when mixed.)

When you place true complementaries side by side you get a "buzz" — the colors seem to overlap each other in a narrow, gray blur. This phenomenon can be useful in decorating; a harsh color of any type can be softened by adding to it a small amount of its complementary. A particularly stark red on a north-facing wall

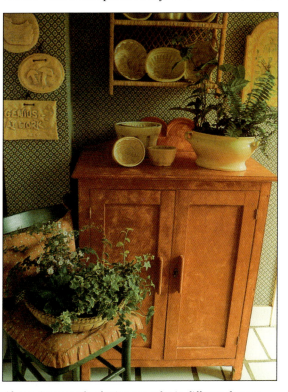

Above: An example of using one color in different degrees of density. A shifting pattern has been achieved on this cupboard by brushing a wet gloss over a lighter tone of the same color and then using a crumpled rag to rumple the texture of the glaze so that the lighter tone shows through. This is known as "ragging."

can be softened to a warmer, weathered brick-red by adding a little turquoise, and orange does the same for a hard, chilly blue.

Of course, artificially produced colors available today have a brilliance that cannot be achieved by hand-mixing primaries and secondaries yourself. But if you seek to understand color, there is no substitute for mixing it yourself. You cannot, for instance, "think" a color. You can imagine scenes in color, of course—just as you may dream in color—but can you reproduce the color you imagine? Assuredly not. Colors are seen in relation to light and other contingent colors, so a color visualized in the abstract lacks a defining context. That is why, when you see a color in your mind's eye and go looking for it on a color chart, you so often can't find it; the color is only in the mind and is isolated from other colors around you. It has no physical existence.

Another excellent way of learning about color, especially

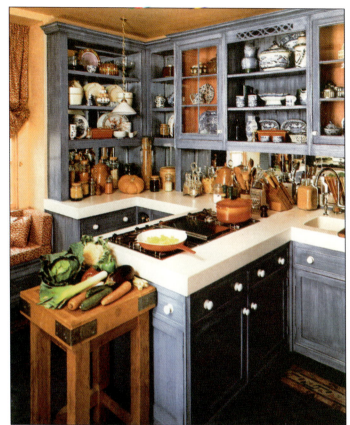

Here, the lighter effect of the blue dragged wood is strong without precluding the use of many other colors.

if you are trying to decide on a color scheme for a room, is just to experiment with a watercolor paint box, painting blocks of color and holding them up. This can save you time—and a fortune in paint. You can also discover interesting color combinations that you may have been conditioned into thinking don't go together, like making delicate olives from purples and greens or juxtaposing blue and green.

Of course, you don't have to mix the pigments of colors together to change them. It is generally agreed that color is at its most beautiful in its transparent state, applied over a white ground, with light shining through the color. Hold up a 35 mm color slide to a light source and it is luminous, like stained glass, because the light shines through it. Almost all colors that artists use are transparent. Only a few are opaque—namely vermilion, cerulean blue, emerald green, ocher, and some yellows. If you apply artists' paint directly from a tube and mix it with either water or mineral spirits, the original purity is never lost. Glaze painting is a technique involving overlaying one of these transparent colors with another or applying a transparent color over a white ground. It is a very ancient way of painting and retains the purity of the colors. Glaze painting is similar to the modern four-color printing process, where the various gradations of color are obtained by printing one color over another on a ground of white paper.

Painting a picture in glazes is a more complicated process than painting by mixing pigments, but there are few such problems in using the technique for the paint finishes described in this book. All

Here, a thin wash of red has been brushed over with a denser layer in a crosshatching pattern using the dragging technique.

you need to know is that if you mix a transparent color and apply it over another color, the process is called glazing and there are certain formal color rules that are useful to know.

In the glaze technique, the aim is just the opposite from that in pigment mixing: transparency is essential for maximum effectiveness, so only transparent colors are used. Starting with a white ground, the painter covers the area with thin layers of transparent paint, which act as color filters. The white light shining down through them is reflected back up and out again from the white ground below. The more glazes that are put on, the less light is reflected back up, so the area appears progressively darker. You can go on until you get black, but you will never get mud color; glazes retain a clean appearance down to the lowest levels of illumination.

In glazing, you are effectively

Above: The different densities of pigment allow light to pass through and be reflected back if the undersurface is pale.

• COLOR IN THE HOME •

91

removing various areas of white light—so you can no longer use the rules of pigment mixing described earlier, but must go by the rules of light mixing. To begin with, sunlight is white (strictly speaking, not a color) unless it is separated with a prism into the colors of the rainbow. When it is separated, it divides into pure colors, that is, colors that are undiluted and are therefore at their maximum intensity. These include the three primaries—red, blue, and yellow. The primary colors for light mixing are orange (sometimes defined as red-yellow), green, and blue. The complementary color of orange is blue-green, of blue is yellow, and of green is violet.

The basic rules of light mixing are: to soften a color, use a thin glaze of its complementary light color; to intensify it, add a second glaze of the same color. Blue over yellow still makes green; red over yellow, orange; but red over blue-green makes olive. So, for example, if you have an apple-green wall you can give it a transparent glaze of rose color and create the same kind of mellow light that you see on a green tree on a sunny, late-summer afternoon. If you mixed the same rose-colored paint in the can with green pigment, you'd get the kind of color you see on an army tank. Similarly, glazing pure rose madder (deep rose) over a white ground gives a clear, deep rose. Mix rose madder paint with white pigment, though, and you'll end up with a paler pink. The result with mixed pigments is a surface color, not a transparent one—a color you can look onto but not into.

When choosing paint, the first priority is color. Paint comes in every hue of the spectrum, giving a range of patterns and tones beyond imagination. To make best use of this variety and to derive the greatest pleasure from paint in interior decoration, it is necessary to know the basics of how color works.

Using Color

Because all rooms vary, there is no universally applicable recipe for a successful interior — but there are more and less effective ways of using color. There is a simple way to observe a room and see what its problems are: walk around and look at all its different angles, paying special attention to the view from the door as you enter.

Note the proportions: the height and width. Is the room too high or too low for its size? Are the doors symmetrically placed? Should they be made a feature or should they be made to blend so as not to detract from the proportions of the room? Are the windows large, small, positioned oddly, too high or too low? Which way do they face? Look at the light from the windows. What will it be like at other times of the day? Will it be cold, clear northern light or warm southern or western light? All these considerations should affect your choice of color and finish. If areas are broken with alcoves, hatches, and recesses, or interspersed with windows of varying heights and widths, the room will benefit from unity of color and finish. The woodwork at least should be integrated with the walls and not finished in a markedly contrasting color or style; otherwise the variousness becomes disturbing, dictating to you rather than providing a pleasant environment.

When the quality of light is cold, such as in a dark, north-facing room, a common approach is to attempt to lighten and warm it with brilliant color. This frequently overwhelms the interior. What northern light lacks is mellowness, so the harsh, deep reds — poppy and geranium — do not work well; they look bloody rather than warm in the gray light. Softer color, like brick-red, lightens and warms the room without being overpowering. A cold, green room can be glazed with red, or a red one with green, to produce amber-olives. Blues, greens, and grays can all be darkened for depth and given a warm undertoning by choosing a shade with a touch of red or yellow; their tendency to coldness can be offset with mustards, mellow terra-cottas, and warm earth colors.

Sunny, southern-facing rooms can become too yellow; an excess of "sunny" colors can make them dull, like stained teapots. They often benefit from cooler coloring; an almost-white pale pink or a very pale green can work very well.

This brings us to the one thing that all artists tend to presume is common knowledge — that some

• COLOR IN THE HOME •

colors are considered cold and others warm. Blues and greens are usually the cool ones; reds and yellows warm. The reason for this is very simple. Color, as any astronomer will tell you, is divided into short and long wavelengths. Blue is a short-wavelength color, so it seems to recede; it looks far away, so a blue room looks cool because it reminds us of distance and space. There are visual associations, too; the blue sky, the sea, and distant mountaintops are all blue and cool. The more yellow blue has in it, the warmer and more summery it looks. Red is a long-wavelength color, so it seems to come toward us and looks close; it is therefore associated with warmth. Visual associations strengthen the sensation of heat—fire, the color of the red-brown earth, blood, and life.

A lot of these associations are subconscious and very ancient, and it is easy to forget that because light is the cause of color, light changes color. To assume, as many people do, that because a color is associated with warmth it is automatically going to make a place look warm is logical but, unfortunately, not necessarily correct. Warmth can become heavy and coolness bleak. These effects are highly subjective.

There is no worse way of approaching a color scheme than as a rigorous intellectual exercise.

The trouble is, we're conditioned by our society to take a logical, analytical approach to problems and to distrust our instincts and feelings as whimsical, self-indulgent, or even as a sign of weakness. Choosing color, however, is all about instinctive feeling in relation to light. "Overthinking" is one of the reasons so many people have problems with color. They hear that dark blue is synonymous with dignity, strength, and quiet dynamism, and so, psychologically, it is; it is a holy color to the Buddhists, not to mention the color of about half the world's military uniforms, but that doesn't mean it's going to work well on a south-facing living room wall. Cover walls with it in that light, and you'll end up feeling like a parking ticket in a policeman's blue pocket. Similarly, if you paint a north-facing room scarlet, the cold light will make the color stark and it won't feel any more vital and warm than being walled up inside a fire engine; paint it bright lemon and you'll know what fruit juice in the freezer goes through.

There are two sorts of color relationships that it's wise to avoid, not because they are wrong but because they often cause other problems. What follows is a discussion of these troublesome color relationships, and how to remedy them.

OFF-HUES

When placed side by side, true contrasting colors do not alter your perception of their color; in other words, vermilion red looks just as red, cerulean blue just as blue, and they also strengthen and intensify each other. On the other hand, colors more similar to one another but not actually adjacent on the color wheel — such as ultramarine blue and one of the red-purples, such as rose madder — send each other off-hue when they are placed side by side. These make very uncomfortable color combinations in a room. They can, however, be transformed by playing around with the proportions of pigment by which they're made and by using other tones that lie between them; they can be linked by an unusual and fascinating series of decorating colors. The difficulty with this is that if you have used large areas of contrasting colors, you will either have to use many smaller painted surfaces with the intermediary tones or else use other materials to supply the link. Try to avoid large areas of true contrasting colors. They can be very disturbing in directly adjacent positions. Alternatively, they can be very effective if you have a large area of one contrasting color and the other in very small areas against it.

DISCORDANT COLORS

These are produced when the sequence of light and dark colors as they appear on the color wheel are unbalanced by adding an equal amount of white to the darker colors and black to the light ones so that their relationships are reversed. A typical grotesque discord would be achieved by adding black to yellow — making mustard — and then adding white to a deep blue; used in equal quantities, this combination may turn your stomach and make you put on your sunglasses. Again, the prime remedy for this is that very small areas of one color can work against large areas of the other — like a scattered pattern on fabric. Never use discordant colors in equal measure against one another.

Color is not a tyrant that cannot be placated until the personality of the individual decorating the room has been removed — quite the contrary. The mere fact that color gives so vast a choice makes sure that the choice reflects individual personality. So, too, does subtlety of color. Subtle colors are assertive precisely because they leave room for additions of stylistic panache and leave the options open for everything from quiet elegance to high drama.

Once you've settled on a color scheme, choose a finish that is suited to it and to the surfaces you

• COLOR IN THE HOME •

Here, ragging gives a damask or white velvet texture to these walls where a plain surface would be excessively neutral. But the walls must be "quiet," as the warm honey-ocher tones of other surfaces are gentle and discreet in themselves while having a distinct tactile quality.

intend to paint. Wood graining a chair in navy blue and turquoise looks eccentric, to say the least; sponging a wall in olive and yellow will make you feel like you're under fire. As each technique is described, the pros and cons of its various uses are discussed. It's worth giving

careful thought to the choice of finish and colors before you start, to make sure there is a pleasing, congruent unity in the finished effect.

PAINTING
Although there is a greater variety of paint available now, there are only two basic types: water-based and oil-based. All paint consists of colored particles—pigment—held together in a binding solution that is soluble in either oil or water. The great majority of water-based paints are not shiny when dry; about half of the oil-based paints are.

For the purposes of interior decoration, most people are interested in what type of finish the paint will give, so manufacturers categorize paints according to the degree of shine they have.

Those with no shine are called flat or matte paints; those with a slight shine are called semigloss, eggshell, silk-finish, or satin-finish; and those with a high shine are called gloss or high-gloss.

Having discussed the variety of paints available and the different effects they will achieve, it is necessary to consider where to apply which paint. This is largely a matter of taste, but there are a few points to bear in mind. It isn't a good idea to put high-gloss or the more shiny semigloss paints on a wall with lumps or undulations because the paint will highlight the flaws. High-gloss paint on woodwork adjoining a matte wall draws too much attention to the woodwork and makes the walls appear to recede. Gloss paint washes more easily than other types, but woodwork tends to look better with semigloss or matte. If you need to protect paint from constant handling—on a banister or door, for example—it is preferable to varnish it. Three coats of varnish over matte paint are no more likely to chip than a thick coat of gloss paint; also, gloss has a hard, cold, colorless shine, whereas flat paint that has been varnished retains a gleam of its own color where it catches the light.

SINGLE-COLOR ROOMS
In interiors with many colorful objects, such as books, it's often a mistake to use more than two colors for walls and woodwork, and a single color for both can lend a pleasing visual unity. Nonetheless, the basic hue of a single-color room must be chosen with care. Dark walls—say, deep blue—need pale, relieving woodwork, but pale walls don't normally need dark woodwork. Mid-tone walls can have either dark or light wooden areas, but usually require some defining contrast. Rooms where wood and walls are all one color look odd with a contrasting ceiling.

• COLOR IN THE HOME •

Warm and Cool Colors

All colors can be either warm or cool. It is easy to see where each color lies on the color wheel, where the predominantly warm and cool sides are apparent.

It gets a bit more complicated, however, as warm and cool versions of the same color exist on either side of the spectrum. For instance, there are both warm and cool blues, reds, and yellows. This fact has implications for the mixing of paint, glaze, and tinter colors in the context of decorative painting. For instance, when a warm red such as vermilion is mixed with a warm blue such as cerulean, the result is a chocolatey brown; however, when a cool red such as alizarin crimson is mixed with a cool blue such as ultramarine or cobalt, the result is a deep violet.

The illustrations below show the three primary colors in both their warm and cool incarnations. Together, these six pigments provide a comprehensive palette from which any color in the spectrum can be created.

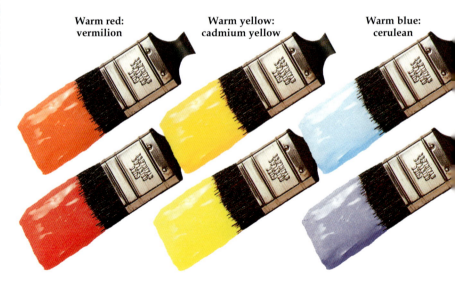

Warm red: vermilion
Warm yellow: cadmium yellow
Warm blue: cerulean

Cool red: alizarin crimson
Cool yellow: lemon yellow
Cool blue: ultramarine or cobalt

Earth and Metallic Colors

Earth colors were the first pigments discovered by humankind. Literally hewn from the ground, they were mixed with water and dabbed onto the walls of early cave dwellings.

Today, raw umber, burnt umber, raw sienna, burnt sienna, red iron oxide, and yellow ocher are the most common earth colors used, although a multitude of variations is available.

Earth colors have both warm and cold elements. Raw umber, for example, is the cooler version of the two umbers. Always keep some raw umber, burnt sienna, and yellow ocher on hand when mixing glazes and tinting paints, as these colors are uniquely useful for aging, dirtying, toning down, and warming up all other colors.

METALLICS

Metallic pigments are made from ground metals, which accounts for their luster and reflective qualities. All metallic paint has a certain amount of metallic pigment in it — the more pigment, the better the quality and coverage — so expect to pay more for these paints (it is worth buying the best quality you can afford).

A range of metallic varnishes and paints is now available in silvers, golds, and coppers, as well as pearlescent and graphite. These paints are not designed to mix with other colors and are best applied in their own right, in sections or over appropriate bases. Given the translucent nature of metallic paint, be sure to choose a base color that takes into account — and will enhance — the metallic finish. For example, pearlescent metallic varnish is beautiful over cool pastel blues and greens, silver works well over cool grays, and gold looks wonderful over warm, sandy tones.

1 — Yellow ocher, 2 — Red iron oxide, 3 — Burnt sienna, 4 — Raw sienna, 5 — Burnt umber, 6 — Raw umber

• COLOR IN THE HOME •

Color and Light

Light, both natural and artificial, will also affect your final choice of color. There is a world of difference between artificial and natural light, and if you intend to use the room in both the daytime and the evening you should view your proposed colors and surfaces under both conditions.

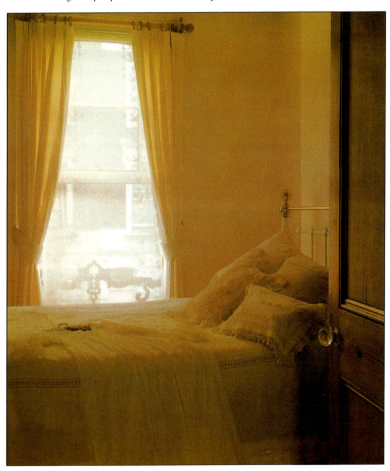

Here, a city bedroom that receives limited sunlight because of the overlooking buildings is warmed by a subtle yellow-gold and cream decor with deeper, stronger touches of the same color provided by the curtain rail and brass headboard.

Above: Upholstered furniture is expensive, and few people will want to abandon or re-cover a sofa or suite each time they redecorate. Such a piece will often of necessity set the theme for a decor, as here, where the blues of paint and paper have been cleverly matched to the fabric.

You can get an unpleasant shock when a room is finished and it's too late to change your mind. For example, some dark shades become almost black under artificial light, while both reds and greens alter their characters according to the type and degree of light they receive.

Levels of light vary dramatically, too, the further away you move from the window, so a color in low light will look completely different from the same color in direct sunlight. Another consideration is the quality and quantity of natural light — how large the windows are and which way they face — since wise choice of color can often improve or enhance existing conditions. This should also be borne in mind when choosing carpets and upholstery fabrics, as some are prone to fading in direct sunlight, especially reds, which are notoriously difficult to dye if faded.

South-facing rooms (north-facing in the Southern Hemisphere) enjoy light and sunshine most of the day; they look naturally warm and

• COLOR IN THE HOME •

bright, so you can use the cooler colors like blue and green without worrying that they are going to create too chilly and uncomfortable an environment. Most colors will respond well to these near-ideal conditions, but to emphasize that light, airy feel, use pale shades or sunny yellows. It is usually the rooms that receive no sun that need a little color assistance to improve their outlook and general ambience. Their chilly light can be warmed by using rich colors like red, orange, and brown and thick, textural fabrics such as velvet and tapestry. Where the room is dull and gloomy, liberal use of white or yellow is an instant lightener and, strategically placed, can even be used to bounce light from one area to another.

If a room is intended for use largely in artificial light, the way different colors perform under your intended lighting treatment should be given priority. Some shades change dramatically under a standard household lightbulb with its yellowish tungsten filament

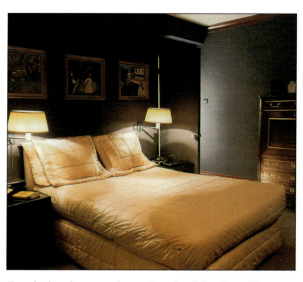

Two shades of gray, one brown-tinged and the other with a strong bluish bias, are given extra warmth and sparkle by the golden glow of bedside lights. Where the illumination is strongest, a third color is created, as well as an attractive scalloped pattern to break up the wall surface.

light. Reds can be warmed and strengthened, but certain greens lose all their color and become a muddy brown.

The clear, white light of low-voltage halogen lights, on the other hand, produces a clean, sharp effect, bringing out an object's true colors. These are useful for reinforcing a highlighted effect or pinpointing a certain feature. Fluorescent lights are the least flattering; their hard, almost bluish light tends to flatten shadows and make colors look dull and cold, although some of the newer types can offer a warmer kind of light.

Getting It Together

If you are still nervous about coordinating all the elements in your design — the paints, papers, fabrics, and accessories — or find it difficult to decide on a theme color, take a tip from the professionals and build up your own personalized color board or folder of samples for each room.

• COLOR IN THE HOME •

Above: The starting point for this bold kitchen treatment was the collection of china in a deep and brilliant shade of lapis-lazuli blue, echoed in the dark blue and near-black of the paintwork. Light woodwork and cream tiles provide a lightening and warming touch.

This is a task that should never be rushed. Try to tackle each step of the project one by one and don't be afraid to collect several options and live with them for a while—maybe pinned up around the house—until you are sure you have made the choice you will be happy with. If you are undecided about certain greens, blues, or yellows, you will gradually begin to have a feeling for which looks best in the room and how they are affected by both natural and artificial light.

It is important that you collect actual samples of the furnishing and decorating options you are considering—snippets of carpet, corners of wallpaper, paint chips, swatches of fabric, and so on, not just a page torn from a magazine or a brochure, as colors tend to be distorted in the printing process and cannot offer an accurate means of matching or coordinating. Write down the code number, supplier, and price (for budgeting) on the back of each of your samples, as it is easy to forget which fabric came from which store or which carpet was the best value. There is nothing more frustrating than spending weeks agonizing over a decision, only to find you cannot carry it through because you have no idea where the sample came from.

Once you have decided on the color key, you can begin to expand on it by building up a portfolio of complementary elements, always keeping your main color in mind so that your ideas for all other effects grow naturally from it. Once you have built up a selection of decorating and furnishing samples, put them together on a board or spread them out on the table and you will see a more complete picture beginning to develop, which can be as subtle or as strong as you wish. You will probably also see that certain samples look out of place and fail to blend well with the others. Be firm with yourself and reject these.

Using a selection of closely allied tints from all across the spectrum of your chosen color will create a sophisticated and gentle transition from one color to the next, while a slightly different and more contrasting look will result from using colors from the upper and lower ranges only—a dark and very pale blue, for example. If you feel that it still looks rather understated and perhaps a little dull, consider introducing an accent or a complementary color from the opposite side of the color wheel. These should be used only in small amounts for the best effect. White woodwork can

be used to act as a highlighter or a second color can be introduced here and there as a trim or accessory.

Another way to prevent a limited color scheme from becoming monotonous is to use a good variety of shapes and textures, so try and collect a good mixture of rough and smooth surfaces, shiny and matte finishes, and plains and patterns within your sample selection. Light and position will affect both textures and colors, so make your final choice of samples in the room where you intend to use them. You will already have a clear idea of how they are going to look together, but you also need to see them on the appropriate surface. Hold up papers and fabrics intended for walls and windows vertically, and to judge the effect of flooring, tablecloths, and so on, lay out samples on a horizontal surface.

The essential final touches, such as knickknacks and all the little bits and pieces that give a successful scheme its character, can usually wait until the room is completed, so there is no need for a panic-stricken rush to assemble or purchase them at the outset. By all means keep an eye open for exactly the right shade of vase or the perfect print when you are assembling your samples, but these final accessories are normally acquired slowly and are often an individual and personal collection built up over a period of time. If the room is well planned, you will know at a glance if an item is suitable, and in this respect you should not be too fanatical about color matching and coordinating. The piece should fit in style, but too much coordination can look lifeless.

Below: The preliminary planning stage for a predominantly brown and beige scheme with accents of deep, slatey gray.

Opposite page: The only way to choose a color is to see it in its surroundings. These "matchpots" are an excellent way of avoiding expensive mistakes.

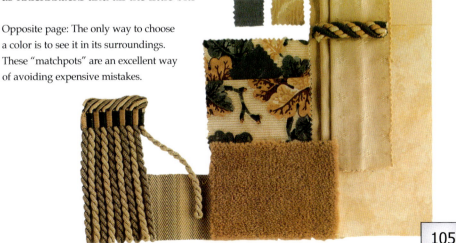

• COLOR IN THE HOME •

105

The Color Blue

Blue is the color of sea and sky – from the faintest wash of color through brilliant cerulean to a deep, stormy petrol blue, almost slate gray in its depth and dullness. Because of these associations, we always associate the blues with coolness and a feeling of spaciousness.

They can never generate a warm, cozy atmosphere or a particularly festive look like the reds, even when rich, deep blues and textural fabrics such as velvets are used. A blue color scheme always creates a certain feeling of detachment and distance, which is not really surprising when you consider that in nature blue so often forms the backdrop color against which all the other colors are set.

WHERE TO USE BLUE

Because of the feeling of space it creates, blue used decoratively can have a calming, relaxing effect, which is why it is often used for waiting rooms in hospitals and clinics. These properties also make it an ideal color for bedrooms, where relaxation is all-important, and it is also a popular choice in bathrooms, which tend to be smaller and more cramped than most of us would like.

Blue is a popular choice, and indeed the majority of people will choose it as their favorite, probably because it is not intrusive; most shades of blue are very easy to live with. Although they have a reputation for making rooms look rather chilly, it is mainly the lighter permutations that have this effect. And these have distinct advantages in some cases: While pale ice blues used on walls might not be the best choice for a cold, north-facing room (south-facing in the Southern Hemisphere), they are wonderful for pushing back the boundaries of a small room. And if you have really set your heart on it, you can still use a cool, pale blue as the main color for a cold room if you add a warmer accent color such as peach or mauve. This could take the form of a border, a window treatment, or selected accessories such as cushions, bedspreads, or chair

covers. There are really no rigid rules in decor—just guidelines to help you make the correct decisions and adjustments.

Where blue walls will make a room seem larger, so a blue ceiling encourages a sense of calm and peace. You can even paint it with stars if you really want to feel the room has no boundaries. The deeper blues are less space-creating and to some extent less cold in appearance, but even an electric blue or a very dark navy used dramatically will retain that quality of cool detachment that characterizes blue. Blue's nature allows it to be toned down to an almost neutral-tinged gray, which is a good shade to complement darker, more positive blues. Pastel blues can sometimes look a little too sickly when paired with these; with their nursery associations, the pastel shades tend to encourage a less sophisticated scheme.

HOW TO USE BLUES
Paint and plains (unpatterned fabrics and wallpaper) are the most popular ways of using blues in the home, with satin or matte-finish paint or good texture such as velvet or jacquard to soften the effect—gloss surfaces in pale or mid-blue seem to harden them in a way that seems rather uncomfortable for everyday living. Although there are patterned papers and fabrics in the blue spectrum, stripes and modern geometrics seem more successful than traditional floral designs, and you will find the choice of these more limited than in other colors. Here there is also an analogy with nature, for while blue does appear frequently in gardens and meadows, it is seldom the predominant color.

ACCENTS AND COMPLEMENTS
Blue looks particularly fresh and clean when used with white to highlight woodwork, selected walls, and special architectural features such as fireplaces, cornicing, and moldings. Depending on the shade of blue used, this sharp combination can either look very chic or have all the traditional appeal of the finest Wedgwood or blue and white china. No wonder it is a popular option for kitchens, even if it seems a rather chilly choice in some locations. Often a room can be given a blue and white theme by no more than a wall or dresser shelf of the actual china. In a predominantly wood kitchen, this will also relieve the sometimes overpowering effect of a predominance of natural wood, which in turn provides a warm counterbalance to the cool blue and white. Alternatively, blinds or curtains can be done in blue and white fabric, a pattern inspired by old china designs.

• COLOR IN THE HOME •

A strong blue scheme will often need a little accent shade to add a touch of warmth and variety, and one of the most successful treatments is to combine it with some natural surface such as wood, cork, burlap, raw cotton, or linen. The grain and texture of these materials, combined with their subtle honey or creamy buff coloring, provide the perfect foil for the blue, bringing it down to earth and giving it a friendly, homey touch.

Alternatively, there are other colors that can look particularly good if used with the right shade of blue. Yellow, for example, is an excellent companion for both the pastel and brighter shades—pale blue and creamy or lemon yellow looks both sophisticated and relaxing in either modern or traditional interiors. A contrasting and warming touch of color can be supplied by using the softest pink/peach/apricot shades— nothing too vibrant or it will begin to dominate. For a closer blend, go toward green or the lavenders and mauves for variety.

To add a touch of sparkle, blue with silver highlights is trim but hard-edged. This is a point to watch in bathrooms with chrome or nickel-plated fittings and a preponderance of rather hard, shiny surfaces such as tiles, baths, and basins. Like white, silver adds a crispness and can also be useful for creating a more modern or high-tech atmosphere. Gold (or brass) has completely the opposite effect, warming and enriching, and tends to transform the deeper blues into something more sumptuous.

THE BLUE SPECTRUM

The range of different blues is enormous, and using too large a selection can end in disaster. There is a vast difference in both tone and atmosphere between a greenish blue, like turquoise, and one that veers toward mauve. The wisest and safest course is to experiment with different degrees of one shade, using it deeper or lighter as needed or adding one of the gray-tinged neutrals as a highlighter. These are the palest blues, barely a color at all.

The true pale blues are as icy as a glacier, graduating toward the softer pastel baby blue—a pretty nursery choice and easier to live with later on than sugar pink, whatever the sex of the child. The brighter blues, such as sky blue, cornflower, or electric blue, and the other startling middle shades create a much more positive impression and can be surprisingly uplifting, even sunny in their effect. If you are feeling bold, use them as blocks of solid color on the walls or, alternatively, restrict them to furniture and furnishings or the

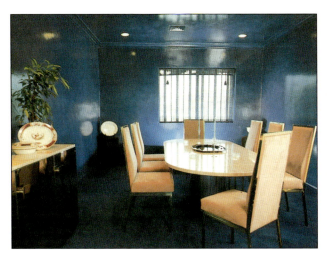

A good example of how total coverage in a dark shade focuses attention on the center of the room, yet where blue is used it does not become oppressive.

occasional accessorized touch in a more muted blue scheme.

These blues, darkened down a shade further, will become deep, dramatic Prussian blue, lovely and bright royal blue—the closest you'll get to a rich, cozy effect, especially if used on a heavy-textured fabric or for plain carpets—and beautiful lapis, which takes its name from the stone, lapis lazuli. It is a strong blue with flecks of gold and shows to particular advantage on a hard surface such as painted wood.

A green influence on blue can either darken and deepen it into an oily petrol blue or be as subtle as delicate duck-egg blue. Turquoise is the trickiest of all the blue-greens. It is really a color in a class of its own and rarely blends well with other blues unless the very lightest or darkest shades are chosen. It is best handled as a special case— as an accent color in other schemes, perhaps, or reserved for creating exotic combinations with an equally strong hot pink, purples, even reds and golds.

Completely different in its somber, old-fashioned stolidness is the darkest and strongest blue of all, good old navy. When combined with white it is a classic pairing, probably because it reminds us of military uniforms. This combination can make a rather severe contrast for a comfortable interior such as a sitting room or bedroom, but it can be relieved and softened by warmer shades. Navy is a good choice for more masculine schemes and also combines well with fawn and beige in striped or paisley patterns. The tiniest touch of bright red or maroon in a thin stripe or other detail emphasizes its sophistication and adds just the right amount of zing and warmth.

Left: Soft Wedgwood blues, with their sobering gray influence, always look extremely neat and sophisticated, especially using white as a highlighter. This classic combination is a clever way to play up a room with fine architectural dimensions.

Right: The bathroom's shiny coolness has been played up by using two shades of blue and lots of ceramic tiles in a richly patterned border design—an excellent way of making a small room look larger.

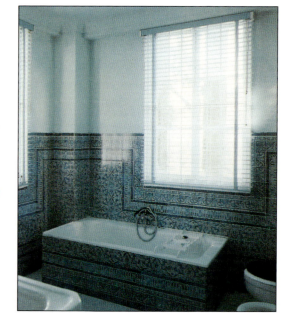

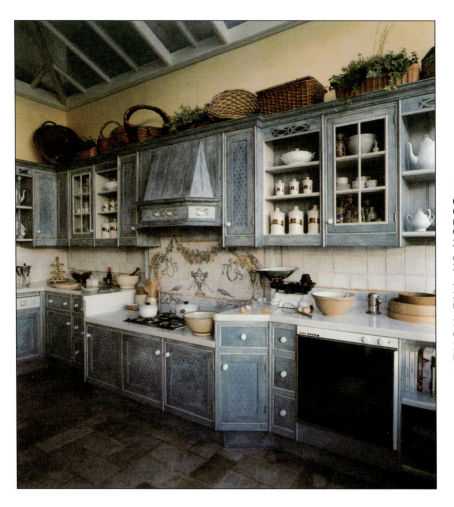

Above: Light blue's cool freshness works particularly well in the kitchen, not just for china and accessories, but on cupboards, too. A broken paint effect and creamy natural textures in floor tiles, baskets, and bowls produce soft harmonies.

• COLOR IN THE HOME •

Companion Colors for Blue

Blue and yellow are perfectly balanced companions, whether you choose the striped seaside umbrella contrasts of royal blue and sunshine yellow or the subtler blends of creamy buttermilk and pale duck-egg blue.

They can be confidently blended in any proportion from blue touches in a cream or yellow room to a blue scheme with cream or gold highlights. But blue will always remain the more dominant partner however little it is used.

WOOD: NATURAL YELLOW

Because it tends to be cool and rather cerebral, blue benefits from the earthier addition of natural surfaces, especially in polished wood shades encompassing the cream/yellow/gold spectrum. This might take the form of a polished wooden or cork floor, a piece of furniture, a picture frame, or simply a small accessory to add both warmth and texture.

Bright yellow is used to add impact and sunny warmth to a slick, pale blue bedroom. Cleverly, the accent color has been restricted mainly to horizontal surfaces to produce an almost striped effect.

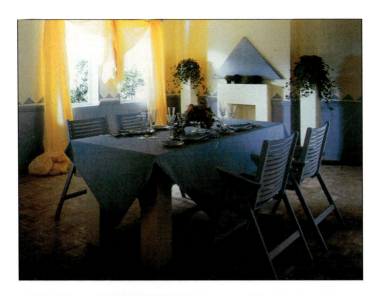

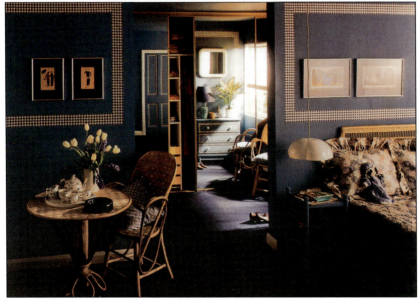

Adventurous use of color over floors, walls, and furniture has produced a feeling of continuity between rooms. Coordinated borders and white woodwork add just enough contrast to prevent it from looking too dominant over such a large area.

• COLOR IN THE HOME •

The Color Green

Most shades of green immediately suggest freshness, rejuvenation, and new life. We associate them with the evocative scent of fresh-cut grass and the health-giving properties of green herbs and vegetables. Because of this feeling of goodness and freshness, greens tend to give any decorative or furnishing scheme a bit of a lift.

Like blue, green in nature is an effective background color, the foil for many other bright shades. The sometimes brilliant emerald green or subtle sage of plains and pastures or the leaves and foliage in a flower bed will either match the brightest blooms and strongest landscape features in tone or provide a counterbalance for them. However strong in hue, green never dominates other colors or clashes with them, nor do we ever tire of its brilliance.

WHERE TO USE GREEN

In the home, as in nature, green combines well with other colors, and as a single color scheme is unlikely to overpower, become tiresome, or go out of fashion quickly. Its general effect is both relaxing and invigorating. The sense of freshness it creates is stimulating, but at the same time it can generate a certain feeling of coolness and calm, unless the really rich, strong shades are used. The success or failure of this emotional contradiction depends on where the color is applied. It works very well in living rooms and other common areas, for example, and is the most popular color for hallways, where the inherent sense of light, space, and well-being is pleasant to live and relax with.

Both the soft shades and the brightest greens are good choices for bathrooms, used either as a background color or for accents. The freshness of the greens serves to underline and emphasize the health and hygiene aspects of the room, and green has remained a top-selling favorite for bathrooms, even for the fixtures. Another big advantage in using green for

bathrooms is the color's ability, again like blue, to make a room look marginally larger than it really is. This applies especially to the paler shades, which are highly efficient reflectors of light.

There is another area of the home where a wealth of indoor foliage creates a green theme— the sunroom or covered balcony. These sunny extensions are rapidly becoming an essential part of every property, from Victorian gothic mansions to first-floor apartments, and often provide valuable extra living space as well as an indoor garden. An effective way of emphasizing the jungle effect of lush green plants is to choose any furniture and furnishings in complementary foliage shades or to select fabrics and accessories that feature strong floral designs against a green background.

In the hot, humid atmosphere of a serious, well-planted greenhouse, there is unlikely to be a great deal of furniture, so this accessorizing may only take the form of the occasional thoughtful touch, such as a couple of cushions for the garden chairs or bench. It may be mainly a matter of devising a well-thought-out scheme of plants where different shades and shapes of foliage are juxtaposed and the brighter colors and blooms are reserved only for highlights.

Frequently though, today's greenhouse is less the province of the enthusiastic amateur gardener than an excuse for a decorative glass extension to the home—another room to decorate, furnish, and enjoy. It will often be adapted to a sunny sitting room, dining room, or kitchen and furnished accordingly. Here a green theme is particularly suitable, as it will compensate for the absence of an expected profusion of plants—impractical where the room is to be used as a proper living area, as plants require temperature and humidity levels too high for human comfort. A small selection of healthy, easy-to-maintain plants strategically positioned and backed by predominantly green features and furnishings will give the feeling of a greenhouse, imparting a green glow and softening the rather hard, strong light that such an expanse of glass can generate. This will also form a harmonious link with the garden or scenery beyond.

Remember that plants can be used to great effect anywhere in the home to add a touch of living greenness to a suitable color scheme. Choose them carefully according to their natural light and heat requirements and then treat them like any other decorative accessory, positioning them for maximum impact and maintaining them in good condition. There is plenty of scope for experimenting with different shades, as indoor

plants vary in color from yellows and bright limes to dark, leafy greens—and there is a similarly wide choice of styles. The small-leaved trailers and creepers are excellent for softening shelves or desktops, while the much larger, strongly shaped plants, in floor containers, have an almost architectural quality. If possible, place plants in groups of three to five for maximum impact— they will be healthier, too, as they seem to enjoy each other's company, creating their own microatmosphere.

HIGHLIGHTS AND COMPANION COLORS

Using white with green enhances its fresh appeal, especially when used with one of the apple or lime tones. This combination produces a very invigorating effect and is ideal for dull bathrooms or even for kitchen units that seem to demand a fresher, brighter approach. The ratio of white to green will affect the overall look considerably. A touch of white detailing will sharpen up the green without losing its calming effect, but a predominance of white, with a green design or stripe, is quite different—snappy but not stark. Green highlighted with a creamier shade is also stylish, but is also more restful, making it a good combination for classical living rooms or softer schemes. Cream contrasts well with any of the greens, but is particularly attractive when used with one of the softer, gentler hues that may themselves contain a touch of gray or cream.

Green goes well with most colors, but it works especially well with pink as an accent shade. A green/pink theme can be very pretty, producing a springlike atmosphere and adding a touch of warmth and interest to the color's natural airiness. The peach and apricot shades have a similar effect and are perhaps a little less overtly feminine—theirs is a more fruity appeal. One of the mauves or violets is also well worth trying with green if you feel there is too great a sense of spaciousness and a need for warmth. This especially applies to a scheme based on the grayer shades of the green spectrum. Such combinations, although they constitute a contrast in color, tend to be subtle ones. It is possible to exercise a bolder hand and greater control over the final look and feel of a scheme by adding a stronger companion. For this to be successful, colors should be as close as possible in tone and depth; as soon as one begins to dominate, you have lost control over your scheme.

Many people shy away from combining blue with green; indeed, there is an old saying that "blue and green should never be seen." But if both colors are carefully chosen and

balanced, the effect can be extremely harmonious, if rather cool. After all, the colors are mingled often in nature, and even come together in some of the more sophisticated shades such as turquoise and eau de nil.

The classic partner for green, of course, is yellow, which, used in any strength or proportion, adds a lively warmth and sense of cheeriness to what can be a rather serious, low-key color. You might be looking for the zing of emerald green and canary or simply be content with the more relaxing tones of several pastel shades, such as primrose with sage or apple green, or the faintest lemon adding a highlight to pale lime—combinations so subtle you can barely distinguish them. You can have trouble with the really acidic yellows, as they tend to make their partnered greens look more acid, so use them with caution. If you are looking for warmth and a cheery atmosphere, accent with one of the more butter-based shades.

THE GREEN SPECTRUM

Used extensively, it is interesting how green's ability to create a feeling of fresh airiness is carried throughout the whole spectrum of shades. The faintest wash of green in white or cream changes subtly with the light, in the morning seeming only crisp and clean,

but as the day darkens, it takes on a stronger, restful hue. The effect is delightful when used freely over walls and ceilings, especially in small rooms looking for a little illusory "wall bending."

Even the colors at the other end of the scale, strong leaf green, forest green, and light-absorbing bottle green, are suggestive of fresh wholesomeness. These, however, are colors to use in small quantities, as details or on furniture, and they will combine as well with other shades of green, as cream and yellow do. Care needs to be taken to make sure that you can still enjoy their effect in artificial light, as the darkest shades can look black or even brown.

In the middle ranges there are the soft sages and gray-greens: lovely in corduroy, velvet, and other textures, or as matte-surface paint. For traditional or chic interiors, there is pastel Wedgwood green, while in the same medium green range there are wide-awake lime greens with plenty of yellow in them to make you really sit up and take notice. These need to be handled with care; they tend to suit modern interiors best and need either plenty of white to dilute the effect or something strong and dark to offset them. And then there are the strong green-as-grass greens like jade and emerald, guaranteed to draw attention and

• COLOR IN THE HOME •

stunning on shiny surfaces such as gloss-painted wood, chintz, and ceramic, or used to give a sense of depth within a deep pile carpet or thick fabric.

Colors as strong as these may be best suited to use in small doses, but rules are made to be broken.

With greens especially, you can often get away with whole walls, floors, and other extensive areas in a strong jade or bottle green. The effect will be dramatic and fairly overpowering, but the color can usually take it without seeming too rich or tiresome.

Below: Beautifully ribboned bed linen has suggested a decorative theme of ribbon trims and stenciled bows in this pretty bedroom, delicately fashioned in pink and green.

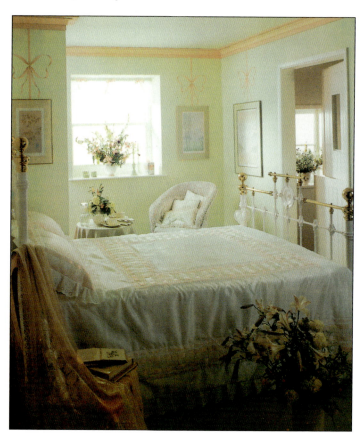

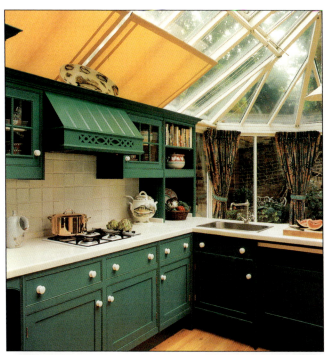

Left: A dark leaf green seems particularly appropriate for the units in this kitchen extension.

Below: Pea green is the main theme for a traditional-style drawing room. Restricted to matte textures, the color is instantly reminiscent of antique velvets and brocades.

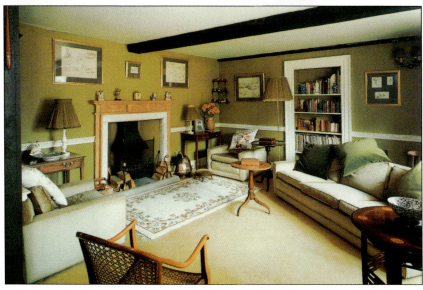

• COLOR IN THE HOME •

Companion Colors for Green

You never have far to look for a starting point for a green decor. Nature provides such a wide range of choices, from the vivid, vibrant yellow-greens of early spring foliage through the sage greens of grassy hills to the deep, almost black shades of hollies and other evergreens.

The best thing about green is that there is little danger of clashes and discords—you can mix and match with impunity, creating extra sparkle where needed with occasional accents of other colors.

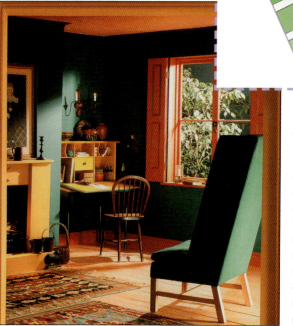

Whatever furnishing style you choose, deep green teamed with red immediately suggests an old-world folksy atmosphere. These two dominant shades need blending with care to get the right balance. Here the addition of a third shade—an earthy golden yellow in exactly the same tone and strength—contributes to the success of the overall effect.

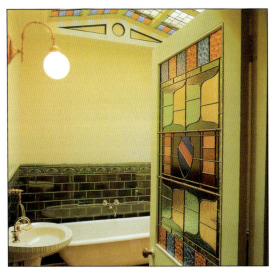

Left: The Victorians loved strong colors like these holly green bathroom tiles and weren't afraid to team them up with other bold effects, such as a strongly patterned black and terra-cotta floor and brilliant stained glass. Shiny surfaces, judicious use of white, and good lighting are important to add sparkle.

Right: Rich polished wood against an emerald green background is a bold but highly successful combination in an old-fashioned, traditional-style home where the two deep shades give each other a complementary glow.

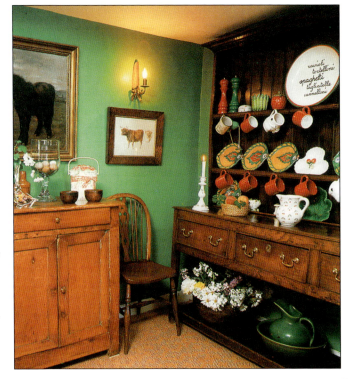

• COLOR IN THE HOME •

121

The Colors Yellow and Gold

Yellow is the color of sunshine, and it tends to have exactly that effect when used in the home. It lightens and brightens and raises the spirits.

Yellow makes us think of spring, which is not surprising since it is the color of so many of the early flowers— daffodils, crocuses, and primroses— that give us our first welcome splash of color after winter's gloom. It is nature's brightener, the color that catches our attention but is never garish in the way pinks and reds can sometimes be.

WHERE TO USE YELLOW

A yellow theme will make a room look both lighter and warmer, even when the paler shades are used. It is the nearest color to light, and indeed does seem to have light-giving properties, bouncing back maximum light rays rather than absorbing them, as do many of the darker colors. Yellow tends to have an inspirational effect, and will create an atmosphere of cheerfulness, especially where the deeper, honeyed tones are used, making it ideal for widespread use in north-facing rooms or on walls opposite a north-facing window. As an antidepressant, it is frequently recommended for office areas and bedrooms.

A touch or more of yellow will brighten up any room, but it is particularly well suited to bedrooms and breakfast nooks, where you can best appreciate the soft glow of illusory sunlight first thing in the morning. Equally, the right shade could benefit a chilly sitting room, either used as the main theme on walls, floor, or fabrics, or as a brightener in accessories and trims. It is a good choice for hallways and entrance halls, not just because these areas tend to be rather cramped and it helps make them larger, but also for its cheery welcome to visitors.

Yellow used in bathrooms and kitchens is slightly more tricky. It

can be used successfully to paint or drag fitted units in soft pastel or lemon shades and then highlighted in a deeper, stronger color such as green, maroon, or blue, but otherwise it can look a little raw surrounded by glossy tiles, baths, basins, and shiny fittings. Nor is it a heavy companion to natural-colored light wood like varnished oak or pine—a popular choice for fitted kitchen cupboards—as they are too close in tone and color.

CHOOSING THE SHADES
The right shade can look wonderful and give a room real vitality and warmth, but yellow can be a difficult color to pin down. The warmer yellows veer toward orange, while the cooler ones hint at green—think of the acid color of a lemon and the warm gold of a daffodil, for example. It can change dramatically under artificial light, too, so it needs to be seen under all likely conditions before the final decision is made on a particular shade.

When you are considering a predominantly yellow scheme, beware of trying to mix too many different shades, as they can be notoriously hard to coordinate and look terrible where the color has turned just a little too acid or a brighter shade is slightly too brash. It is better to use shades of the same color base or tone up or down with

creams or golds—both good, classy additions to the softer yellows.

ACCENTS AND HIGHLIGHTS
Once you have gotten the shade right, you can use quite a lot of yellow to good effect, but it needs the addition of related colors in the form of accents and accessories to maintain its uplifting effect. Although a less dominant color than red, for example, an unrelieved yellow scheme tends to become confusing and irritating after a while.

The lighter or brighter shades of yellow do not respond as well to highlighting with white as do blue and green. Against the pale shades, the white tends to get lost, and with the deeper, brighter yellows it produces a fairly crude effect, making its application limited to very simple schemes such as children's rooms and nurseries. For sophisticated schemes, balancing with cream or gray is far more successful.

Still subtle but extremely stylish, and potentially more masculine, is the use of the paler, softer yellows with browns and beiges—for highlighting, accessorizing, bordering, and flecking on furniture, floors, and furnishings. Such brown shades could be supplied by a natural surface such as wood, cane, or coir. As long as these are darker in tone than the

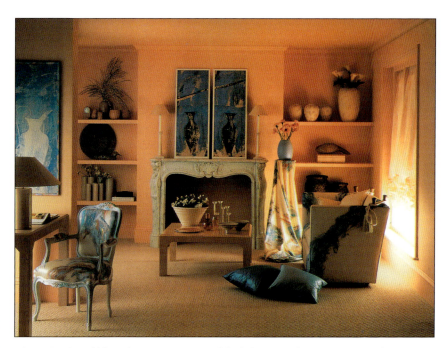

Above: Peach and blue—happy companions if the balance is right. Here just enough blue has been added to prevent the scheme from looking too warm, cozy, and complacent.

yellow, they will provide some contrast as well as a welcome texture—yellow has a tendency toward flatness.

For a stronger contrast, green is a natural companion, producing a mouthwatering freshness in both the light and deeper shades. Pinks, reds, and purples can be rather startling used in conjunction with yellow, but when matched tonally and used in small quantities they can be an electrifying success, particularly where an offbeat or exotic scheme is planned. Bright red touches added to sunny yellow always have something of a circus about them, and could only really be used in a playroom or fun bathroom, but dusky pink or gray/mauve against a faded mustard color looks superb in both traditional and modern settings.

If lemon yellow suggests youth and freshness, at the other end of the yellow scale is the undisputed voice of age and experience, and the last word in luxury—gold. This is a color that definitely needs to be applied in small doses, as a little goes a long way in trims and accessories.

Gold suits all colors and styles,

but looks by far the best combined with the deeper, stronger shades such as maroons, emeralds, and purples, helping to reinforce that feeling of sumptuous richness. For a totally classical look, combine it with plain white or cream. The luster of gold might be added in the guise of tassels and trimmings, as a thin painted line or gilding on furniture and effects, or in the color and denser texture of old gold velvet used as curtains and upholstery.

The rich gleam of gold can also, of course, be supplied by judicious use of metal surfaces and accessories to add a little life to an interior short on shine. Real gold, obviously, would not be feasible, but polished brass produces the same effect and metal banding on glass tables, mirror frames, and fireplaces, or metal lamp urns, copper warming pans, and other such objects will add the necessary rich gleam.

THE YELLOW SPECTRUM

It is not surprising that yellows are so difficult to blend and coordinate when you consider the range of shades within the spectrum. Softest and easiest to use — and ultimately to live with, are the palest lemon and primrose yellows. These are a popular choice for painted cabinets and special paint effects on walls and furniture, often picked out with a suitable powder blue, peach, or other pastel shade. For a bolder, brighter sunshine effect, there are the buttercup and

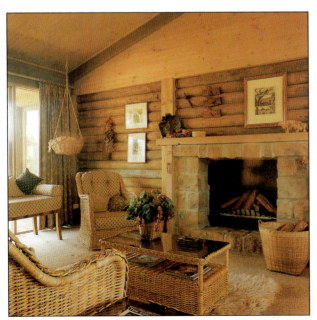

A lovely blend of natural textures — cane and polished and rough wood — produces a wonderfully subtle scheme of yellows through cream to honey.

• COLOR IN THE HOME •

125

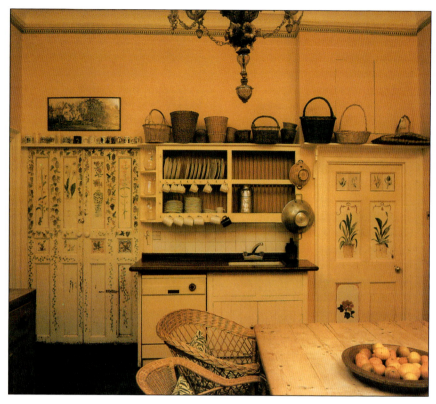

Yellow is a very pleasant color to use in the kitchen. It can encourage a feeling of mellow cheerfulness, especially when decorated with hand painting and lots of old-fashioned accessories.

canary yellows—spectacular if you are brave enough to use them undiluted on floors and walls, but just as effective when restricted to furniture and accessories.

Yellow even has a range of earthy tones, the mustards, sands, and ochers. Subtle and timeless, these are perfect for older properties with uneven walls and period furnishings, or for creating an effective ethnic atmosphere by mixing with terra-cotta, burnt umber, slate blue, and black. The rogue in the pack to watch out for is that particularly vicious acid yellow. It can be extremely difficult to coordinate unless you are looking for fluorescent contrasts with "punk pink" and lime greens, and needs a skilled eye and bold approach.

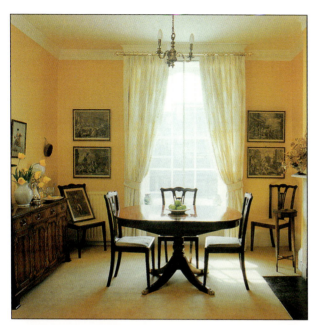

Left: Shades of yellow for traditional elegance in the dining room— a perfect relaxing background for rich, polished woods and good conversation.

Below: By artificial light or candlelight, yellow can take on a rich and golden glow, making it ideal for formal dinners.

• COLOR IN THE HOME •

Companion Colors for Yellow and Gold

Yellow is such a cheery, friendly color that it can take the dramatic touch of bolder companions such as black or dark brown.

It also looks superb paired with green of any shade, but especially with dark forest green, where a feeling of richness and maturity is required.

Below: Dramatic without being unfriendly—black and white combine well with yellow's warmer, brighter nature.

• COLOR MATCHING HANDBOOK •

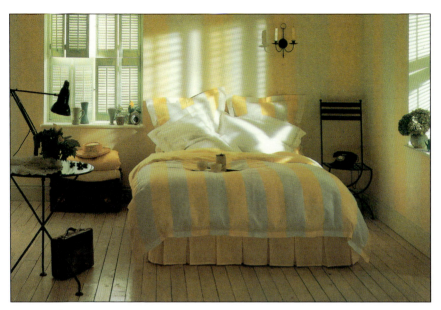

Above: Yellow goes well with subtle stripes—a pattern theme carried straight through from the floorboards to the window louvers.

Left: A fun fireplace for a child's room is set against a lovely and sunny yellow wall.

• COLOR IN THE HOME •

129

The Colors Orange and Peach

Warmer than yellow, less dominant and easier to handle than red, orange is justifiably popular, and considering the natural limitations of shades within the range, you'll find it widely used as a flexible furnishing color throughout the home.

Reminiscent of autumn fruits, blazing sunsets, and open fires, it immediately announces warmth and welcome.

WHERE TO USE ORANGE

Orange does, however, need applying carefully and cannot really be considered for covering large areas unless in one of its very palest, muted forms. For while an orange decor may be relaxing and capable of promoting a pleasant feeling of well-being, the color does not have the light-emitting properties of blue, yellow, or green, and will make a room feel smaller than it really is—ideal for cozy corners but too overpowering in most rooms. The stronger, truly orange options are best used in small quantities as an accent color.

Orange is thus not a particularly good choice for bedrooms, where it

can be rather overstimulating, but it can be used superbly in a kitchen or dining room, where it will encourage a feeling of conviviality and cheer. It is a fun color, something of a fireball in the spectrum, adding fruity zest to greens and yellows and solid warmth to earthy browns, blacks, and grays. You can achieve dramatic effects by using it with dark colors to create geometric patterns and borders on walls and floors, and you will often find it already present, dominating a richly patterned fabric or carpet with other warm, deep shades. It can also be useful for livening up a dingy passageway or adding interest to a dull hall in the form of patterned floor tiles, a dramatic wallpaper, or simply an elegantly decorated border at baseboard, dado, or ceiling level.

True orange and tangerine are uncompromising; they can't really be darkened without slipping immediately into brown, nor do they lighten successfully. For this reason they tend to be used mostly in their pure form, with other colors from the light and dark ends of the spectrum employed to emphasize or temper their effect. The light shades will act to highlight the strength of the pure color, while the darker ones will tone it down.

RELATED COLORS

There are related shades that can possibly be classed as orange, which, because they incorporate the tempering influence of another color, can sometimes be used more extensively, although their natural strength makes sure that they still make excellent accent colors. Coral, with its pink tinge and orange undertones, is one of these colors, as is terra-cotta, once a traditional home-decorating color because it was one of the "earth" pigments obtained from natural soil.

You will often find terra-cotta featured strongly in traditionally colored furnishing fabrics, teamed with cream, black, or sandy ocher. It is also, of course, the color of the hard-wearing clay tiles seen on the floors of hallways, kitchens, and sunrooms in old houses, and is

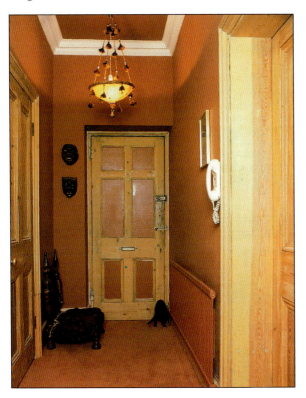

A well-matched allover treatment in a strong shade of tomato makes a warm welcome in this narrow hallway where a touch of white and plain polished wood are enough to add interest and a change of texture.

• COLOR IN THE HOME •

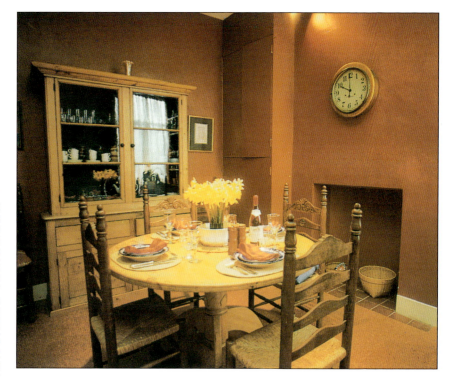

A cozy atmosphere is ideal treatment for any dining area, where a deep russety orange like this on the walls can be used to focus attention on the dining table. A lighter shade has been used on the floor, and far from being overbearing, the effect is attractive against plain wood.

still popular today. These can be laid straight from wall to wall, but this produces a large, unrelieved stretch of color, which is usually varied by the use of specially shaped tiles like hexagons or by laying tiles diagonally in diamond configurations. Another option is to cut the corners of each tile and drop in colored inserts—usually black!

Not strictly orange, but closest to it in color and effect, are the soft pastel apricots and peaches. These muted shades, which can be little more than a tint of cream or a gentle wash of color, have the same therapeutic qualities as their base color. They are relaxing and impart warmth and welcome, but unlike true orange, their potential for use is extensive and flexible. Their very softness of tone and pleasant

coloring means they will fit in almost anywhere, and in generous quantities. Unlike orange, the peach shades are a popular choice for bedrooms, and you often see them giving a gentle glow to walls and ceilings or dragged over large areas of wood paneling or built-in furniture to soften the effect while retaining the interest of the grain.

They blend well with most colors of the same tone, such as sage greens, old-fashioned rose pinks, creams, beiges, and gray-blues, as well as offsetting brighter hues.

Below: A delicate combination of peach and cream and a skilled hand with shapes and patterns has produced a stylish but still softly relaxing seating area.

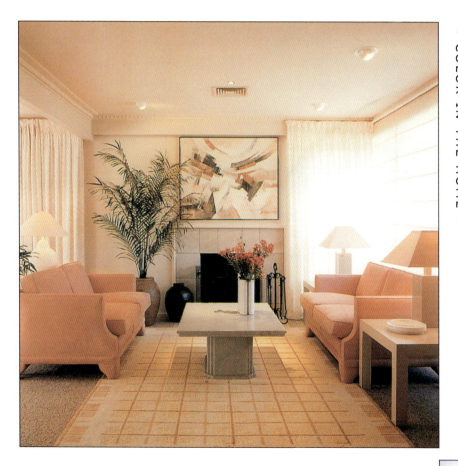

Above: A refreshing true orange has been selected from a strong upholstery design and used with great success as a bold but plain backdrop on the walls, floor, and windows.

Left: In artificial light or by the glow of a live flame, orange takes on a warming glow that can make the largest, bleakest room seem homey and welcoming.

• COLOR IN THE HOME •

Companion Colors for Orange and Peach

Whatever shade or tone is chosen, orange is a dominant color in any room scheme.

When choosing a companion color, one of two approaches can be taken. You can try and tone the combination down a little with a complementary shade of pale blue, cream, or green, or you can jazz it up with a strong contrast such as a black or yellow. Whichever you choose, you can be confident that orange will keep that special warmth and note of excitement.

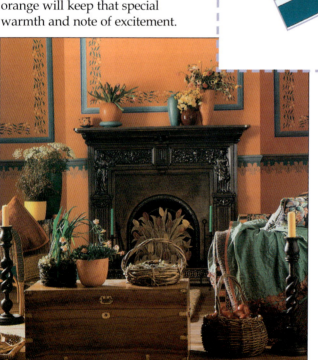

Here is a medley of rich shades, but a predominance of warm orange with blue and green detailing adds interest and pulls the theme together. If the room does not have interesting moldings and dado or picture rails, then you can simply invent them.

Left: Pale peach and powder blue in equal parts are irresistible. This is orange at its softest and most subtle, a classic combination for the most relaxing of schemes.

Above: A balance of blue trimmings in a cozy orange bedroom. It was particularly important to use a prudent hand here, since the floor-to-ceiling mirrors double the effect.

• COLOR IN THE HOME •

The Colors Red and Pink

The eye is immediately attracted to red. It is a signal color, one we simply cannot ignore.

This applies in nature as well as interiors—a couple of berries high on a glossy green holly tree will immediately capture the attention, as will even the smallest scarlet trim in a decorative scheme. Thus, as a furnishing color, red and its derivatives are a powerful design tool that needs to be handled with care. In some ways, it is an easy shade to play with, as you can always be sure of creating an impact no matter how little you use, but it can be tricky to select the right shade and tone from the wide spectrum, especially if you are bold enough to consider covering a large area.

WHERE TO USE RED

Red represents warmth as well as suggesting pageants, a festival atmosphere, and a sense of richness and royalty, so widespread use of it in any room is bound to create something of this kind of mood. Because of its stimulating effect, it is not generally a good idea to use it in unadultered form in bedrooms or any area where you want to relax, but it can be used to good advantage in a child's room or nursery where an active and growing mind needs stimulation rather than relaxation.

Where red works extremely well is in areas where you might be entertaining, such as a dining room—another of its properties is that it is believed to stimulate the appetite. Care has to be taken to find the right location and shade. The brighter reds, such as fire-engine red, would be intolerable over large areas, but a less vibrant red used in paint, paper, or fabric over walls can be sumptuous, creating a wonderfully cozy, rich atmosphere that looks even better by lamplight or candlelight.

Red can also be used effectively in an exercise or activity room, or in a workshop where it may relieve the tedium of a monotonous task, but it is less successful in a study or office, where the constant stimulation can cause fatigue and irritability. Where it really comes into its own is in hallways, often a dreary and neglected area, but one that blossoms under a bold treatment. It doesn't seem to matter in this case that the color is uncompromisingly dominant and unavoidably strong—after all, no one is likely to linger there. The designer should thus go all out for initial impact and a positive response that will color visitors' impressions of the whole house even if they only see it fleetingly. Red says welcome, yet at the same time looks rich and expensive.

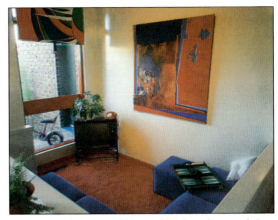

Above: Combining royal blue and bright red cannot fail to conjure up the richness of an Oriental carpet, however modern the interior scheme. In this instance a favorite work of art was the stimulation for the primary colored carpet, modular seating, and smaller decorative touches that somehow get the balance just right in the small and difficult area.

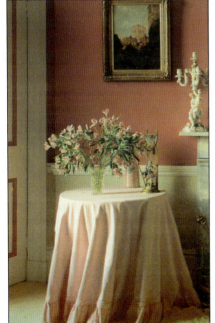

Left: Matte surfaces tend to give the warmer shades like this brilliant fuchsia pink a soft, pleasant glow, especially when contrasted against the crispness of white paintwork and the paler pink of fresh flowers and pretty table linen.

• COLOR IN THE HOME •

139

Hallways, corridors, and entrance halls can get away with this kind of almost claustrophobic, enclosed atmosphere, especially where their dimensions are ugly or awkward. Red visually reduces space, dramatically bringing walls in and ceilings down, and this can be turned to an advantage to create a more intimate atmosphere in a lofty corridor or long, gloomy hallway.

However, the effect can be oppressive, and would not suit any other area of the house, where it could quickly become too much—you cannot look at red comfortably for any length of time, and after a while it could begin to sap your strength instead of stimulating your mind. For this reason, it is normally best avoided on ceilings; few people would welcome the feeling that the ceiling is bearing down on them.

An interesting point to note is that while red makes rooms look smaller, pieces of furniture painted or upholstered in red will appear larger and more bulky than they really are—something to watch out for if you don't want a particular room to look cramped or oppressive even where the basic color scheme is less dominant.

TEXTURE
Another thing to remember about red is that it is more strongly influenced by the texture and finish of the paint, paper, or fabric than any other shade in the spectrum. Also, a synthetic material in red will be brighter than a natural one, which can make color matching difficult when attempting to coordinate different items. Matte paint surfaces and fabrics such as velvets and carpeting, which absorb light rather than bouncing it back, can help to soften the color's glow, while hard, shiny surfaces will have the opposite effect, emphasizing its strength and making it even more dominant. If you want to inject maximum vitality into your proposed scheme, use gloss paint, shiny chintzes, and lacquers. Chinese red lacquer can look superb on a piece of furniture, but make it a focal point and do not attempt to match the color and effect with other furnishings.

The only way to play down red is to surround it with more somber shades or a similar blend of strong colors, for the tried and true method of adding one of the cooler shades such as blue, green, or yellow does not have the desired effect. Blues and greens will only strengthen a dark or bright red, making the kind of rich combination seen in classical paisleys and Oriental carpets. Highlighting with paler shades of those colors also seems to emphasize red's warmth and dominant character. Even good-

natured yellow fails to do the trick; the brighter buttercup yellows positively sing alongside red, while the pastel lemons take a very definite backseat.

There is nothing for it but to give in to the color's character, possibly playing it up boldly with fiery orange; going for an over-the-top exotic atmosphere by adding turquoise, bright pink, and deep blues and greens; or creating a fabulous feeling of luxury and richness with golds and purples.

Red is a popular color for using in small quantities to jazz up an otherwise full scheme: accessorized in the kitchen as utensils, for example, or as a fine trim on pure white, dark navy, black, or bottle green.

Also, many people who feel unable to live with its festive atmosphere would still like to generate the same kind of look and feel at certain times of the year—over Christmas, for example. In this case a more neutral permanent scheme could easily be jazzed up with the addition of rich red

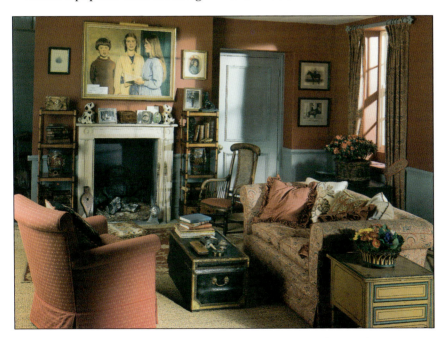

The comfortable country house look often relies on fearless splashes of red to add that welcoming cozy feel, especially in large rooms. Its style is partly inspired by the Oriental rugs and artifacts that appear so frequently as accessories.

curtains and cushions, wall hangings, rugs, and suitable knickknacks as a temporary decoration.

THE RED SPECTRUM

The true, pure reds are brilliant flame, scarlet, and crimson, but there are deeper, earthier shades that aren't quite as startling and are easier to use successfully, especially in an ethnic style or a traditional interior. Sometimes you will have no choice but to plan around a large expanse of brick red in the kitchen or living room where an exposed fireplace or brick wall makes an architectural feature. Earthy red shades appear over large areas in the guise of quarry tiles and terra-cotta, too, and while these might dominate a floor or wall, their naturalness makes them easier to coordinate with stripped wood, polished brass, simple fabrics, and other traditional rustic touches.

Burgundy is a useful and sometimes forgotten red at the darkest end of the spectrum. It always looks stylish, if rather serious, and goes well with similar shades such as navy, bottle green, and burnt umber. This is one of the few shades of red that might benefit from being highlighted by white, cream, or pale sandy yellow. Tomato red is another shade that leans more toward the duller, darker reds, although it still

dominates a room with its glowing warmth. It can look superb on a dining room wall in a matte finish as long as the shade doesn't move too close to orange, which could be too sharp for this kind of classic theme.

PINK

Try to pale down red with white and it perversely changes color altogether—it becomes pink. Although technically part of the red spectrum, pink can almost be considered a color in its own right, with a range wider even than that of its parent shade. Like most of the pale shades, it is identified as a "young" color and is unshakably feminine—its pretty softness makes it ideal for baby rooms, but so strong is our social conditioning that few would consider it for a room that was intended for a baby boy. Similarly, some men find a strong pink predominance in a room—especially if accompanied by ruffles, ribbons, and bows— unbearably prissy. However, there are pinks that go some distance away from the somewhat feminine image: a dusky rather than sickly sugar pink at the softer end of the spectrum and strong fuchsia, magenta, or psychedelic electric pink.

Pink is a pretty color for a bedroom, and a wide range of papers, fabrics, and linens is

available in plains, florals, and modern designs. Surprisingly, perhaps, it has also become a popular color for today's softer, more comfortable kitchens and bathrooms, in the shape of painted cupboards, tiles, and matching accessories. Modern easy-clean surfaces and materials have made pastel schemes such as this a possibility in heavy work areas.

Pink is a pleasant, relaxing color, useful for encouraging a spacious feel when used in large quantities, yet with none of the chilly detachment of blues and greens. Its gentle, rather feminine glow is not to everyone's taste in the main rooms of the house, but often a well-planned pink scheme can transform a cold or gloomy sitting or dining room into a warm and friendly environment that makes few demands on the user. Pep it up where needed with green — perhaps its prettiest partner, whether as a dark leaf green detail or larger amounts of the sage or apple shades.

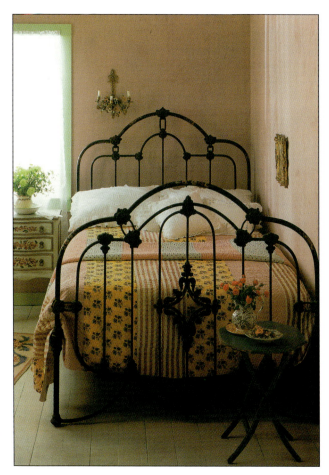

Colors straight out of a candy jar, strengthened with licorice black. Rough-painted pink walls produce a warm, rustic atmosphere.

• COLOR IN THE HOME •

143

Companion Colors for Red and Pink

White is the classic highlighter for red, and when used with fire-engine red, it produces an unmistakably modern look.

For a more traditional feel, creams or soft, sandy yellows as accent colors blend well with dusky brick reds and maroons, helping to balance the effect and giving a softer, less dramatic feel. Black and brown will also mute a strong red shade—although the black-red combination cannot be other than dramatic.

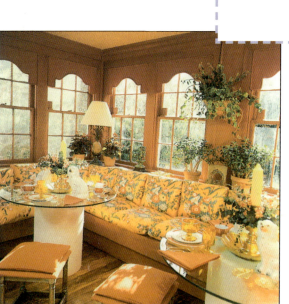

The natural green of plants both inside and outside this sunroom-style extension make a pleasant contrast, and the natural sunshine that bathes the room is brilliantly enhanced by the addition of rich orange and yellow to the red on the seating, echoed in the terra-cotta plant pots.

Left: Pastel pinks added to powder blue and clean white in the bathroom help soften and warm the effect of these cooler shades and cold surfaces such as ceramics and plumbing fixtures.

Below: Creamy yellow paint used to spray a few pieces of cane furniture and to cleverly apply a marbled paint effect to the table and fireplace has lightened the effect of rough-brushed brick red on the walls and pulled this lovely mellow scheme together.

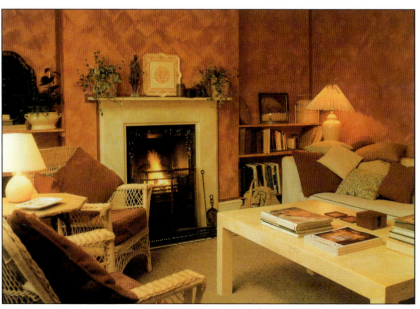

• COLOR IN THE HOME •

Creams and Neutrals

Black and white are sometimes thought of as neutrals, but in fact they are more accurately described as "non-colors." The true neutrals are that large group of subtle hues ranging from creams and beiges to the various permutations of beige-gray.

They are valuable colors in the decorator's repertoire, as not only are they restful and easy to live with, they also have the property of providing an effective backdrop or frame for brighter colors, making them look more thrillingly vivid by contrast.

HOW TO USE CREAM

Cream, like white, is particularly useful for highlighting, and where white can give an overbright harshness to some of the darker colors, cream has a gentle and natural appeal. Not surprisingly, it brings with it a suggestion of softness and richness. It is the color of buttermilk, pearly field mushrooms, and fine oatmeal, a restful, always attractive shade from the faintest milky tinge through to pale beige. It makes a superb background as well as a highlight to any color and shade, immediately softening even the most strident reds and greens and uniquely capable of taking the hard edge off black. Used with the softer, more sophisticated shades, from the pastel peaches, pinks, and apricots to which it is close in tone, to the strong masculine notes of fawn, navy, and maroon, it adds a sense of expensive luxury and elegance.

As a highlighter, cream is marvelous in naturally cold rooms where white would add an unwelcome chilly note, but the creams also stand well as a group of colors or shades in their own right. Light yet still warm, the look they generate over larger areas is one of relaxation and luxury. They make a room look airy without being bright, spacious yet somehow cozy and reassuring. However, because these shades are so subtle, they do need another, stronger color as an accent to prevent them from fading

out altogether and leaving the room completely neutral. A coloristic focal point for a still soft and understated scheme in the bedroom or sitting room can be any one of your favorite colors from pale blue, pink, or peach. This is also a surprisingly popular choice for modern kitchens. For an unbeatably expensive look, cream can be paired with gold — magnificent in a classical bathroom, with cream bath and basin, gold taps, cream tiles, and towels with gold detailing. Or you could opt for a much stronger but still classy combination of cream accented with burgundy, royal blue, or forest green.

COMPANION COLORS

Because they always retain a sense of naturalness and wholeness even at their most sophisticated, the creams and light beiges are equally good companions to the earth-based spectrum of terra-cottas, burnt umbers, ochers, sands, and darker browns. Cream appears naturally in unbleached natural materials such as wool, cotton, linen, and burlap, making it ideal over large areas, such as walls and floors, where something neutral yet still interesting is desired. Berber carpets or real grass wall coverings, with their natural fleck and unassuming neutrality, benefit

Allover cream for a wonderfully relaxing atmosphere and rich sense of comfort. It is the perfect background for the carefully displayed collection of toys and is beautifully complemented by the freshness of live greenery.

An all-cream scheme can look superb, especially where the lighting is good and there are plenty of different textures—soft, hard, matte, and shiny.

both large and small rooms—they are undemanding yet never dull. These are materials that combine extremely well with plain varnished wood, bamboo, cane, even marble, stone, terra-cotta, and other natural surfaces anywhere in the home, from sunrooms to bathrooms.

THE NEUTRAL RANGE

The range of shades appears fairly limited in comparison with the striking contrasts between various shades of blue or yellow, though once you begin to look at color cards you will quickly notice small but distinct variations. They run

from the softest pearly tints (and cream can have a warm, pinkish tinge or a blue-green cooling one, making it adaptable to any scheme), through the natural flecked and textured effects, to beige that is at the palest beginning of the range of browns.

Below: Near-white cream tiles in the kitchen strengthened and warmed by golden wood beams and an open staircase.

This was once a universally used "safe bet" shade, now enjoying a more interesting and exciting life as people become more confident in their use of color and are prepared to add a deeper shade here or touch of texture there. The beauty of these near-neutrals is that they combine well with anything so can be used extensively without any misgivings. You can always rely on them to enhance but never dominate or detract from other colors, yet they never lose their own calming character and feeling of richness.

Below: Cream with a chocolate trim for a streamlined, sophisticated bedroom. Color-coordinated shelves are a useful way to combine practicality with a decorative theme.

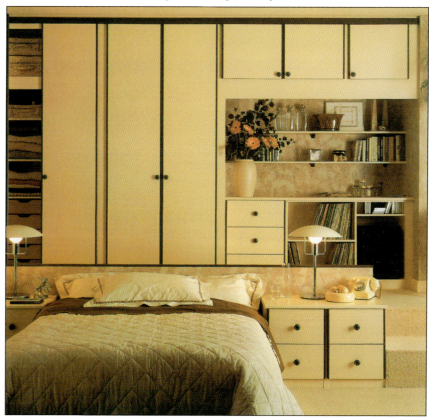

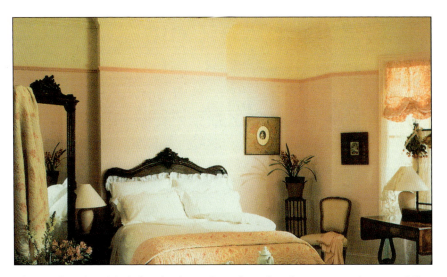

Above: Pale pink and dark chocolate brown have always been happy companions, especially as used here, with the paler color kept to the walls and the good, solid wood providing the stronger statements.

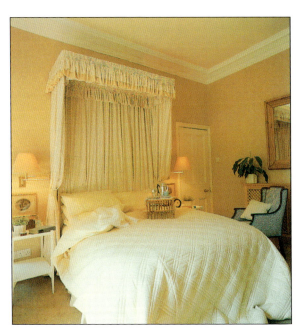

Left: Fawns and creams have produced an altogether softer, more subtle effect in this bedroom, with a clever blend of close shades relying on a variety of textures to provide interest to the scheme.

• COLOR IN THE HOME •

Companion Colors for Creams and Neutrals

Any pastel shade looks superb with cream, producing a gently tinted interior that always gives the impression of light, space, and airy innocence.

Blue also seems to work particularly well with cream. Its coolness is the perfect balance for cream's subtle warmth. It is relaxing and somehow more sophisticated than sugary pink, the rather offbeat mauves, or the pale yellow spectrum whose tone is so close to cream it does not provide much of a contrast.

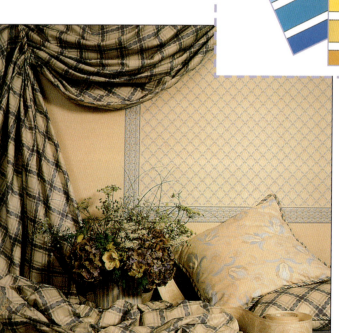

Often the most successful schemes employ a limited choice of colors but a wide variety of patterns and designs. This approach works well with the more subtle color blends.

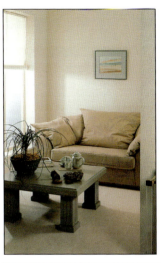

Left: Blues and grays combine with cream for a sophisticated modern living room where variety of texture is as important as color.

Below: Delicately patterned fabrics are blended into a mainly cream background in this delightful cottage bedroom. A small-print wallpaper using both colors in the scheme has cleverly been continued over the doors and ceiling to pull the theme together and maximize the feeling of space.

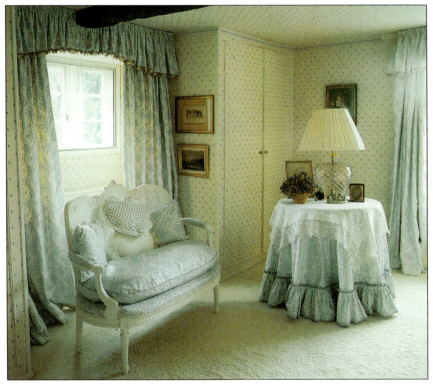

• COLOR IN THE HOME •

153

The Color Brown

Brown sounds dull until you begin to look at all the different shades and textures available and the warm, sophisticated schemes they can create. Brown, russet, and tawny colors can provide a very comfortable, natural environment – wholesome and homey.

A lot of furnishings in the brown range are in fact natural materials such as wood, clay, and cane, given no additional color treatment so that the natural shades speak for themselves. These types of surfaces offer unique color options, as no two pieces are truly the same, and produce an earthy, comforting, relaxing kind of room. There is the potential for both a heavily traditional decor—dark-stained wood, leather, old golds, and dark, browny reds—or a wholly modern one, with a blend of blond, elegant wooden furniture, subtle coir matting, and natural silks and grasses in shades of beige, buff, and camel.

WHERE TO USE BROWN

A brown scheme can work extremely well providing there are a few shiny surfaces such as mirrors, glass, or metal to add a little life and sparkle. As a blend of plain polished wood, fabric, and painted surfaces, the browns are ideal in the study or sitting room, where the subtle interplay of rather low-key or muted shades can be exploited by experimenting with dramatic changes of texture and shape.

Brown in the form of natural wood is often the first choice for a kitchen, particularly where a traditional or rustic atmosphere is desired. Available fitted units run the whole gamut of shades, from dark, imposing walnut and dark oak (not for small kitchens) through light oak, glossy chestnut, and golden pine to the cool sophistication of beech and ash. With such a large expanse of a single color and dominant texture, a carefully chosen accent color is often necessary to prevent the effect from looking too heavy, especially

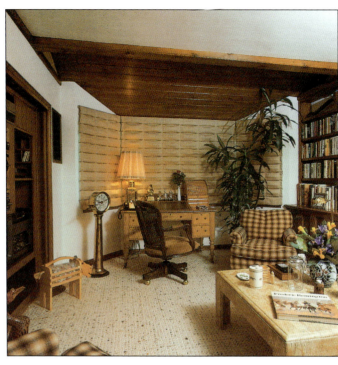

Left: Shades of brown can give the sitting room or study a cozy atmosphere. An old wooden desk or comfortable armchair upholstered with brown fabric is often the starting point.

• COLOR IN THE HOME •

in small rooms or where the natural color of the wood is strong. This might be a blond or beige color, simply lighter shades of brown—for a very subtle scheme—or it could be a complete contrast with touches of red, green, or even blue if the right complementary shade can be found. Accent color can be applied to cupboard handles and trims, work surfaces, wall tiles, flooring, and curtains, or they can be temporary accents such as pots and pans, enabling the color theme and ambience of the room to be changed if desired without major redecoration.

Since paneling, boxing in, and fitted furniture became popular again in the bathroom, the picture there is a similar one. In the most fashionable homes, cabinetwork is being dragged, painted, and bleached, but the majority of rooms, particularly those furnished in traditional styles, are displaying plain varnished pine, oak, and mahogany around baths and basins. This can serve to warm up a room that is normally highlighted by shiny white or cream bath, basin, and tiles, but again, well-chosen accessories can do wonders. These need only take the form of a touch

155

of color in the towels, soaps, or on the walls, though brass- or gold-plated taps would be perfect for adding life and sparkle. Keeping the accents on the soft, warm side of the spectrum, using earthy reds and oranges, pink or autumn-gold yellow, will help to maintain the comfortable, relaxing atmosphere— always an achievement in a bathroom.

The bedroom is perhaps the one room where a brown scheme may not be totally successful unless the lightest shades—more yellow than brown—are selected or predominantly natural surfaces are chosen. Where once bedroom furniture was heavy and dark, accompanied by gloomy or grand furnishings, we now prefer waking to a light, bright atmosphere that will lift the spirits and start the day off on the right foot. However, custom bedroom furniture in natural wood finishes is still popular, resulting in wall-to-wall and floor-to-ceiling cherry, oak, pine, or other selected hardwoods and softwoods.

This is a lot of brown to balance in what is usually a relatively small room, but the effect can be lightened with judicious use of an accent color for other decorations and furnishings. Dusky pinks blend well with chocolate and deep browns, helping to reduce their rather serious character by

introducing a lighter, almost frivolous note. Light greens and yellows will also lift a too-somber scheme, and can be conveniently coordinated with the whole spectrum of browns from the palest beiges and fawns through to the orange-based russets. If you prefer a cozy atmosphere in the bedroom (or indeed any room), balance brown with other earthy terra-cotta and brick-red colors, or mix up a "Persian carpet" palette of reds, blues, and more shades of brown.

ACCENTS AND COORDINATION

Adding darker accent shades to brown can produce a very nice, sophisticated effect. Maroon and navy, gray, and even black will all go well, producing a distinctive clubbish look as masculine as a university blazer and equally stylish. Lighten it where necessary with stone, beige, or soft mustard yellows to maintain the look.

Because brown is a mixture of colors, not a primary like yellow, red, and blue, the brown spectrum does not run neatly from light to dark, but in varying directions, according to the derivative colors of each. But also unlike the primaries, all sit well together and can be mixed and coordinated with confidence. There are browns with a strong orange bias—the tans and russets, browns with a strong red

Right: Browns bordering on antique gold are used in this sumptuous master bedroom with an Oriental flavor. Paint dragged walls to produce a suitably aged effect.

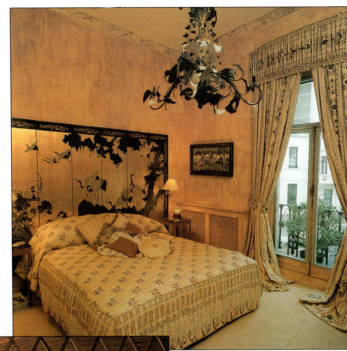

tinge, yellowy mustard browns, and walnut shades with a distinct green look. Deepest and darkest of all is chocolate brown, almost black but with a wonderfully velvet look of luxury about it. Used on the right surfaces and with the right accent color—maybe a gleam of gold—this modest color can make a room look like a million dollars.

Left: Rustic yet still sophisticated, the subtle browns of old wood and clay floor tiles against plain creamy white.

• COLOR IN THE HOME •

The Color Brown and Wood Panels

Wood paneling is by far the most exciting way to introduce both texture and a warming shade of brown to any room in the home

It is also an exceedingly useful way of hiding an unattractive wall or feature. It can be used to incorporate shelves, steps, and cupboards. In a small room it can be laid over floors, walls, and ceilings to create the impression of more space.

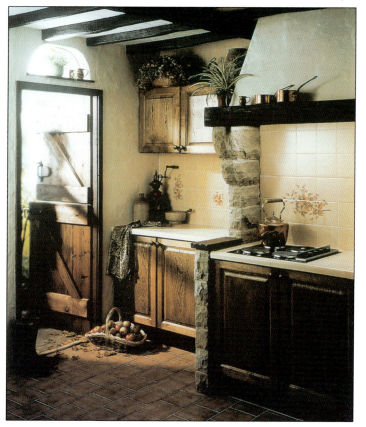

Left: The rich brown of polished wood is popular for traditional country kitchens. Creamy tiles help keep the effect from looking too heavy.

Left: A magnificent staircase and paneling has been enriched by years of polishing to become a match for the wood floor of this lovely hall. The colors of the wood need no more than a gleam of gold to enhance them.

Right: The leopard effect of knotty pine is used to completely panel an open-plan, split-level cooking and living area. By restricting all other colors to black and cream, the grain and color of the wood say it all.

• COLOR IN THE HOME •

Companion Colors for Brown

With their natural sense of earthy richness and warmth, browns can be successfully accompanied by a remarkably large number of companion colors.

Each of these colors will affect the final look quite considerably. Red, of course, emphasizes that cozy warmth and intimate atmosphere. Creams and yellows can lighten and soften to produce a more sophisticated effect. Even pale blues and greens combine well to produce a pleasing contrast in tone and shade.

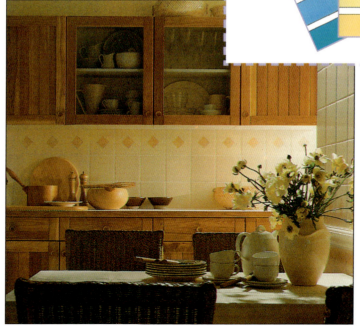

Left: Brown converted into something cool and sophisticated by plenty of white and cream.

Left: Pale blue is used to lighten the effect of lots of exposed wood in a country dining room.

Below: Rich reds and browns are perfectly blended in a clever combination of fabrics, polished woods, wool, and leather.

• COLOR IN THE HOME •

161

The Colors Black, White, and Gray

Even in nature, black and white occur as accents, highlights, and a dramatic background for other shapes and colors.

Consider the starkly exciting effect of skeletal trees outlined against a blanket of snow, the foam on breakers, the sparkle of white flowers in a green field, or the camouflage of a zebra's stripes. They occur naturally together in marble and other stones, and in the speckled fur and feathers of some animals and birds.

WHERE TO USE BLACK AND WHITE

Used in equal parts, as stripes or checkerboard patterns, for example, black and white's strong contrasts are invigorating but far from restful, which is why they tend to be used for flooring in halls and dining rooms. But perhaps surprisingly, where one is allowed to predominate, the effect becomes restful—although exclusive use of black would be taking minimalism a little too far and would not be very practical. Black absorbs light rather than reflecting it, and needs something to relieve that potentially frightening denseness.

Pure, unadultered white is a more viable proposition, but a totally white scheme can be as disturbing as an all-black one if it is not handled with skill. If the addition of even a single accent color is ruled out, great attention should be paid to an interesting balance of shapes and textures within the room, using rugs and wall hangings, bleached wood, ceramics, and other contrasting surfaces.

The effect can be spectacular, and all-white is a popular, if not very practical choice for sitting rooms, bedrooms, or sometimes kitchens and bathrooms, exploiting their cool, clinical properties. White is the classic space-maker, and the more of it you see, the lighter and airier the effect. Some find the

formlessness and lack of boundaries of an all-white scheme difficult to live with (hence the importance of dominant and varied textures), but others enjoy its modern neutrality and the clean backdrop it provides.

HIGHLIGHTS AND ACCENTS

The combination of black and white is frequently employed in an ultramodern way. The absolute contrast seems to dictate straight lines and hard edges, which is why black and white are so often used for dramatic geometric patterns on floors, tiles, and borders, or for angular furniture. Frequently, bright red or yellow is used as a stunning accent color, adding warmth and interest to what can appear as a rather stark scheme.

More muted companions used as accent shades or highlighters, which help tone down the effect and produce a less dramatic but still essentially chic decorative scheme, are fawn and mustard yellow, faded terra-cotta, and olive green. Using these classical shades allows black and white to be used in more traditional interiors—the basic combination has been used for centuries on marble, ceramic, and wood floors.

The rich texture of natural stone is enough to relieve the starkness of a scheme like this, making it the perfect cool welcome in a sultry climate.

• COLOR IN THE HOME •

The dramatic black-and-white carpet follows from the stairs through the hall and is matched by floor tiles and glossy white paint.

For giving a dramatic look to kitchens and bathrooms, both areas where you can afford to create a businesslike atmosphere, you can't beat the black-and-white combination; their crispness can be emphasized by using paint and ceramics, but it is important to add a third color in the form of accessories or other decorative details to relieve the monochromatic starkness. The same scheme adapts well to neat hallways, although here a softening brown touch, perhaps in the guise of a piece of wooden furniture or a fawn or sand color on the walls, would be especially appropriate.

White and black also combine to give us our grays and silvers— a most useful band of neutral highlight and accent shades that go well with a great many other colors.

GRAY

This is a universal leveler, toning down brighter shades and fully complementing softer ones. The gray made by a straight mixture of black and white is a rather dead color, but the gray range is widened by the addition of other colors in small quantities. It comes in a great many shades for harmonizing and coordinating, from the soft mauve-grays through blue- and pink-tinged colors to hard, almost blue, slatey grays that can look superb as an accent with red or deep blue.

In many ways, perhaps because they are almost negative, the more pastel grays have taken over from beige in modern interiors as being a safe option for those who are not totally confident in their ability to mix and match stronger shades. They can always be relied on not to dominate or become tiresome quickly, and most of the paler grays go well with everyone's favorite color, but especially with pink and yellow.

Silver is less amenable, but is a useful highlighter where a touch of

lighthearted sparkle is required. It does not have the sense of richness and expense conjured up by gold, and adds a cooling rather than warm note. As soft-finish nickel or shiny chrome, it is the perfect uplift for Art Deco and more modern interiors, a stylish addition for taps in bathrooms or kitchens where the sometimes vulgar effect of gold or brass is not suitable. Silver can also give a very sophisticated sparkle to sitting rooms and dining rooms in the form of cutlery, candlesticks, and other accessories.

Silver perhaps performs best with other cool shades such as gray and blue, to which it is close, used either as a tonal highlighter for pale shades or to add sparkle to deeper ones. It is also good with black and white themes looking for a little extra highlighting, but is far less successful with the warm colors — the reds, browns, and rich yellows.

Below: A touch of black gloss and a bold mixture of prints on the tablecloth give this russet-tiled corner a cozy bistro air.

• COLOR IN THE HOME •

Above: Sometimes a stray touch, judiciously used to highlight an interesting architectural feature or a handsome piece of furniture, will give a room real strength and character.

Opposite top: A zebra-print fabric framed by lots of white, with a jet-black floor to lead the eye away into another part of the house.

Opposite below: An equal blend of black, white, and gray produces a surprisingly cool and relaxing interior for this modern-style bedroom.

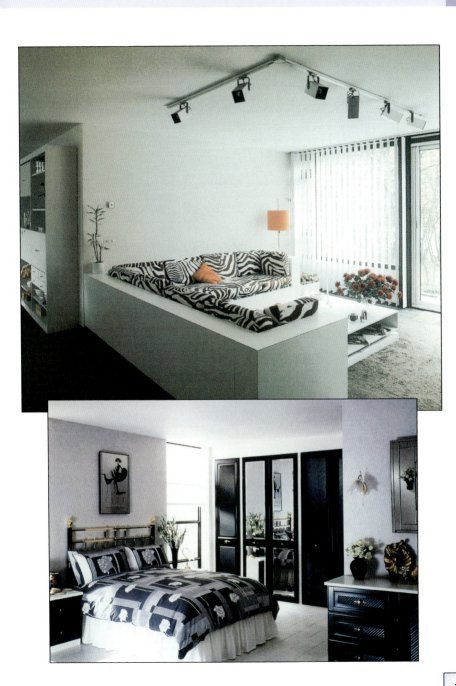

• COLOR IN THE HOME •

167

Companion Colors for Black, White, and Gray

Black and white is such a dominant combination that companion colors have to be equally strong to make any impression on the scheme.

For this reason, the use of a primary—usually bright red or yellow—is popular, often as a means of adding just a splash or highlight of warmth and color to the room. For more subtle combinations, the blues and violets are less of a contrast and simply soften the monochrome effect.

Left: A bold black-and-white bathroom is made more welcoming by a sunny yellow blind and accessories.

Opposite below: The high-tech, ultramodern look always responds well to a splash of bright red. It makes an excellent accent color added to black and white or pure white, providing it is restricted to a touch here and there.

Left: Playing with extremes: the glowing effect of rainbow primaries against large areas of unyielding black.

• COLOR IN THE HOME •

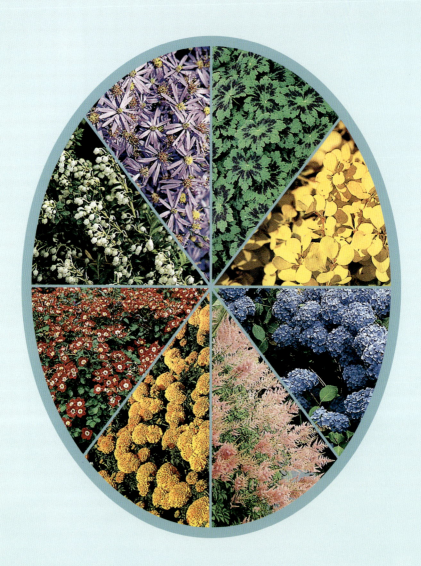

COLOR IN THE GARDEN

Plant compatibility, although an important factor, is not the only consideration when planning a companion garden. Color, shape, texture, and even fragrance should all be taken into account to provide interest throughout the year.

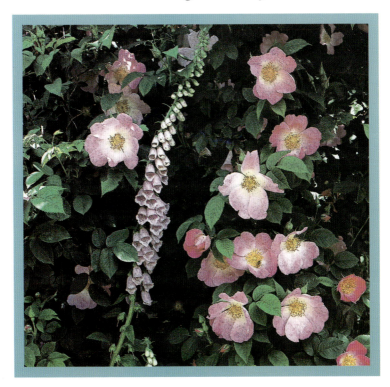

Designing with Color

Plantings where the use of color is restricted are usually far more striking and effective than those that incorporate many different shades.

It is important to realize that your main color will come and go in a mixed planting depending on the time of year. For instance, it is difficult to maintain a blue border year-round because of the lack of blue-flowering plants in winter. This is where blending with another color, such as yellow, will be useful. The dynamics of a two-color border create far more interest in other seasons, too.

Annuals are a great tool for experimenting with different color schemes—if something doesn't work out, you can always try again next season. But for permanent plantings in a mixed border, it's wise to have some kind of evergreen framework or backbone planting to provide continuity. Foliage is just as important a consideration as flowers, and even if it is not quite as colorful, it is far more

enduring. It comes in a wide variety of tints and serves to enhance blooms in specific color schemes.

There are, of course, other factors to consider when designing a border, such as blending different shapes and textures for maximum contrast. The close-up and general-view photographs and descriptive text should give you a good idea of the form of the plant. Try to imagine your scheme in black and white to make sure that there is sufficient variety of form. Flowering time is also important. For a scheme to work well, plants that are in bloom at the same time must combine satisfactorily. And there's no point putting a group of plants together just because they make a pleasing combination on paper if they all bloom at different times.

Finally, there's no reason why you have to stick to a particular color scheme year-round. You can choose a main color to link the seasons and then weave in contrasting or complementary shades as the year unfolds. Bulbs and annuals are particularly useful for bringing about the changes.

Notes on Color

When considering the color planting of your flower garden, remember that it is not only the flowers and foliage that must be taken into account.

COLOR IDEAS

When visiting other gardens, always carry a notebook and jot down ideas as you see them. Sketches or just lists of plants can be very useful when planning your own garden. Visit the same gardens at different times of the year and see how the plantings are affected by the changes of season. The act of writing or sketching will not only act as a memory aid, but will also make you look closer at the subject.

BACKGROUND STRUCTURES

The color of background walls, either of a building or a boundary wall, cannot be ignored and will often dictate the kind of planting that can be placed in front of it. If the color of the wall is objectionable for some reason, then consider covering it with a dense climber, such as ivy, to make it more suitable.

INCREASING PLANTS

Many herbaceous plants are large enough when purchased to be divided into two or more plants. These can be grown to give plenty of material for planting out.

Growing the plants in a reserve bed allows you to check the colors before planting. Prepare the bed thoroughly and be certain that it is free of weeds, perennial ones in particular. In spring mark out on the soil a life-size outline of your plant and put in the bed. It is inevitable that some colors are going to be in the wrong place, so be prepared to move things around or even to obtain more suitable plants.

MIXING COLORS

A flower border would look very stiff and formal if each individual group of plants was kept distinct. Bedding plants, arranged in blocks or geometrical patterns, give this impression. Allow the different plants to fuse together so that the colors merge. Many plants, the violas and geraniums for example, will scramble through their neighbors, blurring the edges of their patches of color. This gives the border a more tranquil and natural appearance. The combination of two adjacent colors will not only make the transition more acceptable, it will also give the impression of another color.

• COLOR IN THE GARDEN •

Color Harmony

As we are visual animals, aesthetics plays a great part in our lives. A jumble of plants is not a garden; some form of visual arrangement must be made in which color, shape, form, texture, and even fragrance are all taken into consideration.

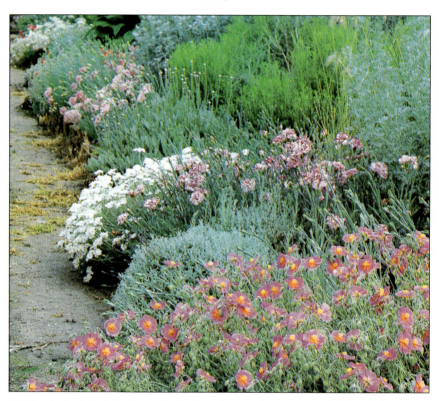

This border is planted closely together in the cottage garden manner so that the plants support each other and suppress weeds. A tranquil effect is achieved by the blending of soft pink flowers and silver foliage.

Many gardeners wince at the thought of consciously attempting to make color relationships in the garden but think nothing of carefully choosing the colors of their clothes and home furnishings. What should make gardeners wince is not the thought of deliberately choosing colors for the garden, but rather the sheer variety of color at

their disposal. In this country, there are many thousands of different perennial plants that can be purchased commercially, plus thousands more that are grown and distributed among friends and gardening clubs. And that does not include the huge range of annuals available. Each of these plants is likely to have its own individual color, and what is more, that color is likely to change as the flower ages and as the sun that shines on the garden changes its position over the course of the day.

All these things give gardeners a tremendously large palette of colors to work with when designing gardens. It is also likely to give them problems, because unless the color relationships are carefully worked out, plants could clash or the overall effect could be spotty. It should be mentioned that color should not be regarded in isolation. Rather, consider it in relation to the

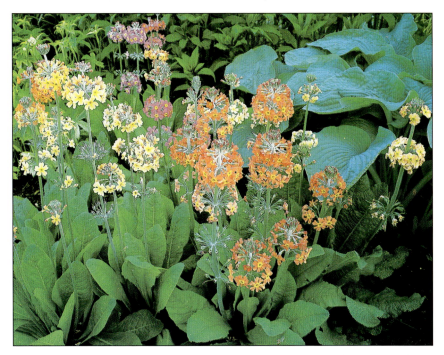

Not all plantings are designed to provide tranquility. Here a combination of the strong colors of the primroses (*Primula*) and the contrasting shapes of the primroses, *Hosta*, and the surrounding plants draw the eye to this point of interest. Such planting shows that the gardener has a very good grasp of how plants relate to each other visually.

• COLOR IN THE GARDEN •

175

overall design and layout of the garden. The background planting of trees, shrubs, and hedges, or structures such as walls and fences, are important. The areas of sunlight and shade also have great effect on the color.

Certainly it is easier to put color into a garden if there is a framework of greenery into which it can be placed. A garden full of color and nothing else will look too brash and overpowering; it certainly will not have a tranquil effect. Greenery can be used to separate contrasting colors and to act as a break between different parts of the design. Some colors, particularly the paler ones, are shown off better against a green background.

One of the basic considerations when using color for any purpose is the question of contrast and harmony. The spectral colors can be arranged in a circle (known as a color wheel). Opposite colors on the wheel are known as complementary colors: red and green, yellow and violet, and blue and orange are examples. If these are placed next to each other, the eye has to rapidly adjust and the result is a sense of restlessness. Adjacent colors on the wheel are much more harmonious to each other. They share certain pigments and blend together easily.

The implications of this to gardeners are enormous. If plants with flowers of complementary colors are planted together, they will decidedly stand out from one another. The sudden change almost seems like a period in a sentence. If these color patterns are repeated down a border, the result is quite disturbing to the eye, as it keeps readjusting from one color to the other. This makes the border appear very restless.

On the other hand, flowers with colors adjacent to each other on the wheel blend in well together, allowing the eye to make a natural transition from one to the next. This is why it is recommended that the gentle transitions of adjacent colors be used as the foundation of the border, with complementary colors acting as focal points or sudden points of interest to stop the viewer here and there.

Another important aspect of color to remember is that some colors are considered warm and others cool. The reds, yellows, and oranges are the warm colors and the blues, grays, and violets the cool ones. Some of the warm colors are positively hot. These work particularly well in the bright light of hotter climates, but in the duller northern light they have to be handled with care, otherwise they can become garish. The cool colors lose their impact in the brighter light of southern gardens but come into their own

in duller, more northerly light.

The warm colors engender a sense of excitement to a border; by contrast, the cooler colors tend to give a feeling of tranquility and peace. Both these feelings can be capitalized upon when drawing up the color scheme for the garden. Warm colors advance and cool ones recede. If pale blue or gray flowers are planted at the end of a border, the border will appear to be longer than it actually is. Conversely, one planted with hot reds or oranges will advance and seem shorter.

The use of color must inevitably become a question of trial and error. There are very few, if any, gardeners who can carry around in their heads the precise color of all the plants they are likely to use. When the plants flower there are bound to be those that need moving because the colors do not quite go together and they will sit more happily elsewhere in the border.

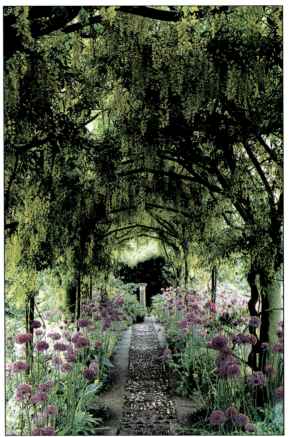

Above: A good example of contrasting colors from opposite sides of the color wheel and contrasting shapes and forms of the globular and pendant flowers.

Even those gardeners who can remember the colors of each and every flower know that in the actual garden there is no such thing as a precise color. The latitude of the garden, the time of day, and the soil type will all affect the appearance of

a color. Moreover, the color of one plant will be affected by the color of its neighbor. A dull color is likely to enliven a brighter one, for example.

This can all begin to get very technical and bewildering, but there are thousands of beautiful gardens out there that are either deliberately or accidentally following the basic rules of color. Look at other gardens and see where and why they are successful. At home, draw out plans and color schemes on paper, then follow these plans in the border. Chances are your plans will need revisions of some kind, but then again, that is what learning is all about.

HOT COLORS

Hot colors include the bright reds through scarlet to orangey red, on to orange, and finally to orangey yellow. These bright colors should be used sparingly, as the eye will tire of them quickly. They can be used where the mood needs enlivening or where emphasis is needed. Use them in bright sunshine, not in shade, where their colors will be muted. A tracery of sunlight on them can be effective.

Suggestions for some of these hot-colored flowers are listed on page 180, as they are more difficult to find than cool-colored ones.

THE COLOR WHEEL

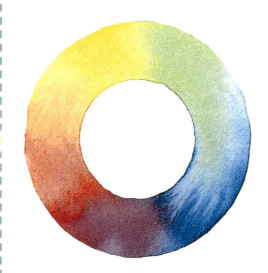

Colors on a color wheel sympathetically merge into one another as they pass around the circle. Colors that lie opposite each other are contrasting and should be used in adjacent positions with care.

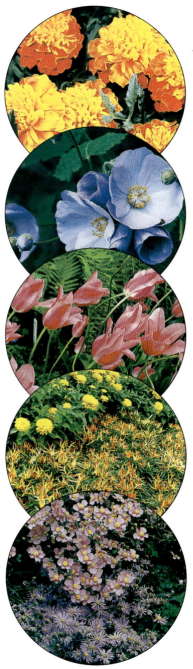

The hot colors of the marigold (*Tagetes*) 'Butterscotch' would blend in with other similar colors such as the *Capsicum* (second from bottom). They could also be used as strong contrast by placing them next to blue flowers.

If strong, blue can be a startling color or, if pale, soft and quiet. Blue is a difficult color, as one of its partners is green, which is a foliage rather than flower color. Its opposite color is orange, with which it can form some very vivid contrasts.

Pinks are always difficult colors to match; they tend to go best with mauves and other pastels. They impart an air of softness to a border and are seen in their greatest contrast, as here, against green.

The yellow of the *Zinnia* 'Gold Sun' blends well with the orange of the pods of the *Capsicum* but would contrast rather badly with the pink of the tulips (*Tulipa*).

Mauve sits next to pink on the wheel and is happiest with it in the garden. A startling contrast can be made by planting some bright yellow from the opposite side of the wheel with it.

• COLOR IN THE GARDEN •

RED FLOWERS	ORANGE FLOWERS	YELLOW FLOWERS
Antirrhinum	Antirrhinum	Achillea
Astilbe	Anthemis	Alyssum saxatile
Canna	Campsis radiacans	Anthemis
Chaenomeles	Canna	Antirrhinum
Cheiranthus	Cheiranthus	Calceolaria
Crocosmia	Calendula	Calendula
Curtonus	Crocosmia	Canna
Dahlia	Curtonus	Cestrum aurantiacum
Desfontainea	Dahlia	Cheiranthus
Eccremocarpus scaber	Eschscholzia	Coreopsis verticillata
Embothrium coccineum	californicum	Crocosmia
Fuchsia	Euphorbia griffithii	Dahlia
Geum	*Dixter* and *Fireglow*	Eschscholzia
Helianthemum	Fritillaria imperialis	californicum
Impatiens	Gazania	Fremontodendron
Lobelia cardinalis	Helianthemum	californicum
Lonicera x brownii	Hemerocallis	Genista cinerea
Lychnis chalcedonica	Impatiens	Geum
Monarda didyma	Kniphofia	Helenium
Paeonia	Ligularia	Helianthus
Papaver	Lilium	Hemerocallis
Pelargonium	Papaver	Inula
Penstemon	Potentilla fruticosa	Kniphofia
Phlox	*Red Ace* and	Ligularia
Potentilla (*herbaceous*)	*Tangerine*	Rhododendron (*Azalea*)
Rosa	Rhododendron (*Azalea*)	Rudbeckia
Salvia	Rosa	Rosa
Tropaeolum	Tagetes	Tagetes
Tulipa	Tropaeolum	Tropaeolum
Zauschneria californica	Tulipa	Tulipa

Foliage Color

Flowers are not the only providers of color in the garden; foliage also contributes a great deal of color.

In a garden context, green is not usually considered a color, but it has a great influence on what we see. The number of different greens that make up the overall impression is staggering. In particular, the spring produces a great variety of fresh greens. These tone down to a medium green in the summer and by fall they are quite dull before they take on the colored tints and drop. Even evergreens change with the seasons. The liveliness of the new evergreen growth is partly due to the shiny surface of the leaves, which reflects the light, and partly due to the emerging leaves being paler, as they have not taken up their complete fill of chlorophyll.

Green should not be ignored as a color. It acts particularly as a foil for

Golden evergreen foliage provides a splash of color even on the dullest winter days, giving the impression of perpetual sunshine. Care must be taken in blending them.

other colors and can create barriers between colors that would otherwise clash. A garden without green is a restless garden; green helps calm the eye.

There are other foliage colors besides green. Silver foliage and gray foliage are quite common. These, in many ways, have the same effect in gardens as green does in calming down the fussiness of too much color. They are particularly useful for cooling down hot colors, and they are equally at home as a foil for the softer pinks and blues. Gray and silver are recessive colors and if planted at the end of a border will make it seem further away. Very few gray- or silver-leaved plants will tolerate shade, so they are best planted in an open border.

• COLOR IN THE GARDEN •

181

Here is a wonderful contrast in foliage color from a group of *Acer*. As dramatic as they are, such contrasts should not be repeated too often because they can become visually uncomfortable and tiring to the eye.

Some plants have foliage that is almost red or purple, but a close examination will show that there is an element of green in the leaves as well. Many plants that have red leaves are at their brightest in the spring when their leaf chlorophyll (which is responsible for the green color in them) is still building up. If planted in a position where the sun can shine through the leaves, the foliage will often glow with a wonderful brilliance.

A garden planted entirely with red or purple plants would be very heavy and surprisingly dull,

especially where it is not a natural foliage color. These warm colors are best used as contrast to greens or as accents. In small quantities they can be used to enliven a border. They have a tendency to intensify the hot colors of flowers and act as a good background to many other colors, especially the pale ones. Most purple plants appreciate a sunny position.

Red is also a color of fall, and many green-leaved plants put on a brilliant red show just before they drop their leaves. Such shows are usually so powerful that they stand in their own right. Some gardens are specifically planted for this time of year with drifts of colors: red, bronze, gold, and yellow. Again, drifts look better than a dotted arrangement, although the occasional accent tree with a particularly strong color does not go amiss.

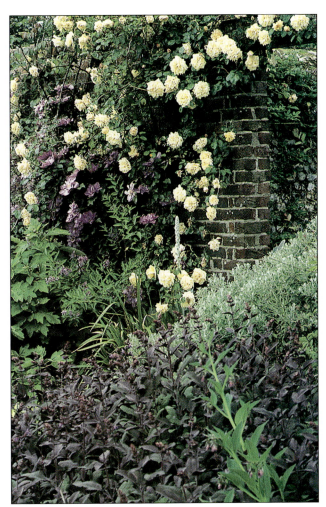

Here is a fine combination of silver and purple foliage that is echoed by the flowers on the wall. Companion planting of this nature gives great pleasure.

• COLOR IN THE GARDEN •

Yellow or gold foliage plants add a lightness to a garden. As with red foliage, it would be wrong to plant the whole garden with these colors, but used with discretion they are marvelous at illuminating a dark corner. They look especially good against dark backgrounds such as conifers. In turn, yellow or gold foliage is difficult to use as background for other plants. Unfortunately, nearly all yellow-foliaged plants scorch badly in the sun, so they really need some shade, especially from the strong midday sun. But since they look best brightening up a shady position, this is no real hardship.

Variegated-leaved plants are undergoing a revival at the moment. These are plants whose leaves have patches, stripes, or spots of color different from the usual base one of green. The extra color can be silver, yellow, or purple. Sometimes, for example, in *Houttuynia cordata* 'Chameleon' or *Salvia officinalis* 'Tricolor', there is more than one other color present.

For all their popularity, variegated plants are difficult to relate to other plants. Again, they are good for lightening up a dull spot or a mass of greenery. They are especially good on rainy, dull days when they give the garden a touch of artificial sunlight. The brightest variegations occur if the plant is in full sun, and unlike their all-yellow relations, they do not generally scorch in the sun.

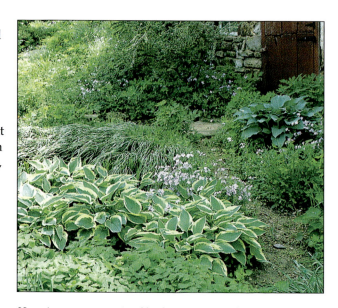

Hosta is a very companionable plant; it seems to fit into any planting design. The shape and texture of its leaves always adds interest to a border, as does its color. The variegated ones always help to brighten a dull corner.

PURPLE-LEAVED PLANTS

Purple-leaved plants are increasing in popularity. They can be used to dramatic effect in a border but should never be overdone, because the border or garden will take on a dull, flat appearance.

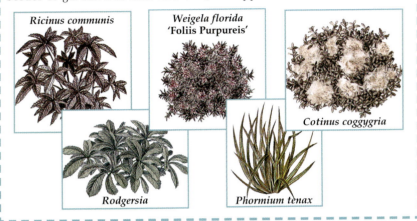

Ricinus communis

Weigela florida 'Foliis Purpureis'

Cotinus coggygria

Rodgersia

Phormium tenax

VARIEGATED-LEAVED PLANTS

Variegated-leaved plants add a bright touch to a border, particularly in the winter. Care should be taken not to place too many together, and color clashes should be avoided.

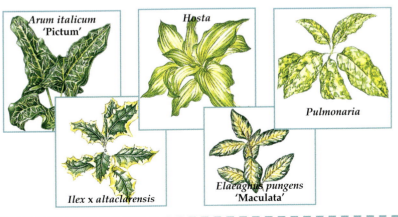

Arum italicum 'Pictum'

Hosta

Pulmonaria

Ilex x altaclarensis

Elaeagnus pungens 'Maculata'

• COLOR IN THE GARDEN •

Single-Color Schemes

Many gardeners have been inspired by the well-known English gardens at Sissinghurst in Kent and at Hidcote Manor in Gloucestershire to produce gardens of a single color.

Calling them single-color gardens is not quite accurate, for while the basic flower color is restricted to one color, the foliage adds another dimension, rather like one-color printing in which the color of the paper must also be taken into account. Thus, the red borders at Hidcote Manor have red flowering plants backed with green and purple foliage, and at Sissinghurst the famous white garden contains flowers of that color along with green, gray, and silver foliage.

Making an entire garden or even a border of a single color is not an easy task. To keep the garden interesting, a great deal of care must be given to the shapes and textures of the plants. Grading the colors is critical, too. It is surprising, for example, how many different

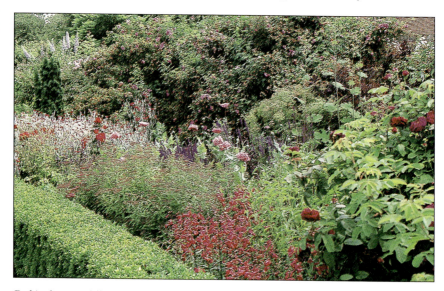

Red is always a difficult color to place in a garden. Creating a whole border devoted to this color presents a real challenge. But when the relationship between the plants works, as here, there is cause for great satisfaction.

shades of white there are and what difficulty there is in arranging them in a pleasing manner. In a white garden, flowers with a touch of green (a cool color) can work in well, but those that might have a bit of pink (a warm color) in them must definitely be left outside the garden gate. White is essentially a cold color, and any hint of a warm one will disturb the scheme.

It is often a good idea to relieve what can become a monotony of one color by adding touches of another color to it. This can be done dramatically by, for instance, using *Lobelia cardinalis* as an accent in a white garden, where it would look like a slash of blood, or it can be more subtle, as at Sissinghurst, where silver foliage adds a gentler effect. In the Red Borders at Hidcote Manor, orangey yellow in the form of *Hemerocallis* has been planted to act as punctuation throughout the borders.

Gardens of one color, particularly the pale or cool colors, tend to be very restful. Two colors tend to be more lively, and a mixture of white and yellow, for example, can be quite thrilling, particularly if reflecting water is involved.

A true monochrome garden can be created entirely out of green foliage. These can look most effective around modern buildings, perhaps with one dash of color. Ivy can be used to great effect in such gardens, scrambling over the ground as well as up and over structures.

The size of such single-color schemes can vary from a whole garden to one border, or just an odd corner. In the case of a border or a corner, foliage in the form of shrubs or a hedge can divide the single-color scheme from other plantings.

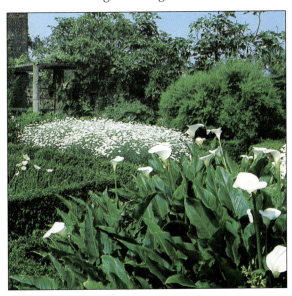

White gardens are the most popular of those devoted to a single color. Gray and green foliage are used as foils.

• COLOR IN THE GARDEN •

187

Successional Planting

At its simplest, successional planting in the flower garden means relating plants to each other so that there is a maximum of color and interest in the garden throughout the year.

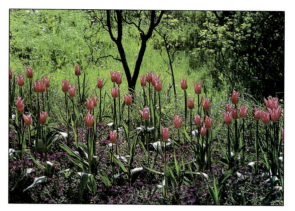

A dark *Aubrieta* forms a wonderful background to these pink tulips (*Tulipa*). Later, the ground will be taken over by completely different flowers.

In many of the larger gardens in former, grander times, it was not unusual to find successional planting of sorts achieved through a series of subgardens. These were individual gardens, each planted specifically to show off the flowers of one particular season. Subgardens would be visited and admired in their due season and then ignored for the rest of the year. Although winter gardens can still sometimes be found, filled with winter-flowering plants or plants that have striking colored bark or evergreen foliage, seasonable gardens are now rare. That is because they are almost impossible to establish in anything but the largest gardens where space, time, and money are not limited.

In addition to being extravagant, such subgardens cannot take advantage of all the benefits of well-planned successional plantings. As in the vegetable garden, when compatible plants that mature at different times are grown together in one garden, the ground stays covered at all times of the year. This helps to control weeds, and it helps to keep the soil from drying out in dry weather and from eroding during heavy rains. It also allows you to grow and enjoy the maximum number of plants in a given garden space.

For effective successional planting, lay out your flower borders in such a way that adjacent plants flower at different times of the year. For example, the neighbors

to the winter-flowering hellebores (*Helleborus orientalis*) could be the bleeding heart (*Dicentra spectabilis*) for spring, *Penstemon* for summer, and *Aster novibelgii* in the fall. Depending on what varieties you choose, they could all be red or reddish purple or even white, giving a continuity of color in that part of the border. While hellebores are in bloom, the others would be just emerging. Hellebores appreciate some shade from the hot summer sun and the other plants would tower over them in turn, giving them the protection they need.

In that example, the plants would be grown next to one another. An even closer form of successional planting can be achieved by underplanting. Here bulbs are planted very close to herbaceous plants or under low shrubs. In the first instance, daffodils (*Narcissus*) might be planted next to a *Geranium pratense*. The daffodil comes up and blooms, and as it dies back the shriveling foliage is covered by the geranium as its growth speeds up in the late spring.

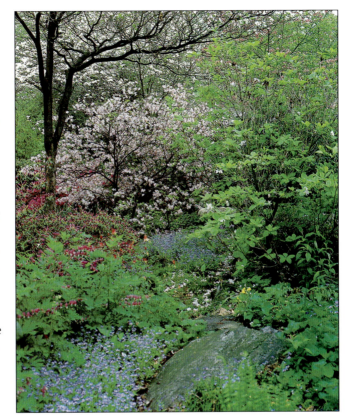

This lightly shaded border is a veritable jungle of spring flowers. As the year progresses the image will drastically change; different plants will spring up to produce flowers that will replace those seen here.

• COLOR IN THE GARDEN •

189

Snowdrops (*Galanthus*) can be used to grow through low-growing shrubs such as heather (*Erica*), which generally looks fairly dull when the snowdrop is in bloom but comes into its own when the snowdrop dies back. Bulbs are not confined to spring. Lilies (*Lilium*) can be interplanted with herbaceous or shrubby plants, the summer bulb itself appreciating the cool situations provided by the foliage of other plants. Similarly, montbretia (*Crocosmia*), which generally blooms in late summer, can be planted in between other plants.

Shady areas are more difficult to keep in bloom throughout the year, but foliage alone can provide a great deal of interest.

Floppy plants can be of use later in the season to cover up holes left by other plants. For example, the Oriental poppy (*Papaver orientalis*) looks messy when the flowers die back. It can be cut to the ground and a clambering plant such as *Lathyrus latifolius* can be allowed to sprawl over its place.

Climbing plants can be used to provide color for trees or shrubs that have flowered earlier in the season. It is possible to run two or more climbers together, each having a different flowering period. Climbers need not always climb; they can be allowed to scramble over a dull ground cover or even over herbaceous plants that have finished flowering, as mentioned above.

There are several other ways of filling gaps left by vegetation that has died back. One way is to plant annuals in its place. This involves preparation, since the annuals should be sown at the right time so that they will be mature and flowering when neighboring plants are spent. Another way is to actually move new plants into position. For example, many of the herbaceous plants with fibrous roots, such as Michaelmas daisies (*Aster novi-belgii*), can be moved when they are in full bloom if they are given a good soaking prior to transplanting. The asters can be lined out in a spare piece of ground,

This vertical garden brightens the front of a house with a wonderful splash of color. By using pots and bringing in new plants to replace those that fade, the display can be kept up all through the summer. Great attention must be given to watering, particularly the clay pots, which could need watering several times a day during very hot spells.

• COLOR IN THE GARDEN •

perhaps at the back of a border. Water them several hours before moving and then dig them up, leaving good rootballs of soil on the plants. They can be moved into prepared holes and again watered. If done carefully the plants will not notice the move. You could also grow a number of plants in quite large pots. When needed the pot can be plunged in the garden soil so that the soil covers the rim, giving the impression that the plant has been there all the time.

In the following pages there are flowers in groups of colors. It is important to note that only a few examples of flowers have been chosen for this section, as there are so many to choose from.

Flowers in Pink

Pure pinks are a blend of true primary red and white, but the range of colors we call pink is much greater.

The cooler blue-pinks eventually merge into lilac and the warmer yellow-pinks into soft peach. Generally speaking, pinks at these extremes do not sit well next to each other in the border. Bright salmon-pinks are often difficult to place, but they look good when surrounded by cool shades—white, clear blue, and lime-green. It used to be a cardinal sin to mix pink with yellow, but salmon-pinks can look stunning with the right yellow. It's just a matter of experimentation!

Soft pinks are gentle on the eye and help to create a restful and harmonious effect in the garden.

What's more, pink borders are relatively easy to create and can look beautiful when set against the simple backdrop of a clipped evergreen hedge. Watch out for brick and terra-cotta, however. Orange and pink really do shout at each other!

Pink makes a romantic statement when blended with diaphanous white flowers and silver filigree foliage. Blue-pinks blend perfectly with light purples and blue for a pastel effect. But try not to get carried away or you might end up with an insipid scheme lacking in depth. Sprinkle in glowing cerise or deep velvety crimson for contrast.

Latin name: *Camellia x williamsii* 'Bow Bells'
Common name: Known by Latin name
Alternatives: 'Donation', 'November Pink'
Description: Evergreen shrub with oblong to lance-shaped, glossy green leaves and rose-pink, semidouble, funnel-shaped blooms over long period.
Height and spread: 10 x 10 ft.
Blooming period: Late fall to early spring
Soil: Acid, humus-rich, moisture retentive

Latin name: *Paeonia suffruticosa* 'Duchess of Kent'
Common name: Peony
Alternatives: 'Sarah Bernhardt', 'Madame Calot', 'Mons. Jules Elie'
Description: Herbaceous perennial with large, glossy dark green leaves that are deeply divided. Bowl-shaped, semidouble blooms with serrated edges; new shoots deep red in spring. Needs support.
Height and spread: 28 x 28 in.
Blooming period: Late spring to early summer
Soil: Rich, well-drained but moisture-retentive

Latin name: *Clematis* 'Nelly Moser'
Common name: Large-flowered clematis
Alternatives: 'Bees Jubilee'
Description: Climber with large, striped blooms—deeper pink on pale mauve-pink. Prune immediately after flowering. A lesser flowering in early fall may occur. Needs support.
Height and spread: 11 x 3 ft.
Blooming period: Early summer (possible repeat early fall)
Soil: Moisture-retentive; plant several inches deep in case of wilt

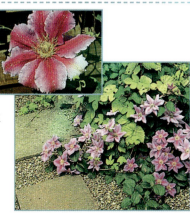

• COLOR IN THE GARDEN •

Latin name: *Centaurea hypoleuca* 'John Coutts'
Common name: Knapweed
Alternatives: *C. dealbata* 'Steenbergii'
Description: Perennial with flowers having thistlelike centers surrounded by rings of showy ray florets. Leaves soft gray-green with gray-white downy undersides, deeply lobed. Silvery seed heads.
Height and spread: 2 x 1½ ft.
Blooming period: Early summer to early fall
Soil: Free-draining, does well on poor soils, including limey

Latin name: *Matthiola icana*
Common name: Stock
Alternatives: Ten-week stocks, e.g., 'Appleblossom'
Description: Biennial with broad, fleshy gray-green leaves and spikes of fragrant double flowers. Sow outdoors in early summer, prick out into pots to overwinter in a cold frame, and plant out in spring.
Height and spread: 1½ x 1 ft.
Blooming period: Early summer
Soil: Any well-drained; good on limey soils

Latin name: *Cosmos bipinnatus* Sensation series
Common name: Known by Latin name
Alternatives: 'Seashells Mixed', 'Picotee', 'Daydream'
Description: Half-hardy annual with ferny foliage and large, dish-shaped blooms on straight stems. For earlier bloom, start indoors in early to mid-spring and plant out once risk of frost has passed.
Height and spread: 3 x 2 ft.
Blooming period: Early summer to early fall
Soil: Moisture-retentive but well-drained

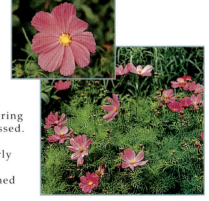

Latin name: *Osteopermum jucundum* syn. *O. barberiae*
Common name: Known by Latin name
Alternatives: *O. j. compactum*, O. 'Stardust'
Description: Evergreen perennial/subshrub making dense mats of foliage topped with daisylike flowers that remain closed on dull days. Ideal ground cover for dry banks and the front of sunny borders.
Height and spread: 1 x 1 ft.
Blooming period: Summer to fall
Soil: Any well-drained, tolerating drought

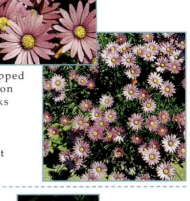

Latin name: *Hibiscus rosasinensis* 'The President'
Common name: Rose of China, Chinese hibiscus
Alternatives: 'Flower Girl', 'Mrs. George Davis'
Description: Evergreen shrub of bushy habit with broad, tapering glossy green leaves that have a toothed edge. Large funnel-shaped blooms of mid-pink with a prominent column of stigma and stamens.
Height and spread: 5–10 x 5–10 ft.
Blooming period: Spring to fall
Soil: Fertile, well-drained

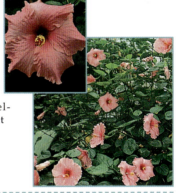

Latin name: *Hydrangea macrophylla* 'Lilacina'
Common name: Lacecap hydrangea
Alternatives: 'Teller Rosa', 'Beauté Vendômoise'
Description: Shrub with large, oval leaves coming to a sharp point and heads composed of tiny inner fertile flowers (blue-purple) surrounded by showy sterile flowers (mauve-pink on alkaline soils).
Height and spread: 6 x 8–10 ft.
Blooming period: Summer to early fall
Soil: Fertile, humus-rich, and moist; acid makes flowers mauve-blue

• COLOR IN THE GARDEN •

Flowers in Orange

Ranging from pale buff shades to rusty browns, the color orange takes in subtle hues like peach, apricot, and amber, as well as pure tangerine and intense — some would say garish — oranges epitomized by marigolds.

COLOR MATCHING HANDBOOK

In the gentle light of fall, all shades of orange, whether leaf, berry, or bloom, seem to glow. At this time blue and purple flowers add a richness that is impossible to appreciate in summer light.

Green is a natural foil for orange. If you want to avoid dazzling yourself in summer, it's wise to have quite a high proportion of leafy luxuriance to cool everything down. Sky blue and lime green will also do the trick. Bronze and purple-green foliage complement true orange well. Purple-black leaves can be too harsh a contrast, and, though popular, bright silver can also be a mistake.

Blue-gray or blue-green leaves tend to make a good partnership. Predominantly orange color schemes, perhaps with touches of scarlet and gold, convey dry, dusty heat. Terra-cotta works well in such a planting in the form of decorations, containers, or sculpture and red brick makes a very suitable backdrop. For a really rich, modern scheme, try vivid light and dark orange shades with purple-blue and blue-gray foliage accented with deep velvet-purple and royal blue blooms. There are many quick and easy orange annuals to choose from, so experiment.

LATIN NAME: *Lilium* 'Rosefire'
COMMON NAME: Hybrid lily
ALTERNATIVES: 'Enchantment'
DESCRIPTION: Bulb with stems clothed in lanceolate leaves. Toward the stem tips are upward-facing, star-shaped blooms that are orange-red with yellow throats. As many as twenty blooms per stem.
HEIGHT AND SPREAD: 3 ft.
BLOOMING PERIOD: Early summer
SOIL: Fertile, well-drained, humus-rich

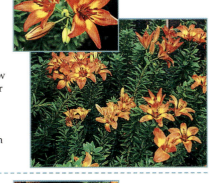

LATIN NAME: *Tagets erecta* variety
COMMON NAME: African marigold
ALTERNATIVES: F1 hybrid series, e.g., Marvel, Perfection, Inca, Zenith
DESCRIPTION: Half-hardy annual of stiffly erect habit with large, deeply divided, dark green leaves and globular flower heads. Even with the sterile Afro-French marigolds it is best to deadhead.
HEIGHT AND SPREAD: 18–36 x 18 in.
BLOOMING PERIOD: Summer
SOIL: Any well-drained

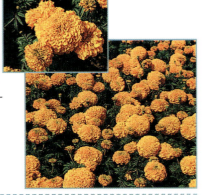

LATIN NAME: *Lilium* 'Enchantment'
COMMON NAME: Hybrid lily
ALTERNATIVES: Hybrid lilies, e.g., Mid-century hybrids, Bellingham hybrids
DESCRIPTION: Bulb with upward stems well-clothed in lanceolate leaves and topped by large, clear orange, star-shaped blooms with reflexed petals. Darker speckling and dark, contrasting anthers.
HEIGHT AND SPREAD: 2–3 x 1 ft.
BLOOMING PERIOD: Summer
SOIL: Fertile, humus-rich, well-drained

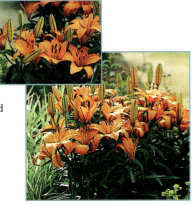

• COLOR IN THE GARDEN •

LATIN NAME: *Zinnia* 'Peter Pan' series
COMMON NAME: Known by Latin name
ALTERNATIVES: 'Star' series, 'Hobgoblin'
DESCRIPTION: Dwarf-growing zinnia with richly colored, fully double blooms on stiff, upright stems. Oval to lance-shaped leaves. Susceptible to mildew.
HEIGHT AND SPREAD: 10 x 6 in.
BLOOMING PERIOD: Mid-summer to mid-fall
SOIL: Well-drained but humus-rich

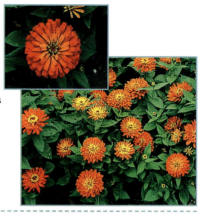

LATIN NAME: *Crocosmia* hybrids
COMMON NAME: Monbretia
ALTERNATIVES: 'Severn Sunrise', 'Emily McKenzie', 'Jackanapes'
DESCRIPTION: Bulbous plant spreading beneath soil surface to form large clumps. Broad, grassy leaves and arching spikes of tubular flowers widely flared at the mouth. Needs frequent division.
HEIGHT AND SPREAD: 24 x 9+ in.
BLOOMING PERIOD: Summer to late fall, depending on cultivar
SOIL: Any moisture-retentive; dislikes very heavy clay

LATIN NAME: *Dahlia* cultivar
COMMON NAME: Cactus or semicactus dahlia
ALTERNATIVES: 'Biddenham Sunset', 'Highgate Torch', 'Melissa'
DESCRIPTION: Tender tuberous perennial with oval leaflets and tall, branched stems bearing double flowers with long, pointed petals. In cold regions, lift after first frost, cut down stems, and store tubers.
HEIGHT AND SPREAD: 3–4 x 3–4 ft.
BLOOMING PERIOD: Midsummer to fall
SOIL: Fertile, well-drained, humus-rich, and moisture-retentive

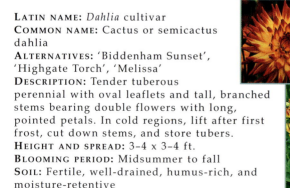

Flowers in Green

When designing color schemes, we hardly give a second thought to green. It is the most common color in the garden, and, as such, the easier to ignore.

When you begin to look at foliage in its own right, you discover a wealth of shades. Rich greens make the perfect foil for most flower colors, especially those at the red end of the spectrum. Green leaves can be tinged orange, pink, red, or purple, and they can be distinctly glaucous or blue. Green mixed with yellow gives brilliant lime or acid shades. When a green leaf is covered with a white bloom, waxy coating, tiny hairs, or wool the overall color ranges from grays through silver to almost white. White- or yellow-variegated leaves introduce another huge selection of foliage variants. In fact, when you consider the tremendous range of foliage color and pattern, form, and texture, you could easily plant a colorful and interesting border without using flowers. Look under the different colors for additional plants.

Green foliage is particularly important in shade, where flowers tend not to perform so well. Here, the lime-green, all-yellow, and yellow-variegated foliage of herbaceous plants and deciduous shrubs creates the effect of dappled light. Add some white flowers and create a scheme of cool elegance. Green flowers are relatively rare, as they tend not to be seen by pollinating insects.

• COLOR IN THE GARDEN •

Latin name: *Euonymus fortunei* 'Emerald 'n' Gold'
Common name: Known by Latin name
Alternatives: 'Blondy', 'Sunspot', 'Golden Prince', 'Sunshine'
Description: Dwarf evergreen shrub making excellent ground cover. Grows taller if trained against a low wall. Glossy oval leaves broadly margined golden yellow. Pinkish red tints in winter cold.
Height and spread: 2 x 6 ft.
Blooming period: Insignificant
Soil: Any well-drained

Latin name: *Asplenium scolopendrium* syn. *Phyllitis scolopendrium*
Common name: Hart's tongue fern
Alternatives: Crispum group, Cristatum group
Description: Evergreen fern with long, undulating, strap-shaped leaves. Easily grown provided it has adequate moisture and shade, making an excellent contrast with cut-leaved ferns and other foliage plants.
Height and spread: 12 x 12 in.
Blooming period: None
Soil: Well-drained, humus-rich, and moisture-retentive

Latin name: *Chamaecyparis pisifera* 'Golden Map'
Common name: Known by Latin name; also Japanese false cypress
Alternatives: *C.p.* 'Filifera Nana'
Description: Dwarf evergreen conifer of spreading, moundlike habit with threadlike pendulous stems covered in golden-green leaves. Seen to best advantage when allowed to cascade over an edge.
Height and spread: 2 x 3 ft.
Blooming period: None
Soil: Well-drained

LATIN NAME: *Adiantum raddianum*
COMMON NAME: Delta maidenhair fern
ALTERNATIVES: 'Fritz Luthi' and many others
DESCRIPTION: Semievergreen or evergreen fern with delicate, highly dissected fronds with very small, triangular leaflets. The stems are fine, wiry, and purple-black in color. Requires shelter. Remove fading fronds.
HEIGHT AND SPREAD: 12 x 12 in.
BLOOMING PERIOD: None
SOIL: Neutral to acid, humus-rich, moisture-retentive

LATIN NAME: *Salvia officinalis* 'Icterina'
COMMON NAME: Golden-variegated sage
ALTERNATIVES: None
DESCRIPTION: Evergreen or semievergreen perennial of domed habit with lance-shaped, gray-green, aromatic leaves, splashed light green and gold. Small purple-blue blooms.
HEIGHT AND SPREAD: 2 x 3 ft.
BLOOMING PERIOD: Summer
SOIL: Any well-drained, preferably alkaline

LATIN NAME: *Zantedeschia aethicopica* 'Green Goddess'
COMMON NAME: Arum lily, lily of the Nile
ALTERNATIVES: *Z. aethiopica* 'Crowborough'
DESCRIPTION: Herbaceous perennial with deep green, broad, arrow-shaped leaves. Upright stems carry green spathes with a white throat that are lovely for flower arranging but need a contrasting backdrop.
HEIGHT AND SPREAD: 1½–3 x 1½–2 ft.
BLOOMING PERIOD: Summer
SOIL: Fertile, humus-rich, and moisture-retentive to moist; mulch heavily

• COLOR IN THE GARDEN •

Flowers in Red

In nature, red is a warning sign and signifies danger. Bright red blooms are particularly attention-grabbing, especially when used sparingly against a green backdrop.

Red is also the color that partially sighted people find easiest to discern.

We associate red with strong emotions—fiery passion, love, and anger—so this is not a color to use exclusively if you want to create a restful and calming scheme. When we think of the reds of romance and valentines, these tend to be the velvet reds, crimsons, and wine colors of roses and other blooms at the blue end of the scale. Bright, clear reds coupled with rich greens suggest the Orient or tropical rain forests. In the Northern Hemisphere, red winter berries along with white blooms and glossy green foliage bring to mind the festive season.

Blue-reds work well with other cool colors like deep blue, purple, silver, white, or pale lemon-yellow to give quite an old-fashioned look. In contrast, warm orange-reds combined with pure blues, golden yellows, clear oranges, white, and lime-green produce fresh, vibrant, and modern-looking schemes. Given a foil of deep-purple foliage and flower, you can successfully combine all shades of red—the bright reds adding a welcome vibrancy.

Latin name: *Papaver orientale* var. *bracteatum*
Common name: Oriental poppy
Alternatives: 'Goliath' group
Description: Herbaceous perennial with hairy, deeply divided foliage. Thick stems bear bowl-shaped flowers with central knob that becomes the "pepper-pot" seed head. Foliage dies by midsummer.
Height and spread: 3–4 x 1–3 ft.
Blooming period: Late spring to early summer
Soil: Any well-drained to dry and reasonably fertile

Latin name: *Rosa* 'Precious Platinum' (syn. 'Opa Potschke', 'Red Star')
Common name: Large-flowered (hybrid tea) bush rose
Alternatives: 'Alec's Red', 'Deep Secret', 'My Love', 'Royal William'
Description: Rose of bushy habit with glossy leaves and very large, well-shaped double blooms in bright red. Very slight scent. Deadhead to prolong flowering and prune hard in spring.
Height and spread: 36 x 26 in.
Blooming period: Summer to fall
Soil: Rich, moisture-retentive; does well on clay

Latin name: *Rosa* 'Eye Paint' syn. 'Maceye', 'Tapis Persan'
Common name: Dwarf shrub rose
Alternatives: 'Phantom'
Description: Shrub of dense habit, well covered in dark foliage. Striking single blooms (scarlet-red with a white "eye") in large clusters. Little scent.
Height and spread: 40 x 30 in.
Blooming period: Summer to early fall
Soil: Rich, moisture-retentive. Does well on heavy soils, e.g., clay

• COLOR IN THE GARDEN •

Latin name: *Lychnis chalcedonica*
Common name: Maltese cross, Jerusalem cross
Alternatives: 'Red Tiger'
Description: Herbaceous perennial with upright stems carrying cross-shaped flowers of brilliant scarlet. Best given a spot sheltered from wind. The strong color needs careful placing.
Height and spread: 3–4 x 1 ft.
Blooming period: Midsummer
Soil: Rich, moisture-retentive, but well-drained

Latin name: *Salvia splendens* variety
Common name: Scarlet sage
Alternatives: 'Lady in Red', 'Vanguard', 'Maestro', 'Scarlet King'
Description: Tender evergreen subshrub normally grown as a half-hardy annual bedding plant with fresh green oval leaves and spikes of tubular, bright scarlet blooms. Pinch out the seedlings to induce branched habit.
Height and spread: 12 x 8–12 in.
Blooming period: Summer to fall
Soil: Well-drained

Latin name: *Knautia macedonica* syn. *Scabiosa rumelica*
Common name: Known by Latin name
Alternatives: None
Description: Herbaceous perennial with a basal rosette of deeply divided leaves. Wiry, divided stems. Each branchlet tipped with pincushion-shaped bloom of deep crimson. Long-flowered.
Height and spread: 2 x 2 ft.
Blooming period: Summer
Soil: Well-drained

LATIN NAME: *Hemerocallis* 'Little Red Hen'
COMMON NAME: Daylily
ALTERNATIVES: 'Sammy Russel', 'Pardon Me', 'Siloam Red Ruby'
DESCRIPTION: Herbaceous perennial with flowers like trumpet lilies produced from cluster of buds at top of stem (each lasts a day). Arching foliage making dense mounds, attractive in spring.
HEIGHT AND SPREAD: 1½ x 2 ft.
BLOOMING PERIOD: Summer
SOIL: Fertile, moisture-retentive

LATIN NAME: *Tropaeolum majus* 'Hermine Grashoff'
COMMON NAME: Nasturtium
ALTERNATIVES: 'Red Wonder', 'Empress of India', 'Jewel Red'
DESCRIPTION: Trailing tender perennial with rounded pale green leaves and rich scarlet double blooms. Useful for containers and to cascade over the edge of a raised bed. An annual in cold winter areas.
HEIGHT AND SPREAD: 9 x 18 in.
BLOOMING PERIOD: Summer to early fall
SOIL: Well-drained, not too rich

LATIN NAME: *Dahlia* 'Aylett's Gaiety'
COMMON NAME: Known by Latin name
ALTERNATIVES: 'Bishop of Llandaff'
DESCRIPTION: Tender tuberous perennial with purple foliage divided into jagged leaflets. Contrasting red flowers, flattened semidouble with broad, rounded petals and a center of yellow stamens.
HEIGHT AND SPREAD: 3–4 x 3–4 ft.
BLOOMING PERIOD: Summer to fall
SOIL: Fertile, moisture-retentive, humus-rich, and well-drained

• COLOR IN THE GARDEN •

Flowers in White

White is a cool color. When sprinkled lightly among other shades, it can refresh and enliven a border without disturbing the balance.

In full sun, white flowers can dazzle with their brilliance—a point to remember if you're trying to create a restful scheme. In shade, white is unparalleled in its ability to raise a border out of the gloom. White glows magically in deep shade. Use it generously in a garden designed for evening entertainment or to line a path walked at twilight.

Since white is such an attention-grabbing shade, it can have a dramatic effect on perspective. White used at the end of a long, narrow garden will foreshorten the view, just as misty blues, purples, and grays will lengthen it. So, if you want to make the garden appear longer, keep white flowers and foliage nearer to the house.

White speaks to us of purity and innocence, but it is rarely pure and most often tinged with tiny amounts of apple-green, creamy yellow, or blush-pink. But it is a mistake to be too restrictive with your choice of plants in an all-white scheme, as you risk the end result feeling rather cold and lifeless. A smattering of other colors will add warmth and depth without spoiling the effect. In a sunny border, white flowers work wonderfully against a foil of silver, gray, and blue foliage.

Latin name: *Galanthus elwesii*
Common name: Snowdrop
Alternatives: *G. nivals, G. n.* 'Flore Pleno'
Description: Small bulb with narrow, strap-shaped leaves and slender stems bearing the dropperlike white buds that open to reveal the inner tube of petals. Faint honey scent.
Height and spread: 4–12 x 2–3 in.
Blooming period: Late winter to early spring
Soil: Humus-rich, moisture-retentive to moist

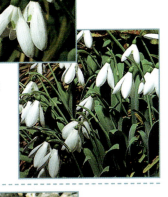

Latin name: *Magnolia stellata*
Common name: Star magnolia
Alternatives: 'Royal Star', 'Waterlily', *M. x loebneri* 'Merrill'
Description: Slow-growing, dense, rounded shrub that produces starry, white, fragrant blooms with strap-shaped petals on bare branches in spring. The deep green leaves are narrowly ovate.
Height and spread: 9 x 12 ft.
Blooming period: Early to midspring (from late winter in mild areas)
Soil: Fertile, humus-rich, moisture-retentive. Avoid extreme alkalinity

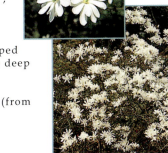

Latin name: *Leucanthemum x superbum* 'Phyllis Smith'
Common name: Shasta daisy, chrysanthemum
Alternatives: 'Bishopstone'
Description: Perennial with stout, upright stems topped with daisylike flowers with long-fringed petals and yellow centers. Divide and replant every two years to maintain flowering performance.
Height and spread: 3 x 1½ ft.
Blooming period: Early summer to early fall
Soil: Any fertile soil, provided it is well-drained

• COLOR IN THE GARDEN •

LATIN NAME: *Cistus ladanifer*
COMMON NAME: Gum rock-rose
ALTERNATIVES: 'Albiflorus', Palhinhae Group, 'Pat', 'Blanche'
DESCRIPTION: Evergreen shrub with flowers up to 4 in. in diameter and petals marked at base with maroon blotch. On hot, sunny days, the gum-exuding foliage releases a pleasant aroma.
HEIGHT AND SPREAD: 5 x 4½ ft.
BLOOMING PERIOD: Early to midsummer
SOIL: Any well-drained, including those with reasonably high alkalinity

LATIN NAME: *Aruncus dioicus*
COMMON NAME: Goat's beard
ALTERNATIVES: 'Glasnevin'
DESCRIPTION: Perennial forming 4 ft. high hummocks of large, fernlike leaves. The creamy-white flower plumes are more showy in the males, but female plants carry long-lasting ornamental seed heads.
HEIGHT AND SPREAD: 6–7 x 4 ft.
BLOOMING PERIOD: Early to midsummer
SOIL: Any reasonably fertile; growth more luxuriant on moist soil

LATIN NAME: *Yucca gloriosa* 'Nobilis'
COMMON NAME: Spanish dagger, moundlily yucca
ALTERNATIVES: *Y. gloriosa*, *Y. g.* 'Variegata'
DESCRIPTION: Shrub forming a rosette of dark green, sword-shaped leaves with sharp points. A stout flower stem bears pink-tinted buds that open creamy white. 'Nobilis' opens earlier than the species, avoiding frost damage.
HEIGHT AND SPREAD: 6 x 6 ft.
BLOOMING PERIOD: Late summer
SOIL: Well-drained, even dry

Flowers in Blue

True blue is quite rare in the world of garden plants. You're far more likely to come across a purple-tinged variant or a steely gray-blue than pure electric or sky blue.

So when you do catch sight of a pure blue flower or berry, you tend to notice it. However, blue is rarely a showstopping color like red or white. Plantings of soft mauve-blues and smoky grays evoke distant hills shrouded in mist. If you use these colors farther away from the house, it has the effect of visually extending the garden, making it appear longer.

Color schemes that use nothing other than shades of blue are difficult to design because there are relatively few plants to choose from that give continuity for much of the season. Added to this is the fact that all-blue schemes often end up looking flat and uninteresting. If you broaden your selection to include flowers of purple-blue with highlights of white, soft pink, crimson red, cerise, and velvet purple, you will have a much richer and more satisfying scheme that will be cool and calming. For foliage interest here, try mixing in white-variegated, silver, gray, and purple-leaved plants. True blues look stunning with the yellow, gold, and red shades of fall and fortunately there are quite a number of suitable plants to choose from at this time of the year.

COLOR IN THE GARDEN

LATIN NAME: *Cichorium intybus*
COMMON NAME: Chicory
ALTERNATIVES: None
DESCRIPTION: Herbaceous perennial, naturalized along roadsides in parts of the United States and Australia. Slender upright growth with clusters of sky blue daisy flowers that open after midday. Basal rosette of leaves.
HEIGHT AND SPREAD: 4 x 1½ ft.
BLOOMING PERIOD: Early summer to fall
SOIL: Any well-drained, especially limey

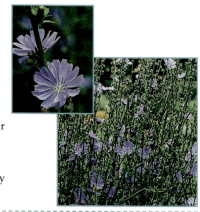

LATIN NAME: *Delphinium* 'Centurion Sky Blue'
COMMON NAME: Known by Latin name
ALTERNATIVES: 'Galahad', 'King Arthur', 'Dreaming Spires'
DESCRIPTION: Herbaceous perennial with divided leaves forming a rounded basal clump, from which several upright stems arise bearing spikes of blue, open flowers, each with a paler blue eye.
HEIGHT AND SPREAD: 5–6 x 2½–3 ft.
BLOOMING PERIOD: Summer
SOIL: Fertile, humus-rich, moisture-retentive

LATIN NAME: *Nigella damascena*
COMMON NAME: Love-in-a-mist
ALTERNATIVES: 'Miss Jekyll'
DESCRIPTION: Hardy annual with bright green leaves divided into hairlike segments. The sky blue blooms are followed by balloonlike seed pods turning brown, good for drying.
HEIGHT AND SPREAD: 24 x 8 in.
BLOOMING PERIOD: Summer (spring to summer in Australia)
SOIL: Well-drained

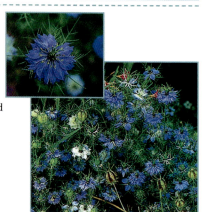

210

LATIN NAME: *Centurea annua*
COMMON NAME: Cornflower, bluebottle, bachelor's buttons
ALTERNATIVES: None
DESCRIPTION: Hardy annual with narrow, lance-shaped leaves on upright, branched stems topped with double daisylike heads of rich blue. Good for cutting. Self-sows freely.
HEIGHT AND SPREAD: 3 x 1 ft.
BLOOMING PERIOD: Spring or summer to fall
SOIL: Well-drained but not dry

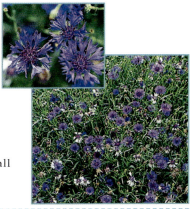

LATIN NAME: *Ipomoea tricolor* 'Heavenly Blue'
COMMON NAME: Morning glory
ALTERNATIVES: *I. purpurea*
DESCRIPTION: Half-hardy annual climber needing support for its twining stems. The light green leaves are large and heart-shaped and the almost circular blue blooms have a white throat. Flowers close in the afternoon.
HEIGHT AND SPREAD: 10 ft.
BLOOMING PERIOD: Early summer to early fall
SOIL: Well-drained, humus-rich

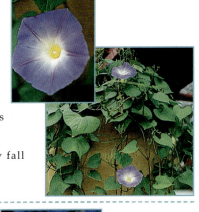

• COLOR IN THE GARDEN •

LATIN NAME: *Hydrangea macrophylla* cultivar
COMMON NAME: Hortensia, mop-head hydrangea, big leaf hydrangea
ALTERNATIVES: 'Blue Deckle', 'Altona'
DESCRIPTION: Shrub of rounded habit with broad leaves, pointed at the tip and large rounded heads made up mainly of showy, sterile florets. On acid soil becomes blue; alkaline soil results in pink flowers.
HEIGHT AND SPREAD: 5 x 5 ft.
BLOOMING PERIOD: Midsummer to early fall
SOIL: Fertile, humus-rich, moisture-retentive but not waterlogged

Flowers in Yellow

There are cool and warm yellows, ranging from acid yellow (mixed with plenty of green but no red) to gold (with red, but not so much that you begin to distinguish it as orange).

Just as with other colors, these two ends of the scale rarely sit well with one another. Yellow is also mixed with white to give a wide variety of cream shades, and these softer colors are perfect for lifting heavy schemes of purple and deep blue.

Yellow reminds us of sunshine and so is particularly effective at livening up dull and shady spots in the garden—try a zingy scheme of yellows with touches of white, lime-green, and sharp orange.

Citrus shades of yellow, orange, and terra-cotta add a Mediterranean feel to a hot, sunny border. Use a backdrop of blue-painted trellis or stand a couple of rich, blue-glazed pots among the flowers for a truly stunning effect.

An all-yellow border is easy to create because there is a wide range of flowers and foliage available throughout the year. But, as with most colors, you can have too much of a good thing. In full sun, the effect can be overwhelming. For contrast and to cool the scheme down, use deep blue-purple and cerise-red blooms and rich green and glaucous foliage. Or raise the temperature with flame-red, orange, and bronze.

LATIN NAME: *Primula polyantha* Rainbow series 'Cream Shades'
COMMON NAME: Polyanthus
ALTERNATIVES: 'Crescendo' seed strains
DESCRIPTION: Short-lived perennial usually grown as a biennial for winter/spring bedding. Makes rosettes of crinkled green leaves from the center of which thick stems carrying stalked circular blooms arise.
HEIGHT AND SPREAD: 9–12 x 12 in.
BLOOMING PERIOD: Late winter to late spring
SOIL: Moisture-retentive but well-drained

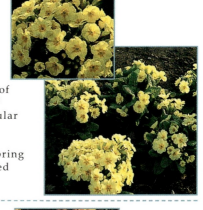

LATIN NAME: *Crocus x luteus* 'Golden Yellow' syn. 'Dutch Yellow'
COMMON NAME: Known by Latin name
ALTERNATIVES: *Crocus chrysanthus* cultivars
DESCRIPTION: Corm of robust nature that naturalizes easily in grass and produces its large, bright yellow, weather-resistant blooms in early spring. Narrow, grassy foliage.
HEIGHT AND SPREAD: 3–4 in.
BLOOMING PERIOD: Early spring
SOIL: Well-drained

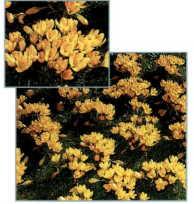

• COLOR IN THE GARDEN •

LATIN NAME: *Narcissus* 'Cheerfulness'
COMMON NAME: Double daffodil
ALTERNATIVES: 'Yellow Cheerfulness', 'Tahiti', 'Unique'
DESCRIPTION: Bulb with narrow, straplike leaves on upright stems topped with buds that open to double, pale yellow, scented blooms. Deadhead once faded. Leave stems and leaves to die down.
HEIGHT AND SPREAD: 15 in.
BLOOMING PERIOD: Midspring
SOIL: Moisture-retentive

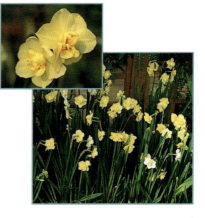

LATIN NAME: *Hemerocallis* 'Dubloon'
COMMON NAME: Day lily
ALTERNATIVES: 'Corky', 'Golden Chimes', 'Favorite Things'
DESCRIPTION: Herbaceous perennial making a clump of long, narrow leaves that are particularly bright and attractive in spring. Slender stems bear clusters of buds and starlike blooms with narrow petals.
HEIGHT AND SPREAD: 2½ x 1½ ft.
BLOOMING PERIOD: Summer
SOIL: Well-drained but moisture-retentive

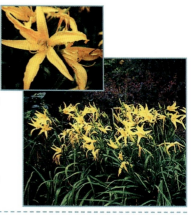

LATIN NAME: *Helianthus annuus*
COMMON NAME: Sunflower
ALTERNATIVES: 'Lemon Queen', 'Titan', 'Mammoth Russian'
DESCRIPTION: Hardy annual making a single stem culminating in a giant flower with a central disk and surrounding circle of petals. The sunflower seeds that develop are attractive to birds in the fall.
HEIGHT AND SPREAD: 4–5 x 1½ ft.
BLOOMING PERIOD: Summer
SOIL: Well-drained

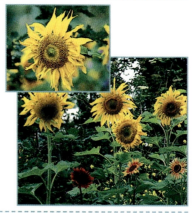

LATIN NAME: *Gazania* 'Dorothy'
COMMON NAME: Known by Latin name
ALTERNATIVES: 'Mini-star Yellow', *G. uniflora* 'Royal Gold', 'Gold Rush'
DESCRIPTION: Tender perennial normally treated as a half-hardy annual making carpets of green lanceolate leaves. Large daisy flowers that only open on bright days and close in the evening.
HEIGHT AND SPREAD: 9 x 8–12 in.
BLOOMING PERIOD: Early summer to midfall
SOIL: Any well-drained; performs well on poor, dry soil and near sea

LATIN NAME: *Kniphofia* 'Gold Else'
COMMON NAME: Red-hot poker, torch lily, tritoma
ALTERNATIVES: 'Buttercup', 'Candlelight', 'Sunningdale Yellow', 'Gold Mine', 'Ada'
DESCRIPTION: Herbaceous perennial making small clumps of grassy leaves and erect, bare-stemmed spikes of soft yellow, downward-facing tubular flowers. Protect roots from frost with a deep mulch.
HEIGHT AND SPREAD: 2½ x 1½ ft.
BLOOMING PERIOD: Midsummer
SOIL: Any well-drained, especially during winter

LATIN NAME: *Dendranthema* 'Sea Urchin'
COMMON NAME: Spray chrysanthemum
ALTERNATIVES: 'Yellow Triumph', 'Golden Mound'
DESCRIPTION: Herbaceous perennial best grown from cuttings taken in spring from last year's rootstocks that have been overwintered under protection. Needs staking and regular feeding and watering.
HEIGHT AND SPREAD: 4 x 2–2½ ft.
BLOOMING PERIOD: Late summer to midfall
SOIL: Light, well-drained, but moisture-retentive

LATIN NAME: *Achillea* 'Moonshine'
COMMON NAME: Yarrow
ALTERNATIVES: 'Taygetea' is very similar
DESCRIPTION: Perennial with flat heads of sulfur-yellow flowers over soft gray-green divided foliage. Evergreen to semievergreen. Unlike taller varieties, 'Moonshine' does not need staking.
HEIGHT AND SPREAD: 24 x 20 in.
BLOOMING PERIOD: Early summer to early fall
SOIL: Any provided fertile and well-drained

• COLOR IN THE GARDEN •

Flowers in Purple

Purple ranges from almost black through deep maroon to pale mauve and lilac.

COLOR MATCHING HANDBOOK

There are warm red-purples and cool blue-purples. Happily, the different colors tend to be quite easy to combine, especially when mixed with purple-green or bronze-purple foliage. Deep purple flowers and foliage blended with other rich colors like scarlet, crimson-red, and deep blue can create brooding and passionate schemes full of drama, especially in dappled shade. Add filigree silver and scatterings of creamy yellow or white to lighten the scheme and make it more romantic.

You can create stunning, theatrical schemes using black-purple varieties of flowers like tulips, bearded iris, dahlias, and violas mixed with white, silver, or bright lime-green flowers and foliage. Deep, glowing purples also contrast well with clear orange, lemon, and golden yellow flowers.

Pastel purples create restful schemes with silver and gray-leaved plants but benefit from dottings of more intense purple-reds that will enliven the scene. In a border where yellows predominate, soft purple flowers and purple-green or bronze foliage plants make the ideal foil.

Purple bulbs, berries, shrubs, and herbaceous perennials come into their own in fall when the golden and flame-orange leaves make a marvelous backdrop.

216

Latin name: *Campanula persicifolia*
Common name: Peach-leaved bellflower
Alternatives: 'Blue Gardenia', 'Grandiflora'
Description: Herbaceous perennial making a basal rosette of slender evergreen leaves from which arise flower stems with bell-shaped blooms of lilac blue. Long in flower and a good self-seeder.
Height and spread: 3 x 1 ft.
Blooming period: Early to late summer
Soil: Any fertile, well-drained

Latin name: *Vinca minor* 'Aureovariegata'
Common name: Lesser Periwinkle, vinca
Alternatives: 'Atropurpurea', 'Bowles Variety' ('La Graveana'), 'Multiplex'
Description: Evergreen subshrub with long trails of pointed yellow-variegated leaves in pairs. Stems root where they touch the ground, forming good ground cover. Purple-blue flowers.
Height and spread: 6 x 36+ in.
Blooming period: Midspring to early summer
Soil: Moisture-retentive

Latin name: *Lavandula amgustifolia* 'Munstead'
Common name: Dwarf lavender
Alternatives: 'Hidcote', 'Twickle Purple', 'Royal Purple'
Description: Evergreen shrub of bushy habit with gray-green aromatic foliage and slender stems carrying short, fragrant spikes. Clip over lightly.
Height and spread: 1½–2½ x 2–2½ ft.
Blooming period: Midsummer
Soil: Well-drained; does well on limey soils

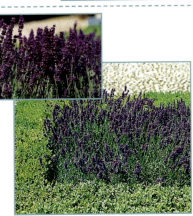

• COLOR IN THE GARDEN •

Latin name: *Iris* cultivar
Common name: Tall bearded iris
Alternatives: 'Sable', 'Matinata', 'Mary Frances'
Description: Herbaceous perennial spreading by thick, fleshy rhizomes. Bold, sword-shaped glaucous-green leaves and flower stems carrying several large, velvet-textured blooms. Some cultivars need staking at flowering time.
Height and spread: 3 ft. x indefinite
Blooming period: Spring to early summer
Soil: Preferably alkaline to neutral, rich, well-drained

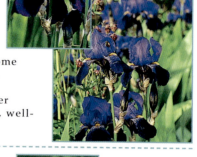

Latin name: *Abutilon* x *suntense*
Common name: Known by Latin name
Alternatives: 'Jermyn's', 'Ralph Gould', 'Violetta', *A. vitifolium*
Description: Frost-hardy shrub making rapid growth and flowering prolifically against a warm wall or in a sheltered border. Light green jagged-edged leaves and dish-shaped mauve flowers. May die off suddenly.
Height and spread: 15 x 10 ft.
Blooming period: Late spring to midsummer
Soil: Any fertile, well-drained

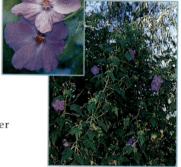

Latin name: *Campanula glomerata* 'Superba'
Common name: Clustered bellflower
Alternatives: 'Joan Elliott'
Description: Herbaceous perennial with a spreading rootstock that is somewhat invasive. Upright stems carry dense, spherical clusters of rich violet-purple, bell-shaped blooms.
Height and spread: 2½ x 2 ft.
Blooming period: Early to midsummer
Soil: Any well-drained

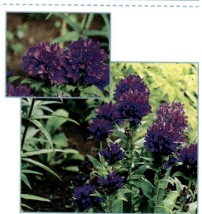

Latin name: *Osteospermum* 'Pink Whirls'
Common name: Known by Latin name
Alternatives: None
Description: Tender, evergreen perennial of sprawling habit with mauve-pink, daisylike blooms with a darker blue-purple center and back. Petals spoon-shaped. Foliage gray-green, toothed edge.
Height and spread: 24 x 12–18 in.
Blooming period: Summer to fall
Soil: Fertile, well-drained

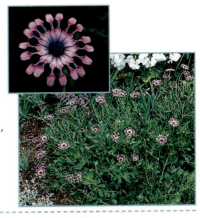

Latin name: *Buddleja davidii* 'Empire Blue'
Common name: Butterfly bush, buddleia
Alternatives: 'Nanho Purple', 'Lochinch', *B.* x *fallowiana*
Description: Shrub with strong growth and upright habit. Foliage dark gray-green, lanceolate. Tapering, light lavender flower heads produced on new wood. Sweetly fragrant. Cut back hard in late winter.
Height and spread: 10–13 x 10–13 ft.
Blooming period: Midsummer to early fall
Soil: Well-drained

Latin name: *Aster* x *frikartii* 'Mönch'
Common name: Michaelmas daisy
Alternatives: *A. frikartii*, 'Wonder of Staffa'
Description: Herbaceous perennial with oval, gray-green leaves and branching flower stems bearing rich lavender-purple daisy flowers with yellow centers. Unlike some asters, *A. frikartii* is mildew resistant.
Height and spread: 36 x 15 in.
Blooming period: Midsummer to midfall
Soil: Fertile, well-drained

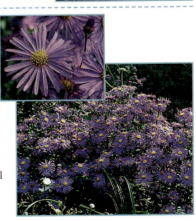

Glossary

ADVANCING COLORS
Colors that appear to come toward the front of the picture plane. The colors that have this property are in general the warm, strong ones, such as reds and bright yellows.

BASE COLOR The foundation or background color of a design, on occasion also called the ground color. Off-white, for instance, is the base color of white Sicilian marble.

BROKEN COLOR A slightly imprecise term sometimes used as a synonym for optical mixing. In fact, broken color simply means color that is not laid as a flat area and does not completely cover another color below or the color of the canvas or paper.

CHLOROPHYLL The green pigment found in plant leaves and stems.

CHROMA The term used to describe and measure the purity of a color. Pure red or blue, for example, are high on the chromatic scale, while neutral gray contains no chroma.

COLORED GROUND Artists working in the opaque paints (which includes pastel) often color their ground before painting. In oil and acrylic, this is usually done by applying a thin layer of paint over a white primer, though some mix pigment into the primer itself. Pastel painters either work on one of the colored papers specially sold for the purpose or prepare watercolor paper by laying a light wash of color.

COMPANION PLANTS Plants that relate in a positive way to their neighboring plants.

COMPLEMENTARY COLORS Pairs of colors that appear opposite one another on the color wheel, such as red and green and violet and yellow. When juxtaposed in a painting they create powerful effects.

DEPTH The illusion of space in a painting.

FOCAL POINT A point to which the eye is drawn.

GLAUCOUS Covered in a bluish bloom.

GROUND A layer of paint or other substance that isolates the support from the paint placed on top. A ground is necessary for oil painting because without it, the oil from the paint

COLOR MATCHING HANDBOOK

220

sinks into the surface of the canvas or board and eventually causes the fibers to rot (*see also* Colored ground).

HARMONIOUS COLOR Colors that are close together on the color wheel (i.e., blues and violets, reds and oranges) and thus do not set up sharp contrasts.

HUE The type of color, on a scale through red, yellow, green, and blue.

IMAGE A term used to describe either the particular subject being painted, the painting itself, or a specific part of the painting.

LOCAL COLOR The actual color of an object regardless of the effects created by light or distance.

PICTURE PLANE The plane occupied by the physical surface of the picture. In most representational

painting, all the elements in the picture appear to recede from this plane, while trompe l'oeil effects are achieved by painting objects in such a way that they seem to project in front of the picture plane.

PIGMENT Finely ground particles of color that form the basis of all paints, including pastels. In the past, pigments came from a wide variety of mineral, plant, and animal sources, but most are now made synthetically.

PRIMARY COLORS Those colors that cannot be made from mixtures of other colors. The primaries are red, yellow, and blue.

RECEDING COLORS Cool colors, such as blues, blue-greens, and blue-grays, that seem to recede from the viewer, while the

warm, strong colors come forward (*see* Advancing colors).

SATURATED COLOR Pure, intense color, unmixed with any black or white.

SECONDARY COLORS The colors made by a mixture of two of the primary colors: green, orange, and purple are all secondary colors.

SUCCESSIONAL PLANTING The positioning of plants in a garden so that one takes its place visually as the other dies back.

TRANSLUCENT COLOR Color that allows you to see the presence of another beneath, in the manner that gauze allows you to see through it.

TRANSPARENT COLOR Color that alters the tint of another beneath it without obscuring it, as tinted sunglasses alter the color of the sky.

• GLOSSARY •

Index

Page numbers in italics refer to illustrations and captions.

A

atmosphere, 64

B

Beach at San Bartolomeo, Andrew Macara, *53*
Beach Study, Arthur Maderson, *62*
black, white, and gray, the colors, 162
 gray, 164
 highlights and accents, 163
 where to use black and white, 162
black, white, and gray, companion colors, 168
blue, the color, 106
 accents and complements, 107
 blue spectrum, 108
 how to use blue, 107
 where to use blue, 106
blue, companion colors, 112
 wood; natural yellow, 112
brown, the color, 154
 accents and coordination, 156
 where to use brown, 154
brown, companion colors, 160
brown and wood panels, the color, 158

C

choosing a color scheme, 88

color, 7
color in art, 33
color character, 15
color in the garden, 171
color harmony, 174
 color wheel, 178
 hot colors, 178
color in the home, 87
color and light, 100
color terms, 16
color wheel, 20
colors, the 76
 black and gray paints, 82
 blue paints, 76
 green paints, 80
 purple and violet paints, 81
 red paints, 79
 starter palettes, 84
 white, 83
 yellow and brown paints, 77
complementary colors, 53
 using complementary colors, 54
creams and neutrals, 146
 companion colors, 147, 152
 how to use cream, 146
 neutral range, 148
creams and neutrals, companion colors, 152

D

deceiving the eye, 31
deciding on the final colors, 42

designing with color, 172
Diane's Pink Gown, Doug Dawson, *70*
discordant and vibrating colors, 28

E

earth and metallic colors, 99
expressive color, 71

F

Fishing for Mackerel, Cleybeach, Jeremy Galton, *39*
flowers
 blue, 209
 green, 199
 orange, 196
 pink, 192
 purple, 216
 red, 202
 white, 206
 yellow, 212
foliage color, 181
 purple-leaved plants, 185
 variegated-leaved plants, 185
form and space, 51

G

getting it together, 103
green, the color, 114
 green spectrum, 117
 highlights and companion colors, 116

COLOR MATCHING HANDBOOK •

222

where to use green, 114
green, companion colors, 120

H
harmonious and complementary colors, 25
complementary mixtures, 25
harmony, 67
how colors work together, 26

I
interpreting color, 73
adjusting the balance, 73
dominant color, 74

J
judging color relationships, 36
making color notes, 36

L
Low Tide, Charmouth, Hazel Harrison, *40*

M
method for direct color matching by Jeremy Galton, 45
other color matching methods, 45
Mistral Plain, Robert Buhler, *60*
mixing primaries, 17
to make secondaries, 18

N
notes on color, 173
background structures, 173
color ideas, 173

increasing plants, 173
mixing colors, 173

O
optical mixing, 30
orange and peach, the colors, 130
related colors, 131
where to use orange, 130
orange and peach, companion colors, 136

P
pattern and color echoes, 60
Portsmouth, Albert Goodwin, *57*
properties of color, 9
Provençal Village, Lacoste, Jeremy Galton, *46*

R
red and pink, the colors, 138
pink, 142
red spectrum, 142
texture, 140
where to use red, 138
red and pink, companion colors, 144
responses to color, 12
Rolled Hay, Doug Dawson, *69*
Rydal Water, Moira Clinch, *38*

S
secondary colors, 22
seeing colors you want to paint, 34
mixing the right color, 35
single-color schemes, 186
Still City, Early Dawn, Robert Buhler, *68*

Still Life with Daffodil, Jeremy Galton, *34*
successional planting, 188
Sunshine Stakes, Weymouth, Arthur Maderson, *37*
Supper with Bernard off the Piazza Bra, Diana Armfield, *62*

T
thinking in color, 49
Three Geraniums, Robin Mackertitch, *55*
tonal values, 50
tone and color, 52
Turkish Robe, John Ward, *58*

U
understanding color, 8
using color, 93
discordant colors, 95
off hues, 95
single-color rooms, 97

W
warm and cool colors, 98
warm and cool, dark and light colors, 24, 56
color balance, 59
color temperatures, 56
what is color?, 10

Y
yellow and gold, the colors, 122
yellow and gold, companion colors, 128
accents and highlights, 123
choosing the shades, 123
where to use yellow, 122
yellow spectrum, 125

• INDEX •

Picture Credits
&
Acknowledgments

The material in this book previously appeared in:

Art School, by Colin Saxton

Choosing and Mixing Colours for Painting, by Jeremy Galton

Companion Planting, by Richard Bird

The Complete Painting Course, by Ian Simpson

Creative Colour Schemes, by Virginia Stourton & Yvonne Rees

Drawing with Colour, by Judy Martin

The Gardener's Palette, by Jenny Hendy

Paint Effects, by Emma Callery

Paint Finishes, by Charles Hemming

The Painted Kitchen, by Henry Donovan